STRUCTURING YOUR NOVEL

ABOUT THE AUTHORS

Robert C. Meredith and John D. Fitzgerald are well qualified to prepare a book on novel writing. Mr. Meredith was Chairman of the English Department at Chicago State University and taught creative writing for many years. Mr. Fitzgerald, a professional writer, also taught creative writing. They are co-authors of the very successful textbook on short-story writing, *The Professional Story Writer and His Art,* and of several articles on writing the novel which have appeared in *The Writer's Digest.*

Mr. Meredith is the author of several short stories and three books on writing, *Writing in Action, An Anthology for Young Writers* and *The Art of Composition.* Mr. Fitzgerald is the author of more than two hundred published short stories and five novels, including *The Great Brain, Mama's Boarding House, Uncle Will and the Fitzgerald Curse,* and *Papa Married a Mormon.* His novels were selected by five book clubs and have been published in seven foreign countries. *Papa Married a Mormon* made all best-seller lists.

Structuring Your Novel:

From Basic Idea to Finished Manuscript

ROBERT C. MEREDITH

and

JOHN D. FITZGERALD

 HarperPerennial

A Division of HarperCollins*Publishers*

The authors are grateful to the following authors and publishers for permission to reprint excerpts from the following novels:

From Here to Eternity by James Jones, copyright 1951 by James Jones. Reprinted by permission of Charles Scribner's Sons and Collins Publishers.

The Pearl by John Steinbeck, copyright 1945 by John Steinbeck. Reprinted by permission of The Viking Press, Inc. and McIntosh and Otis, Inc.

The Spy Who Came in from the Cold by John le Carré, copyright © 1963 by Victor Gollancz. Reprinted by permission of Coward-McCann, Inc. and A. P. Watt & Son.

The Grapes of Wrath by John Steinbeck, copyright 1939, copyright © renewed 1967 by John Steinbeck. Reprinted by permission of The Viking Press, Inc. and McIntosh and Otis, Inc.

To Kill A Mockingbird by Harper Lee, copyright © 1960 by Harper Lee. Reprinted by permission of J. B. Lippincott Co., William Heinemann Ltd., and McIntosh and Otis, Inc.

Madame Bovary by Gustave Flaubert. Reprinted by permission of Airmont Classics.

Tom Jones by Henry Fielding. Reprinted by permission of Airmont Classics.

The authors also wish to acknowledge that portions of this book originally appeared in *The Writer's Digest*.

HarperCollins books may be purchased for educational, business, or sales promotional use. For information, please call or write: Special Markets Department, HarperCollins Publishers, Inc., 10 East 53rd Street, New York, NY 10022.

First HarperPerennial edition published 1993

LIBRARY OF CONGRESS CATALOG CARD NUMBER 70-170126

ISBN 0-06-273170-X (pbk)

98 H 10 9 8

Contents

Contents

Preface

The purpose of this book is to teach the would-be novelist the techniques employed by successful novelists. Readers who have never written a novel may learn how to write one, and those who have started a novel that they have not been able to finish may learn how to complete it. Those who have written a novel that was rejected by several publishers will learn how to rewrite the novel to make it salable. Readers who have had a first novel published which received poor reviews and had low sales may learn how to make their next novel a success.

We must qualify the last paragraph with the statement that obviously no book on writing can make a successful novelist out of anybody who lacks the inherent talent to write fiction. What we do suggest is that if readers have such ability, this book may enable them to produce a salable novel. The mere fact that a person is reading this book indicates that perhaps he or she has the talent to write a novel. A musician who desires to write music is likely to become a composer. So too with the writer; the desire to write a novel will probably lead him or her to become a novelist. In both cases the individual is limited only by the inherent talent he or she possesses. Some readers of this book will write popular (commercial) novels and some will write literary novels, just as some composers write popular songs and some symphonies.

This book is designed to help would-be novelists find their own level in the field of novel writing. It is also designed to teach them craftsmanship without restricting creativity. We know that writing a novel is not a mechanical process but an individual creative effort born out of the writer's knowledge, observations, conclusions, and personal experiences about life.

We believe this is the only available book of its kind which defines and illustrates the use of the elements of structure found in all traditional novels and which explores the techniques of craftsmanship employed by successful novelists. These fourteen elements of structure have proved to be durable in the history of the novel. They can be found in the novels of Dumas, Thackeray, Dickens,

Tolstoy, the Brontës, James, Dreiser, Wolfe, Maugham, Ferber, Cozzens, Marquand, Mailer, Wouk, O'Hara, Bellow, Ellison, and Gold, and in the novels appearing currently on best-seller lists and selected by major book clubs. These novels are called "traditional" because they all possess the fourteen elements of structure and are written in the traditional way.

A few nontraditional novels are, of course, published each year. However, since most novels published today and to be published in the near future are traditional novels, we will confine this book to the writing of the traditional novel. Nontraditional novels will be discussed briefly in the last chapter.

To show the wide range of the traditional novel, we have selected for study two novels that are classics, three well-known American novels, and two contemporary novels. Some of these are popular novels and some are literary novels; some are novels with a plot and some are novels with a story line. Copies of these novels are available in paperback editions or at public libraries. To get the full benefit of this book, the reader should study all seven novels and also reread some of his favorite novels to see how the principles of craftsmanship were employed. He will then be able to use these principles intelligently in writing his own novel.

The exercises that accompany each chapter will help the reader further in applying these principles. Part I of the exercises is designed to stimulate his imagination and get him involved in the actual writing, using the principles set forth in each chapter. Part II tests his understanding of what he has learned. For easy reference and review, each chapter dealing with one or more of the elements of structure is preceded by a statement summarizing that element (or elements) of structure.

We selected the following novels: *Madame Bovary* by Gustave Flaubert because it is known as a "novelist's novel"; *Tom Jones* by Henry Fielding because it has one of the best plot structures of any novel ever written; *The Grapes of Wrath* by John Steinbeck because it is a novel of great range, force, and compassion; *The Pearl* by John Steinbeck because it is a novella (short novel) illustrating key techniques of craftsmanship; *From Here to Eternity* by James Jones because it has a powerful story line based on personal experience (it also won the National Book Award); *To Kill a Mockingbird* by Harper Lee because it is a first novel that won the

Pulitzer Prize for its literary excellence and timeliness; and *The Spy Who Came in from the Cold* by John le Carré because we wanted to include a mystery novel, and because it has received international attention and acclaim.

1

How to Develop an Idea into a Novel and Test It

All traditional novels begin with an idea that inspires the author to write it.

The source of ideas for a novel is unlimited because novels are about people and life. One of the principal sources is personal experience.

An idea based on an actual personal experience

In using this source remember that a true account of a personal experience would be nonfiction. A novel based on personal experience contains some fictional events and exaggerates the actual experience to make it more interesting, or exciting, or meaningful than perhaps it actually was. Personal experience during the Spanish Civil War inspired Hemingway to write *For Whom the Bell Tolls*. The idea for *From Here to Eternity* came from James Jones's personal experience as a peacetime soldier in the United States Army. Harper Lee based *To Kill a Mockingbird* on her personal experience as a child in a small Southern town. *David Copperfield* is a fictionalized version of Charles Dickens as a boy. Nine out of ten first novels published are based on actual personal experience; thus the would-be novelist should give this source careful consideration.

An idea based on something that might have happened during a personal experience

A personal experience often suggests something that might have happened that could be used as the basis for a novel. John Steinbeck worked for a time as a marine biologist in southern California. During that period he came to know many poor pearl fishermen. He never did meet a poor pearl fisherman who found a priceless pearl, but he thought about what might happen if one of the fishermen actually found one. It was this idea that inspired him to write *The Pearl*. John le Carré (real name David Cornwell) was a member of Her Majesty's Secret Service and also served in the British foreign service. He may never have really met a British spy who pretended to defect to the East. But he found himself imagining what might happen if a British spy did pretend to do so. This idea arising out of personal experience inspired him to write *The Spy Who Came in from the Cold*.

An idea based on a philosophical conclusion about life as a result of a personal experience

Fielding's personal experience convinced him that man often fails to see goodness in anybody. He decided he could best portray this conclusion in fiction by using a protagonist born out of wedlock. The novel he wrote was *Tom Jones*. James Joyce reached certain philosophical conclusions about life and art as a result of his education in Dublin and wrote *A Portrait of the Artist as a Young Man* to present these conclusions in fictional form.

A personal experience based on something we see or hear can provide an idea for a novel.

The sight of a jalopy filled with Okies gave Steinbeck the idea for *The Grapes of Wrath*. Somerset Maugham heard about the life of the French artist, Gauguin, out in the South Pacific, and this gave him the idea for *The Moon and Sixpence*.

Although personal experience is the most common source of ideas that inspire novels, there are many others.

History is a source of ideas for novels.

A person may become so fascinated by a historical personage that he will be inspired to recreate that life in fiction. *The Agony*

and the Ecstasy by Irving Stone is an example. Or a person may become so enthralled with a certain period in history that he will write a historical novel, as did Margaret Mitchell (*Gone with the Wind*). The Bible is a frequent source of ideas for novels; a well-known example is Douglas's *The Robe*. The thing to remember in writing a historical novel is that you are writing fiction, not history. Generally, historical novels are only partly factual and mostly fiction, the author having exaggerated the historical content and added fictitious characters and events to enhance reader interest.

A friend or acquaintance will sometimes give an author an idea for a novel.

Louis Bouilhet suggested to Flaubert that he write a novel about a Norman physician's wife who had committed suicide. The novel Flaubert wrote was, of course, *Madame Bovary*. A chance remark by William Dean Howells to Jonathan Sturges, reported by the latter to Henry James, was the source of the idea for James's *The Ambassadors*.

A strong feeling *against* something can provide an idea for a novel.

A classic example is *The Adventures of Huckleberry Finn* by Mark Twain, a novel that indicts slavery. A contemporary example is *The Ugly American* by Lederer and Burdick, which exposes our embassies in Asia as incompetent.

A strong feeling *for* something can provide an idea for a novel.

Harriet Beecher Stowe's strong feeling for the abolition of slavery inspired her to write the classic, *Uncle Tom's Cabin*. A contemporary example is *A Guest of Honour* by Nadine Gordimer, whose strong desire to help the underdeveloped regions of South Africa gave her the idea for the novel.

A current event or a newspaper story can provide an idea for a novel.

A classic example is *Robinson Crusoe* by Defoe. A well-known American novel based on a newspaper report is *An American Tragedy* by Theodore Dreiser. It was inspired by the much-publicized Chester Gillette-Grace Brown case.

A chance incident can provide an idea for a novel.

It does not matter whether the incident is real or imagined. What is important is that it sticks in the mind of the writer. Such an incident occurred in Graham's Greene's thought, and it was nothing more than the idea of the arrival in a leper colony of a stranger. This imagined incident served as the basic idea for his novel *A Burnt-Out Case.* Joseph Conrad mentions a number of chance incidents, some of them lasting no more than a few moments, in which he met the major characters of his novel *Victory,* and these incidents coalesced to form the basis of the novel.

A burning desire to live an adventurous life the author has never personally experienced is a source of ideas for novels.

Not only is this responsible for the romantic adventure novel, such as Hervey Allen's *Anthony Adverse,* but also for the many mystery and science-fiction novels that are published each year.

A change in the manners and mores of society resulting in a relaxation of the publishing taboos of the past can provide ideas for novels.

Changing attitudes toward sex and the abandoning of censorship of published material have led to a deluge of sex novels and novels depicting previously taboo subjects such as homosexuality and lesbianism. Examples of novels that frankly exploit current interests of this kind are Gore Vidal's *Myra Breckenridge* and Joyce Elbert's *The Crazy Ladies.*

The introduction of new inventions into our society is a source of ideas for novels.

For example, Burdick and Wheeler's *Fail-Safe* could not have been written as a realistic possibility prior to the discovery of the atom bomb because it is based on that discovery.

Social upheavals are a source of ideas for novels.

As an illustration, the black American's just demand for equal rights and the social unrest in this country have been the subject of novels like *Back Seat in the Bus* and *Another Country* by James Baldwin. Similarly, **wars** are a source of ideas for novels even though their authors may not have been military participants. Examples of such novels are Tolstoy's *War and Peace* and Crane's

The Red Badge of Courage. **A strong interest in some business or industry** may also provide an idea for a novel, as in the case of Arthur Hailey's novels *Hotel* and *Airport.* Even **diseases** are a source of ideas for novels. A good example is Erich Segal's *Love Story,* which is about the death of a young wife from leukemia. In short, anything that happens in this world having any effect upon human beings can provide an idea for a novel.

Every reader of this book must have an idea for a novel of his own or he wouldn't be reading this. We will now show the reader how to test his idea to see if it merits being made into a novel.

1. The idea must give rise to the author's intention to use it in writing a novel, and he should be able to state his intention in a single sentence.

An intention is a psychological necessity for the performance of any act. In novel writing, it is also a way of clarifying in the author's mind the focal point of his idea. An intention records the principal subject matter of the idea and commits the author to the task of writing the novel. Let us illustrate this principle with some of the novels we have selected for study. These are the intentions of the authors:

Madame Bovary: To write a novel about the wife of a physician living in small French villages whose adultery, extravagances, and self-indulgence drive her to suicide. *Tom Jones:* To write a novel about a foundling boy to show that he is his own worst enemy until he can be recognized for what he really is—legitimate and good in heart. *From Here to Eternity:* To write a novel based on personal experience as a peacetime soldier. *The Grapes of Wrath:* To write a novel about the life of migrant workers during the 1930's. *The Pearl:* To write a novel about a poor pearl fisherman who finds a priceless pearl. *To Kill a Mockingbird:* To write a novel based on personal experience as a child in a small southern town. *The Spy Who Came in from the Cold:* To write a novel about a British spy who pretends to defect to the East.

2. Before beginning a novel, a novelist must state with integrity what his attitude is toward his intention, and he must be able to state his attitude in a single sentence.

This principle reaches right down into the guts of a writer. A novelist's attitude toward his intention must be strong and all-

consuming with no room for doubt. It must remain constant throughout the novel and cannot change or weaken. Let us apply this principle to some of the novels selected for study by formulating the probable attitudes of the authors toward their intentions:

Madame Bovary: A strong belief in the sanctity of the marriage vows. *Tom Jones:* A strong belief that a person's basic goodness could be a greater threat to him than the malice and hypocrisy of others. *From Here to Eternity:* A strong belief that peacetime military service degrades character. *To Kill a Mockingbird:* A profound love for a father who helped her grow up in a motherless home, and a strong belief in racial tolerance. *The Spy Who Came in from the Cold:* A strong belief that international espionage is a cold-blooded, cruel, and heartless business.

We cannot stress enough that an author's attitude toward his intention must be strong and unwavering because his attitude will determine the theme of the novel. If Jones's attitude toward his intention had been that the life of a peacetime soldier builds character, an entirely different novel with an entirely different theme would have resulted. If Flaubert's attitude toward his intention had been that a woman who committed adultery and wasted her husband's money faced no penalties in life, he would have produced an entirely different novel from *Madame Bovary.*

3. A novelist's attitude toward his intention must result in a statement of purpose for wanting to write the novel. He should be able to state his purpose in a single sentence. This statement of purpose will point the direction he must take in writing the novel.

The failure of the would-be novelist to state his attitude with complete integrity can only result in a statement of purpose that will be too weak for the creation of a salable novel. When a novelist's attitude is strong, clear, and meaningful, then his purpose in writing the novel will also be strong, clear, and meaningful. We are not using the word purpose to indicate the author's "message," but to indicate the *reason why* the author wants to write the novel. In other words, just what is the author trying to prove about life with his novel? To illustrate this principle let us look at some of the novels selected for study and determine *why* the authors wrote them.

Madame Bovary: To *prove* that violation of the marriage vows

can lead only to the disintegration of character. *Tom Jones:* To *prove* that every time a person demonstrates his basic goodness, there are others who turn his actions to their own advantage, discouraging his good intentions and perhaps leading him to wickedness. *From Here to Eternity:* To *prove* that the life of a peacetime soldier can lead only to the degradation of character. *To Kill a Mockingbird:* To *prove* that a good and wise father can successfully develop the character of his children in a motherless home, and that racial bigotry in the Deep South is a stronger force than civil law. *The Spy Who Came in from the Cold:* To *prove* that international espionage as practiced by civilized countries uses human beings as pawns.

At this point in developing an idea into a novel, if the word *prove* doesn't appear in the statement of purpose, the would-be novelist might as well give up his idea because it has failed to pass the test. In other words, if the would-be novelist cannot prove something about life in writing a novel, it simply means that he has nothing of interest to say. Moreover, if the word *prove* doesn't appear in his statement of purpose, it will be difficult if not impossible for him to develop a good, strong theme because it is an author's interpretation of his statement of purpose that results in the theme of a novel. We will discuss and illustrate this in detail in Chapter 5.

We have said in our principle that a statement of purpose points the direction an author must take in writing a novel. Let us now clarify this for the reader with an example.

James Jones's purpose in writing *From Here to Eternity* was "to prove that the life of a peacetime soldier can lead only to the degradation of character." This statement of purpose points the direction as follows:

(a) It points to a peacetime Army base as the environment for the novel.

(b) It tells the author he is going to write a novel about character disintegration and therefore his protagonist must be of good character in the beginning of the novel.

(c) It places the protagonist in conflict with his environment.

(d) It sets the stage for the struggle between "good" and "evil."

(e) It indicates to the author what the protagonist's chief motivating force and its tangible objective are to be, and from this, the author begins to visualize his story line.

We realize at this point that the reader will not understand some of the common elements of structure we have used in this example. These will be discussed and illustrated in later chapters. We have mentioned them here to impress upon the reader the great importance of learning how to develop an idea into an intention, and an intention into an attitude, to arrive at a statement of purpose that will point the direction he must take in writing his novel.

After the would-be novelist has arrived at a statement of purpose that has passed the test, he must ask himself a very important question:

Am I qualified by personal experience to write this novel, and if not, am I willing to spend the time necessary in research to make myself qualified?

The failure of many would-be novelists to answer this question honestly results in their wasting time trying to write a novel. Many people blithely embark upon writing a murder mystery without the slightest idea of police procedures. And people who have lived in a small town all their lives sometimes try to write a novel with a big city setting. We could cite dozens of examples from novels submitted by students which clearly indicate that these students were not qualified to write the novels. The following principle is therefore extremely important:

To write a salable novel the author must know the people and environment the novel depicts either from personal experience or from detailed research.

Flaubert knew before writing *Madame Bovary* that he would have to do some medical research in order to portray Charles Bovary realistically as a doctor. He also knew that he would have to familiarize himself with life in a small French village during the period of his novel. Fielding already had personal experience that qualified him to write about rural and urban life of the period of *Tom Jones*. Steinbeck was qualified from his experience as a marine biologist in southern California to write *The Pearl*, but he knew he would have to do considerable research on migrant workers during the 1930's before beginning *The Grapes of Wrath*. James Jones's service in the peacetime Army enabled him to portray so realistically in *From Here to Eternity* the many types of soldiers and the conditions of their daily existence. Similarly, John

le Carré's work in Her Majesty's Secret Service and the British foreign service gave him the necessary background to write *The Spy Who Came in from the Cold*. Harper Lee, having lived in a small southern town, could use this setting convincingly in *To Kill a Mockingbird*.

Because knowledge of the people and the setting of a novel is so essential, we suggest that the reader base his first novel on personal experience. If he is haunted by the fear of "rattling skeletons in the family closet," he can change the names of things, places, and characters. If he is afraid of exposing sides of his character to friends and the public, he can write his novel in the third person.

We come now to the exercises for this chapter. Part I is designed to get the reader started on his novel immediately. The Part I exercises must be completed before the reader goes on to the exercises in the next chapter. This holds true of Part I of the exercises for each succeeding chapter. By the time the reader completes all the Part I exercises in the book he should have five chapters of his novel written. The Part II exercises are designed to test the reader's knowledge of the techniques he has learned in each chapter. By the time he finishes all the Part II exercises he will have sufficient knowledge of novel writing to complete his novel.

Exercises for Chapter 1

Part I

1. State in a few words the source of the idea for your novel and what the idea is.
2. State in a single sentence what your intention is toward your idea.
3. State in a single sentence what your attitude is toward your intention.
4. Explain why you believe your attitude is strong, clear, and meaningful.
5. State in a single sentence what your purpose is in wanting to write this novel.
6. Does the word *prove* appear in your statement of purpose?
7. Do you honestly believe your statement of purpose will point the direction you must take in writing this novel?
8. Are you qualified from personal experience to write this novel?

9. If not, are you willing to start right now doing the necessary research to make yourself qualified?

Part II

1. After reading *The Grapes of Wrath*, which of the following attitudes do you believe to be correct?
 (a) A strong feeling of compassion for migrant workers during the 1930's.
 (b) A strong belief that nature was cruel to the Okies during the 1930's.
 (c) A strong belief that better farming methods were essential if the conditions of the dust bowl were not to be repeated.
2. After reading *The Pearl*, which of the following attitudes do you believe is correct?
 (a) A strong belief that men are naturally greedy.
 (b) A strong belief that sudden riches cannot bring happiness.
 (c) A strong belief that the lives of pearl fishermen are basically unhappy.
3. After reading *The Grapes of Wrath*, which of the following statements of purpose do you believe is correct?
 (a) To prove that migrant workers during the 1930's were forced to live under poverty-stricken conditions no matter where they went.
 (b) To prove the people of Oklahoma were inherently better than the people in California.
 (c) To prove that nature controls man's destiny.
4. After reading *The Pearl*, which of the following statements of purpose do you believe is correct?
 (a) To prove that the discovery of a large pearl will corrupt any man.
 (b) To prove that pearls are bad luck for anybody who possesses them.
 (c) To prove that dreams of wealth of a poor but happy man will corrupt his happiness and tend to destroy his home.

2

How to Develop the Basic Conflict

All traditional novels have a protagonist representing a group, a class, a profession, or some other segment of society who is in conflict with his own environment or the environment of others.

All traditional novels have a protagonist with a chief motivating force and a tangible objective.

These are the two elements of structure for developing the basic conflict in a traditional novel. Let us begin by defining a protagonist.

The protagonist in a novel can be singular (just the main character) or plural (more than one of the leading characters).

Two of Steinbeck's novels will illustrate this. In *The Pearl,* Kino is a single protagonist. In *The Grapes of Wrath,* the Joad family is a plural protagonist.

The reader has only to look at his intention toward his idea to know what group, class, profession, or other segment of society his protagonist will represent. Flaubert's intention suggested that his protagonist, Emma, in *Madame Bovary* would represent as a group many married women in the nineteenth century living in small French villages, filled with boredom and longing for romantic escape. Fielding's intention suggested that his protagonist, Tom, in *Tom Jones,* would represent as a group all young men born

out of wedlock and searching for their true identity who are good-hearted and generous to a fault. Jones's intention suggested that his protagonist, Robert E. Lee Prewitt, in *From Here to Eternity,* would represent as a profession all peacetime Army career soldiers of good character. Le Carré's intention suggested that his protagonist, Leamas, in *The Spy Who Came in from the Cold,* would represent as a profession all British international spies. Harper Lee's intention suggested that her plural protagonist, the Finch family, in *To Kill a Mockingbird,* would have a father representing as a profession all lawyers who believed in the sanctity of the law, and as a group all widowers left with motherless children to raise, and children, Scout and Jem, representing as a group all children growing up to the age of reason in a motherless home.

Before going any further it is imperative that the reader fully understand what is meant by environment in a traditional novel.

Environment in all traditional novels is composed of three elements: one or more physical settings; a generalized significance that grows out of the social, moral, and cultural human intercourse within each setting; and an atmosphere that is the emotional mood of each setting.

The reader has only to look at his *idea* for a suggestion as to the physical setting or settings of his novel. Flaubert's idea of writing a novel about a Norman physician's wife living in small French villages who committed suicide predetermined the physical settings for *Madame Bovary*—they must obviously be small French villages. Fielding's idea of writing a novel based on personal experience indicated that he would use physical settings he knew such as the rural villages and farms, the roads and inns, and the urban metropolis of London for his novel *Tom Jones.* Jones's idea of writing a novel based on his service as a peacetime soldier required that he use a peacetime Army base and a nearby city as settings in *From Here to Eternity.* Le Carré's idea of writing a novel based on his work in Her Majesty's Secret Service called for the use of settings he knew from experience in *The Spy Who Came in from the Cold.* Harper Lee's idea of writing a novel based on her early life predetermined that she would use a small southern town like the one in which she was raised in *To Kill a Mockingbird.*

The generalized significance and the atmosphere of an environ-

ment in a traditional novel are dependent on the viewpoint used and on the author's attitude and statement of purpose. When the viewpoint shifts from one narrator to another the generalized significance and atmosphere of the novel *may* or *may not* change. When only one narrator is used the generalized significance remains constant and the atmosphere *may* or *may not* change. Let us clarify this with some illustrations.

In *Madame Bovary,* from Emma's point of view the generalized significance of the settings grows out of the narrow, insipid, humdrum qualities of the lives led in these small French villages. The atmosphere for Emma changes from moods of joy to moods of desperation. From the point of view of her husband Charles and other narrators, the generalized significance grows out of a satisfied acceptance that borders on smugness in these same small French villages, and the atmosphere from the viewpoint of these narrators is one of tranquillity, peace, and happiness. To a lesser extent we find the generalized significance in *From Here to Eternity* changing with a shift in narrators. It is Warden who comes nearest to articulating the generalized significance of the settings as the preponderant mindlessness and dehumanizing strength of the military system, but Warden learns to live with the system, whereas Prewitt fights the system and destroys himself in doing so. The atmosphere varies from one of dehumanizing brutality to attempts at gaiety. In *To Kill a Mockingbird* the generalized significance and atmosphere change with narrators. The generalized significance of the town of Maycomb to Scout is that it is puzzling and full of irrational demands as she grows up: it would be much simpler to go on being a tomboy able to swear. The generalized significance to Atticus concerns the various tribes of man and their interaction with one another, specifically that conflict between those who are human and mature and those who remain locked in their culture when humanity is tested. The atmosphere of the novel varies from joy, to puzzlement, to fear, to humor, and to a sense of change. In *Tom Jones* the generalized significance does not change: it indicates the relative possibilities for innocence and virtue in rural England and the great possibilities for human degradation in a large city. The atmosphere varies from the idyllic mood of rural villages and farms to the frenzied pursuit of the road journey portion of the novel to the atmosphere of pending disaster in the

final comic release in the London portion. In *The Spy Who Came in from the Cold* the generalized significance does *not* change although there is a shift in narrators from Leamas to Liz Gold. It grows out of an international conflict of differing ideologies; the way in which human lives are expended or saved seems irrelevant to the ideological tangles in which human beings are trapped. The atmosphere remains constant throughout the novel, being an emotional mood of suspense and danger.

With an understanding of what environment is in the traditional novel the reader is now prepared to set the stage for the basic conflict in his novel.

To set the stage for the basic conflict in a traditional novel, place the protagonist in conflict with his own environment or the environment of others.

In real life we react to our environment in one of the following ways:

(a) We are satisfied with the status quo of our environment.

(b) We are dissatisfied with the status quo of our environment.

(c) We are satisfied with the status quo of our environment part of the time and dissatisfied part of the time.

The reader can readily see that the first of these real-life principles is the least likely to produce any conflict. The novelist, therefore, knows he must derive the conflict in his novel from one of the other principles. Experience has taught the novelist that he can broaden these two real-life principles into ten principles for placing a protagonist in conflict with his own environment or the environment of others, to set the stage for the basic conflict in a novel. In some traditional novels only one of these principles is used; in others more than one is used. Let us now look at these ten principles.

1. A change within the environment that affects the protagonist can put the protagonist in conflict with the environment.

This is one of the two principles used in *To Kill a Mockingbird*. Scout Finch comes into conflict with her environment when it changes from one of carefree childhood to one of social responsibility as she grows up. Upon reaching an age when she must attend school, the change in her environment places restraints on her personality. This produces conflict between her and the change.

As she grows older her environment continues to change. She must give up her tomboy ways which were all right in her childhood environment; her brother Jem grows away from her; her aunt Alexandra comes to live with the family, changing the old environment of her home life. This all sets the stage for part of the basic conflict in the novel.

2. Uprooting a protagonist from one environment and placing him in a strange environment can put him into conflict with the environment.

A classic example of this principle is *Robinson Crusoe* by Defoe. The single protagonist is shipwrecked and finds himself the sole survivor on an island. A contemporary example is *Lord of the Flies* by Golding. Here the plural protagonists are placed on an island as a result of an airplane crash.

In using this principle the reader must keep in mind that the "uprooting" is an event which is outside the character of the protagonist and something over which he personally had no control. The principle, for example, would not apply to *The Grapes of Wrath* in which the Joad family uprooted themselves from the dust bowl in Oklahoma.

3. Placing a protagonist in an environment that is in conflict with another environment puts the protagonist in conflict with the environment of others.

This is the principle used in *The Spy Who Came in from the Cold*. Leamas as a British spy is placed in conflict with the environment of the East German spy system during the Cold War. This is also one of the two principles used in *The Grapes of Wrath*. Upon their arrival in California the Joad family find themselves in an environment (that of the migrant workers) that is in conflict with the environment of others (the fruit growers).

4. Placing a protagonist in an environment he wants to change can put the protagonist in conflict with the environment.

This is the principle used in Silone's novel, *Fontamara*. The protagonist, Berardo, like all poor peasants, is in perpetual conflict with the poverty-stricken land, but even age-old conditions are altered for the worse when the rise of fascism brings Berardo into open conflict with an environment he wants to change.

5. Giving a protagonist an environment to conquer puts the protagonist in conflict with the environment.

A classic example of this principle is Balzac's novel *Old Goriot,* in which the protagonist, Rastignac, tries to conquer the environment of upper-world Parisian life. The environment to be conquered can also be an inanimate one, such as the mountain in *White Tower* by Ullman.

6. Placing a protagonist in an environment from which he wants to escape puts the protagonist in conflict with the environment.

This is the most frequently used principle for developing the basic conflict in a traditional novel. It is the principle Flaubert used in *Madame Bovary.* Emma wants to escape from the dull, prosaic, unromantic environment of the provincial French villages where she lives with her husband, Charles. It is also one of the two principles used in *The Grapes of Wrath.* The Joad family want to escape from their poverty-stricken environment in the dust bowl in Oklahoma.

7. Placing a protagonist in an environment in which he is not wanted puts the protagonist in conflict with the environment.

The difference between principles 6 and 7 lies in the difference between a protagonist's wanting to escape from an environment and his wanting to be accepted by it. Fielding employs principle 7 in *Tom Jones.* Tom comes into conflict with an environment in which he is not wanted because of his supposed birth as a bastard, although he only wants to be accepted. A contemporary novel using this principle is *The Man Within* by Graham Greene.

8. Placing a protagonist in an environment for which he is unsuited by character puts the protagonist in conflict with the environment.

A classic example of this principle is *The Adventures of Huckleberry Finn* by Mark Twain. A contemporary example is *The Winter of Our Discontent* by Steinbeck, in which the protagonist, Ethan Allen Hawley, is unsuited by character for the environment of corrupt commercialism.

9. A change in the status quo of the protagonist within the environment can put the protagonist in conflict with the environment.

This is the principle Jones used in *From Here to Eternity*. The protagonist, Robert E. Lee Prewitt, is a gifted young man of good character wanting only to make a career of Army life. He is given promotions and shown many favors until he blinds an opponent while boxing. As a result, he makes a decision never to box again. This change in his status quo brings him into conflict with his Army environment because his superior officers want him to continue boxing with the hope of his winning the welterweight championship for his company and regiment.

This is also one of the two principles used by Harper Lee in *To Kill a Mockingbird*. Atticus Finch is in harmony with his own environment of Maycomb until he makes a decision to defend the African-American, Tom Robinson, who has been accused of raping a white girl. This decision changes Atticus's status quo in the town of Maycomb by bringing him in conflict with the racial bigotry existing in the environment.

10. A change in the status quo of an environment can put the protagonist in conflict with the environment.

This is a principle used in novels of wars and revolutions in which governments change hands, thereby changing the status quo of the political environment. It is most often used in historical novels, for example, *Gone with the Wind* by Margaret Mitchell during which the status quo of the environment of the Confederacy changed. The principle can also be used in topical novels such as *Peaceable Lane* by Keith Wheeler in which a black's move into an all-white neighborhood changes the status quo.

The reader will find that all traditional novels employ one or more of these ten principles for setting the stage for the basic conflict. The reader should have no trouble deciding which one or more of these principles to use in his own novel because his idea, intention, attitude, and purpose will suggest the proper choice. Let us illustrate this with one of the novels selected for study.

Madame Bovary: Idea—a suggestion by a friend that Flaubert write a novel about a Norman physician's wife who committed

suicide. *Intention*—to write a novel about the wife of a physician living in small French villages whose adultery, extravagances, and self-indulgence drive her to suicide. *Attitude*—a strong belief in the sanctity of the marriage vows. *Purpose*—to prove that violation of the marriage vows can lead only to the disintegration of character.

In studying the preceding paragraph the reader can come to only one conclusion—the protagonist was in conflict with an environment from which she was trying to escape. Emma tries to escape from her marriage vows by committing adultery. She tries to escape from the dull life of small French villages by committing extravagances. She tries to escape from conformity to the mores and manners of her environment by being self-indulgent.

The reader can now go back to Chapter 1 and review the idea, intention, attitude, and statement of purpose of each of the authors of the novels selected for study. This will point the direction these authors had to take in deciding which principle or principles to use for placing their protagonist in conflict with his own environment or the environment of others. If the reader's own idea, intention, attitude, and statement of purpose do not strongly suggest which principle to use, his idea cannot be developed into a salable novel.

We pointed out in Chapter 1 that an author's statement of purpose must *prove* something about life. Placing a protagonist in conflict with his own environment or the environment of others doesn't prove anything about life. Moreover, it merely sets the stage for the basic conflict and doesn't develop it. This brings us to the second element of structure for developing the basic conflict.

To develop the basic conflict in a traditional novel, give the protagonist a chief motivating force with a tangible objective. The response of the protagonist to the stimulus of the environment must result in a determination to do something about it (chief motivating force) in order to achieve some tangible objective.

We use the word *tangible* in this principle to mean both that which can be touched, a concrete condition or circumstance, and that which can be realized or understood by the mind. Let us now illustrate this principle for developing basic conflict with five of the novels selected for study.

Madame Bovary: The protagonist, Emma, is placed in conflict with the environment of dull, provincial, small French villages where she lives with her stuffy husband, Charles. Her response to the stimulus of this environment *results in a determination to escape from it* (chief motivating force) with the tangible objective of *finding romance, glamour, and the indulgence of her sensibilities.*

Tom Jones: The protagonist, Tom, is placed in conflict with an environment that will not accept him because of his supposed birth as a bastard. His response to the stimulus of this environment *results in a determination to act as any normal boy would while searching for his true identity* (chief motivating force) with the tangible objective of *demonstrating he is worthy of Squire Allworthy's and Sophia's love so that he can take his place in society and marry Sophia.*

From Here to Eternity: The protagonist, Prewitt, comes into conflict with his peacetime Army environment because of his refusal to continue boxing. His response to the stimulus of this hostile environment *results in a determination not to permit his superior officers to force him back into boxing or let the enervating influence of drinking, sex, and brutality degrade him* (chief motivating force) with the tangible objective of *preventing the degradation of his character.*

The Spy Who Came in from the Cold: The protagonist, Leamas, comes into conflict with the environment of others, Communist espionage agents, when he accepts a mission to act as a counterspy for Control by pretending to defect to the East. His response to the stimulus of this environment *results in a determination to carry out the orders of Control* (chief motivating force) with the tangible objective of *making a lot of money for himself so he can retire from the espionage business.*

To Kill a Mockingbird: Because the author employed two principles for placing a protagonist in conflict with the environment in this novel, we have two chief motivating forces and two tangible objectives. Scout's response to the stimulus of the change within her environment *results in a determination to try to adjust to the change* (chief motivating force No. 1) with the tangible objective of *pleasing the father she loves so dearly* (tangible objective No. 1). Atticus comes into conflict with his own environment as a result of a change in his status quo when he agrees to defend a

African-American accused of raping a white girl. His response to the stimulus of this environment *results in a determination to defend the black man with all the ability and legal talent he possesses* (chief motivating force No. 2) with the tangible objective of *preventing a miscarriage of justice* (tangible objective No. 2).

The Grapes of Wrath: In this novel Steinbeck employs two principles for placing the protagonist in conflict with his environment and consequently there are two chief motivating forces and two tangible objectives. The Joad family are placed in conflict with a depleted environment in Oklahoma. Their response to the stimulus of this environment *results in a determination to escape from their poverty-stricken environment* (chief motivating force No. 1) with the tangible objective of *finding work, economic security, and dignity in California* (tangible objective No. 1). Upon their arrival in California they are placed in an environment of thousands of migrant workers who are in conflict with the environment of others (fruit growers) because of the starvation wages paid to the migrant workers. This results in a determination by the Joad family *to survive in the environment* (chief motivating force No. 2) with the tangible objective of *holding the family together* (tangible objective No. 2).

One of the reasons why these two novels are significant novels, apart from the literary skill of the authors, is found in the sustained interweaving of these varying chief motivating forces and tangible objectives. We would suggest, however, that the reader use for his first novel just one of the principles for placing a protagonist in conflict with his environment, and just one chief motivating force and one tangible objective.

We come now to a final principle for sustaining the basic conflict in a traditional novel.

The basic conflict cannot be developed or sustained unless the author exaggerates the reaction of the protagonist to the stimulus of the environment.

The basic conflict in a traditional novel derives its interest and pressure for resolution from the protagonist's exaggerated response to the stimulus of the environment. In real life when we come into conflict with our environment we complain but more often than not do nothing about it. The novelist, however, must so exaggerate

the protagonist's conflict that important issues arise that cannot be resolved by a weakening of the chief motivating force. For example, Flaubert in *Madame Bovary* exaggerates Emma's boredom and sense of emptiness to develop and sustain the basic conflict.

To help the reader get started on his own novel let us now look at the actual notes made by a student during the year the authors experimented with Part I of the exercises for Chapters 1 and 2:

> The source of my idea is my mother's marriage to my father whom she divorced when I was eight years old because he was a cruel and worthless man. I was happy living alone with my mother for the next four years until she married my stepfather. I hated my stepfather at first because I believed all men were like my father. I did everything I could to break up this second marriage until with patience and understanding my stepfather made me love him. But I think it would be a better novel if the protagonist did break up the second marriage and will write it that way. I intend to write a novel based upon personal experience about what might have happened if I'd broken up my mother's second marriage. My attitude must be a strong belief that a selfish girl of twelve can destroy what might have been a happy second marriage. My purpose will be to prove that a selfish child of a cruel and worthless father can develop such a hatred for all men that she will lie, cheat, and do everything she can to break up her mother's second marriage. I will call the novel *Dark Summer* because the novel I'm going to write happened during one summer. My protagonist is single and represents as a group all selfish children of divorced parents living alone with their mother who had a cruel and worthless father. My settings will be the apartment in the city where I lived with my parents before their divorce, and the home in the suburbs my stepfather bought after marrying my mother. The generalized significance of the environment will grow out of the clash of wills between the protagonist and her mother and stepfather. The atmosphere will be charged with suspicion, fear, hate, and jealousy on the part of the protagonist and attempts to win over the protagonist by the mother and stepfather. I will use principle 10 because the status quo of the environment of the protagonist changes after her mother's remarriage. The response of the protagonist to the stimulus of this environment results in a determination to break up this second marriage with the tangible objective of forcing her mother to divorce her stepfather.

This student is off to a good start on her novel. The reader after completing Part I of the exercises of Chapters 1 and 2 should have similar notes for his own novel.

Exercises for Chapter 2

Part I

1. Give the novel you are going to write a title.
2. Is your protagonist singular or plural?
3. What group, class, profession, or other segment of society does your protagonist represent?
4. What is the physical setting (settings) of your novel?
5. What is the generalized significance of each setting?
6. What is the atmosphere of the environment going to be?
7. Which one of the ten principles for placing a protagonist in conflict with his environment are you going to use?
8. What is the chief motivating force of your protagonist?
9. What is the tangible objective?

Part II

1. Which one of the following groups does the Joad family represent in *The Grapes of Wrath?*
 (a) Poor farmers during the 1930's.
 (b) All migrant workers during the 1930's.
 (c) Just the Okies during the 1930's.
2. Which one of the following groups does Kino represent in *The Pearl?*
 (a) All poor pearl fishermen.
 (b) All human beings who discover that unexpected wealth can corrupt their families.
 (c) Just Latin-American pearl fishermen.
3. The generalized significance of the settings in *The Grapes of Wrath* is:
 (a) Earth is a natural force which should bind mankind together into one brotherhood, but its force is abused.
 (b) Earth is less productive than machinery.
 (c) The world of nature is alien to man.
4. The generalized significance of the setting in *The Pearl* is:
 (a) The solidarity and peace of a human family in a world of rapacity and greed.

 (b) Pearl fishermen are doomed to die in poverty.

 (c) The perils that befall pearl fishermen.

5. Is the atmosphere in *The Grapes of Wrath* constant, or does it change?

6. Is the atmosphere in *The Pearl* constant, or does it change?

7. Which one of the ten principles for placing a protagonist in conflict with his environment did the author use in *The Pearl?*

8. Which one of the following chief motivating forces and tangible objectives is correct for Kino in *The Pearl?*

 (a) A determination to become rich with the tangible objective of educating his son, Coyotito, and giving the boy a better life.

 (b) A determination to sell the pearl with the tangible objective of becoming a big man in the village.

 (c) A determination to sell the pearl and use the money to get even with the people who tried to cheat him out of it or steal it from him.

3

How to Develop a Plot
or Story Line

*All traditional novels have a plot or a story
line.*

*All traditional novels have a time element
into which the story is telescoped.*

*All traditional novels present one major com-
plication, sometimes more than one, and minor
complications within the framework of the
major complication.*

Up to this point we haven't been concerned with whether a
novel has a plot or story line because the principles discussed thus
far are applicable to both. Let us now define a plot and a story
line in a traditional novel.

**Both a plot and a story line in a traditional novel are a chain
of causally related events that gives a novel continuity, pace, and
thematic significance.**

Webster's Seventh New Collegiate Dictionary defines *causal* as
"1: expressing or indicating cause: causative; 2: of, relating to, or
constituting a cause; 3: involving causation or a cause; 4: arising
from a cause."

In novel writing the author begins with an event outside the
character of the protagonist that starts a chain of causally related

events. When we speak of events in novel writing, we are speaking of things that happen in a novel which have some effect on the characters. For an event to have any force in a novel it must produce some effect. The novelist is therefore working from a cause (an event) that results in an effect (a minor complication that produces conflict or reveals something about character). Each event is the cause of an event that follows immediately or occurs later in the novel. It is from this premise that we get our definition of a plot or a story line in a traditional novel. Because of the nail the shoe was lost; because of the shoe the horse was lost; because of the horse the rider was lost; because of the rider the battle was lost; and so on. We find this same chain of causally related events in all traditional novels. As an example, let us list the chain of events in the first two chapters of *From Here to Eternity*. Although these events are told in flashbacks we will make them chronological for the sake of clarity.

Event 1: A strike by the coal miners in Harlan, Kentucky. The protagonist's father is a coal miner. This event is outside the character of Prewitt because he personally had nothing to do with it.

Event 2: As a result of event 1 Prewitt's father is put in jail and his mother dies during the strike.

Event 3: As a result of event 2 Prewitt leaves home.

Event 4: As a result of event 3 Prewitt bums around the country until old enough to enlist in the Army.

Event 5: As a result of event 4 Prewitt is sent to Fort Myers where he learns how to box and play the bugle.

Event 6: As a result of event 5 he gets a leave and while on leave meets a society girl who gives him gonorrhea.

Event 7: As a result of event 6 he loses his service record and cannot get back into the Bugle Corps.

Event 8: As a result of event 7 he reenlists in the Army and asks for duty at Schofield Barracks.

Event 9: As a result of event 7 and losing out on the Bugle Corps he goes back to prizefighting and becomes runner-up in the welterweight division of his outfit.

Event 10: As a result of event 9 he blinds a soldier named Dixie in a boxing match workout.

Event 11: As a result of event 10 he gives up boxing.

The above illustration involves just the first two chapters but if continued throughout would prove that the story line of the novel consists of a chain of causally related events. This brings us to our first principle for developing a plot or a story line.

Begin a novel with an event outside the character of the protagonist that starts a chain reaction of causally related events.

Let us look at some additional examples of this principle.

Tom Jones: The novel begins with an event outside the character of the protagonist—Tom's birth as a supposed bastard. This event triggers the chain reaction of causally related events that follow.

The Spy Who Came in from the Cold: Control's decision to plant a supposed defector among the high East German intelligence system to save a master British spy named Mundt is the event that triggers all the causally related events in the novel. This event was completely outside the character of Leamas, who personally had nothing to do with Control's decision.

Madame Bovary: The novel begins with the event of Charles Bovary's becoming a doctor. This is completely outside the character of the protagonist, Emma, who didn't even know Charles at the time. But it starts the chain reaction of events that follow.

To Kill a Mockingbird: The novel begins with an event completely outside the character of Scout Finch—the arrival of Charles Baker Harris in Maycomb. This triggers the chain reaction of causally related events that follow.

Now a writer could go on and on creating events causally related to the first event and write a novel so dull that it wouldn't get by the first reader at a publishing house. The novelist must, therefore, employ the following principle:

To create causally related events in a novel, the novelist creates one major complication (sometimes more than one) and minor complications within the framework of the major complication, including an ante-climax complication (sometimes more than one) that resolves the major complication.

Let us first make clear what is meant by a complication in a traditional novel. We will bypass the dictionary definition and create one of our own for a clear understanding of this term.

A complication in a traditional novel is something unpleasant that happens to a character which, if the character had had the freedom of choice, he would have chosen not to happen.

Let us deal with the major complication first. By placing the protagonist in conflict with his own environment or the environment of others we have created the major complication. By giving the protagonist a chief motivating force with a tangible objective we have created the means for sustaining the conflict inherent in the major complication throughout the novel. The major complication of any traditional novel can be put into the form of a question for the reader:

Will the chief motivating force of the protagonist succeed or fail to reach its tangible objective?

Will or will not Emma Bovary find romance, glamour, and the indulgence of her sensibilities? Will Tom Jones find his true identity, take his rightful place in society, and marry Sophia? Will Robert E. Lee Prewitt be able to prevent the sex, drinking, and brutality of his military environment from degrading his character? Will Leamas, by carrying out his mission for Control, succeed in making enough money to retire from the espionage business?

We have stated in our principle that sometimes a traditional novel will have more than one major complication. *To Kill a Mockingbird* is an example. Will Atticus Finch succeed in preventing a miscarriage of justice? Will Scout Finch succeed in adjusting to her changing environment?

The author knows the answer but the reader doesn't; this is what makes a reader keep on reading. This principle is therefore a very important one for developing a plot or a story line.

Is the chief motivating force of the protagonist going to succeed or fail to reach its tangible objective?

The author's statement of purpose as explained in Chapter 1 should give him the answer. For example, if Flaubert is going to prove in *Madame Bovary* that the violation of the marriage vows and adultery can lead only to the disintegration of character, he knows full well that Emma's chief motivating force is going to fail to reach its tangible objective.

Now, when a novel has two major complications as a result of having two chief motivating forces and two tangible objectives, as does *To Kill a Mockingbird,* the author also turns to his statement of purpose for direction. If Harper Lee is going to prove that a good and wise father can successfully develop the character of his children in a motherless home, she knows that Scout Finch's chief motivating force is going to reach its tangible objective of pleasing her father and her brother Jem. And if Harper Lee is going to prove that racial bigotry in the Deep South is a stronger force than civil law, she knows that Atticus Finch's chief motivating force is going to fail to achieve its tangible objective of preventing a miscarriage of justice.

The next step is to determine if the novel is going to have a plot or a story line.

In a novel with a plot the emphasis is on events (things that happen), and the protagonist emerges from the novel with his character relatively unchanged from what it was in the beginning.

In *Tom Jones,* a novel with a plot, the protagonist, Tom, emerges from the novel with his character relatively unchanged from the generous and lovable rascal he was in the beginning. In *The Spy Who Came in from the Cold,* another novel with a plot, the protagonist, Leamas, has remained much the same up to the moment of his death.

The would-be novelist must take a long, hard look at his protagonist and decide whether or not he is going to remain static in character throughout the novel. If the protagonist is going to emerge relatively unchanged, the novel is going to have a plot.

In a novel with a story line the emphasis is on character, and the protagonist always emerges from the novel with his character different from the way it was in the beginning of the novel because of character development or character disintegration.

In *Madame Bovary,* a novel with a story line, the protagonist, Emma, is not at the end the simple farm girl she was in the beginning. Similarly, in *From Here to Eternity,* another novel with a story line, the protagonist, Robert E. Lee Prewitt, undergoes a radical change from the decent, sensitive, and well-meaning person he was originally. These are examples of character disintegra-

tion. In *To Kill a Mockingbird,* also a novel with a story line, Scout Finch changes from a tomboy into a young lady who will assume all the obligations of the particular "tribe" her father represents. This is an example of character development.

There are novels with a story line in which both character development and character disintegration take place. For example, in *Thaïs,* Thaïs becomes a good woman through character development while the holy man who has tasted of evil becomes a victim of character disintegration. We strongly suggest, however, that the would-be novelist writing a novel with a story line make it one of either character development or character disintegration.

Once the decision has been made whether or not the protagonist's chief motivating force is going to reach its tangible objective, and whether or not the novel is going to have a plot or a story line, the following principle becomes very important:

There is a point of recognition for the reader in all traditional novels at which he knows whether the chief motivating force is going to succeed or fail to reach its tangible objective.

It is from this principle that the two basic structural designs for a plot or a story line are derived, as shown below:

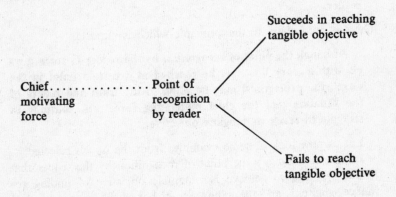

Although there are several other structural designs for a plot or a story line, we believe the would-be novelist should use one of the two basic designs until he has established himself. In fact, nine out of ten traditional novels published employ one or the

other of these two designs. Let us now consider the two principles for determining where the point of recognition will be reached by the reader.

In a novel with a plot, the point of recognition is always delayed until near the end.

The reason for this is that the reader's interest is centered on events (things that happen), and the only way to hold his interest in a novel with a plot is to delay the point of recognition until near the end. In *Tom Jones* the reader doesn't learn that Tom will achieve his tangible objective of finding his true identity, taking his rightful place in society, and marrying Sophia until near the end of the novel. In *The Spy Who Came in from the Cold* the point of recognition that Leamas will fail to achieve his tangible objective of making a lot of money and retiring from the espionage business is delayed until the very last paragraph of the novel when Leamas is killed.

In the story line novel the case is different.

In a novel with a story line the point of recognition that the chief motivating force of the protagonist is going to succeed or fail to reach its tangible objective may occur at any point in the novel once the major complication has been made clear to the reader.

There is a corollary to this principle which is important.

Although the point of recognition by the reader in some novels with a story line may be reached at a certain point in the novel, the protagonist may be blind to the truth and reality of the situation and the chief motivating force will continue to struggle to reach its tangible objective.

Let us now look at some examples from the novels selected.

In *Madame Bovary* the point of recognition by the reader that Emma will fail to achieve her tangible objective of finding romance, glamour, and the indulgence of her sensibilities is reached after she has been jilted by Leon and Rudolphe. But Emma is blind to the truth and reality of the situation and rushes into prostitution in a desperate attempt to stave off financial ruin. Her blindness about the possibilities of life, in fact, leads to her death.

In *From Here to Eternity* the point of recognition that Prewitt

will fail to prevent the degradation of his character is reached when he refuses Warden's offer of help if he will give himself up as an AWOL soldier. The reader may have suspected earlier in the novel when Prewitt becomes a murderer, drunkard, and pimp that he would fail to achieve his tangible objective, but it isn't until this one final offer of Warden's is refused that the reader is certain that Prewitt is doomed. Prewitt is not blind to the truth and reality of the situation; he admits to Warden he knows he should give himself up but just can't do it because he will not go back to the stockade.

In *To Kill a Mockingbird* we are dealing with two major complications and therefore have two points of recognition. The reader knows that Atticus will fail to achieve his tangible objective of preventing a miscarriage of justice when the jury brings in a verdict of guilty in Chapter 21. The point of recognition that Scout Finch will achieve her tangible objective of pleasing her father is reached in the last chapter. Scout and her father are not blind to the truth and reality of their situations, although up to the last chapter Scout has been unaware that she has been maturing.

In *The Grapes of Wrath* we are again dealing with two major complications and therefore have two points of recognition. The first is in the form of a question: Will the Joad family find work, economic security, and dignity in California? The point of recognition that the chief motivating force will fail to achieve its tangible objective is reached soon after the arrival of the family in California, although the Joads are blind to the truth for some time. The second point of recognition is also in the form of a question: Will the Joad family succeed in staying together? The point of recognition that the chief motivating force will fail to achieve its tangible objective is reached in the last chapter.

It is worth noting that Steinbeck in this great novel employed two principles for placing the protagonist in conflict with his environment, two chief motivating forces, and two tangible objectives to sustain the basic conflict. Had the author used only the first principle, the novel would have had to end soon after the arrival of the Joad family in California, after the chief motivating force had failed to reach its tangible objective of finding work, economic security, and dignity. To sustain the basic conflict the author then placed the Joad family in conflict with the environment of others, giving them a new chief motivating force to survive in the hostile

environment and a new tangible objective of holding the family together.

The principle for creating causally related events, given earlier in this chapter, states that every traditional novel has an ante-climax complication (sometimes more than one) that resolves the major complication. This is achieved with the following principle:

As a result of the irreversible causally related events that have preceded it, an event must occur that causes an ante-climax complication (or more than one). This in turn forces the protagonist to make a decision that resolves the major complication, or that decision is forced upon him by another character or characters.

In *Tom Jones,* the event that leads to the ante-climax complication is the disclosure that Allworthy's sister, Miss Bridget, is Tom's mother. As the result of this disclosure, we have the ante-climax complication which is simply that Allworthy finds out that Blifil has kept this information secret from the very beginning. Thus Allworthy is forced to make a choice involving his previous value judgments. He makes the decision that Tom is a good young man and furthermore his own nephew. This decision in turn allows Tom to decide to be both good and prudent, and as a consequence, the major complication is resolved.

In *The Spy Who Came in from the Cold* the event that causes the ante-climax complication is the attempt by Leamas and Liz Gold to escape from East Germany with Mundt's help. The ante-climax complication occurs at the Berlin Wall when Liz Gold is killed. This forces Leamas to make the decision to die with Liz rather than escape and to accept death as the only possible honorable alternative. This decision resolves the major complication for Leamas.

In both these novels with a plot the point of recognition is reached during the ante-climax complication. This is generally true of novels with a plot because the point of recognition must be delayed until near the end.

In *Madame Bovary* the event that causes the ante-climax complication is Emma's failure to get the money she desperately needs from Rudolphe. As a result of the ante-climax complication Emma makes the decision to commit suicide, which resolves the major complication.

In *From Here to Eternity* the event causing the ante-climax complication is the attack by the Japanese on Pearl Harbor, which induces Prewitt to try to get back to his company. The ante-climax complication occurs in Chapter 52 when Prewitt is stopped by a patrol on the Waialae Golf Course on his way back to his company. As a result of this complication Prewitt is forced to decide whether to use Alma's gun to kill a couple of members of the patrol and try to escape, or to let himself be killed. He decides to let himself be killed, which resolves the major complication.

In *To Kill a Mockingbird* there are two ante-climax complications because we are dealing with two major complications. The event causing the first is the trial of Tom Robinson which results in an ante-climax complication for Atticus—will the jury find Tom Robinson guilty or not guilty? Atticus has a decision forced upon him when the jury finds Tom Robinson guilty. This decision resolves the major complication of Atticus's trying to prevent a miscarriage of justice. The event causing the second and most important ante-climax complication is Bob Ewell's hatred for Atticus. The result of his hatred is his attempt to kill Scout and Jem, only to be killed himself by Boo Radley. This ante-climax complication forces Atticus and Heck Tate to make a decision, which is to pretend that Ewell's death was an accident, and this decision resolves the complication. This ante-climax complication also forces Scout to make a decision. Knowing that she owes her life and the life of her brother to the very man they plagued as children, she realizes she can no longer be a tomboy and live without moral significance. In Boo Radley and her father she now sees clearly the kind of "tribe" she is going to join and realizes that she will grow up to be a lady of principles and a decent human being. She makes the decision that she is no longer a child and can no longer act like a child as she says in the last chapter, ". . . Jem and I would get grown but there wasn't much else left for us to learn, except possibly algebra." This decision resolves her major complication.

In *The Grapes of Wrath,* the ante-climax complication that resolves the first major complication occurs soon after the Joad family arrives in California. They come to the conclusion that they have been tricked by the handbills and by what they have heard about California and have simply traded one poverty-stricken environment for another. They are then faced with the second major complication of trying to survive in the environment and hold the

family together. This is a complication affecting each of them. The irreversible causally related events culminate in the following ante-climax complications that finally resolve the major complication: Tom Joad kills a guard in Chapter 26 and makes the decision to leave his family. In Chapter 30, Rose of Sharon's baby is born dead and she decides there is no hope for the family. Uncle John sends the box containing the body of the baby downstream and he, too, decides that the family is doomed. The flood creates another ante-climax. Ma Joad makes the decision to go to higher ground, which resolves the major complication for her and Pa, while Al decides to stay with Aggie and leave the family. Ma and Pa both realize the family is splitting up. As a symbolic gesture Ma lets Rose of Sharon give her milk to a starving man in the barn where they seek shelter from the rain. It was the lack of the milk of human kindness that destroyed her family, and now the brotherhood of man must take the place of family for their salvation.

We can clearly see from these examples how the ante-climax complications resolve the major complications when the chain of causally related events becomes irreversible, so irreversible that in three of the novels we have selected the only possible way the major complication could be resolved without resorting to sentimentality was by the death of the protagonist. Authors of first novels too often abandon their vision of truth and resort to sentimentality, completely destroying the theme. The authors of the novels we are discussing avoided this pitfall. In *Madame Bovary*, Emma refuses to see that she has indeed become a prostitute. If she had admitted this to herself, there might have been a way out for her. She might have retreated from the degradation of her soul, accepted financial ruin, and lived out her life with Charles. But Flaubert knew that to have ended the novel this way would have been sentimental and contrived. In *From Here to Eternity*, Prewitt could have accepted Warden's offer and given himself up as an AWOL soldier, taken his court martial, and ended up as a career soldier. In *The Spy Who Came in from the Cold,* Leamas could have leaped from the wall to the West Berlin side and saved himself. Then he could have retired from the espionage business and grown old with memories of his love for Liz Gold.

This seems to be an appropriate place to discuss a misconception among some students and even some instructors—that they

can apply what is called "the moment of truth" in a short story to a novel. In our book, *The Professional Story Writer and His Art* (now out of print), we defined the moment of truth in a short story as follows: "A Moment of Truth occurs in the short story when the protagonist must face up to the truth about himself and see himself for what he really is. The moment of truth always results from the complication the protagonist faces. . . ."

A short story is based on a single complication and therefore can have but a single moment of truth. In a novel there are many complications the protagonist must deal with during which he comes face to face with a moment of truth about himself, about another character, or about the complication itself. Consequently there are many moments of truth for a protagonist in a novel. This is true of both novels with a plot and novels with a story line, although generally there are more moments of truth in a novel with a story line because the emphasis is on character. However, in every novel there is one moment of truth for the protagonist that supersedes all other moments of truth. This occurs as a result of the ante-climax complication, when the protagonist comes to a complete realization of the major complication and makes an honest evaluation of himself. This moment of truth, then, is the *protagonist's* point of recognition that he will succeed or fail to achieve his tangible objective.

Before proceeding further with our discussion of how to develop a plot or a story line let us briefly point up some differences between the two.

In a novel with a plot the author can plot the event outside the character of the protagonist that triggers the chain of causally related events. The author can plot where the point of recognition by the reader will occur. The author can plot the ante-climax complication that resolves the major complication. And he can plot the major complication.

In a novel with a story line the author does plot the event outside the character of the protagonist that starts the chain of causally related events. The author does plot the major complication. However, he may or may not know when the point of recognition by the reader will be reached and he may or may not know what the ante-climax complication will be. This is due to what is called "character possession" during which the characters become so alive for the

author they begin to assert themselves and say and do things the author had no idea they would say and do when he began the novel. Sometimes the chief motivating force of the protagonist may give up trying to reach its tangible objective before the author intended it should, and the author "possessed by character" can't prevent it without making his protagonist a puppet. Conversely, the chief motivating force of the protagonist may keep on trying to reach its tangible objective long after the author originally planned that it should. This makes it impossible for the author to determine exactly where the point of recognition by the reader will occur. And sometimes a minor character will come on so strongly that he becomes a supporting character to the extent that the ante-climax complication may revolve around him. An example of such a character is Liz Gold in *The Spy Who Came in from the Cold.* Or the author will go on writing about a minor character after the major complication of the protagonist himself is resolved, as Jones did with Warden in *From Here to Eternity.* Many novelists begin writing a novel of character disintegration or development without any idea of what the ante-climax will be and trust implicitly to "character possession" to create the ante-climax complication for them. On the other hand there are novelists who write the ante-climax complication and final big scene of a novel first and then direct the rest of the novel toward this denouement. We would not suggest that the novice try the latter method. Instead we would suggest the following principle:

In writing a novel with a story line, when the point of recognition by the reader and the ante-climax complication are not crystal clear to the author, the author should let "character possession" decide both for him.

We have now only to provide principles for creating minor complications within the framework of the major complication.

Causally related events in a novel are things that happen which have some effect upon the protagonist or some other character in in the novel. The effect invariably produces a minor complication for the protagonist. The minor complication reveals something about the protagonist's character that the reader didn't know before. To do this there must be conflict inherent within the minor complication.

The means for creating minor complications that produce con-

flict are almost unlimited. Human beings can come into conflict with other human beings: man against man, man against woman, men against men, woman against woman, woman against man, women against women, child against adult, child against child, the old against the young, group against group, and so on. Human beings can come into conflict with nature: floods, droughts, tornadoes, storms, the sea, mountains, rivers, deserts, earthquakes, animals, diseases. Human beings can come into conflict with the unknown: ghosts, psychic phenomena, outer space. Human beings can come into conflict with the mores of society: laws, customs, traditions, conventions, moral codes, religious persuasions, accepted beliefs, governments. Human beings can come into conflict with themselves: the acts one has committed and the conscience one has about them, one set of values or traits as opposed to another, the training of the past and the demands of the present, the heart against the mind.

To include all these conflicts in a novel would require a hundred volumes or so. The novelist is aware of this and confines the conflict in his novel to one or more of the following three principles:

(1) Have conflict between the protagonist and an opponent or opponents. (2) Have conflict between the protagonist and an obstacle or obstacles. (3) Have conflict between the protagonist and a disaster he faces.

The novelist is limited by his subject material. He may use just one of these principles for producing conflict, or he may use two of them, or all three. Let us look at some examples.

Madame Bovary: Flaubert uses all three principles in this novel. Emma is in conflict with her husband, a wordless, continuous conflict because of his dullness. She is in conflict with the daily obstacles provided by the banality of life in provincial French villages, each small task producing ennui instead of fulfillment. And she is in conflict with a disaster she faces—the financial ruin that she fails to avert.

Tom Jones: Fielding also uses all three principles but he stresses principle 1. The conflict between Tom and his opponents is actually Tom's conflict with himself. He is too indiscreet in his behavior, and this allows other opponents, especially Blifil, to use Tom's actions against him. Tom is also in conflict with the obstacles raised by his being sent away from Allworthy's and the diffi-

culties in trying to convince Allworthy and Sophia of his true feelings for them. And he faces a potential disaster: being hanged for having killed a man in a duel.

From Here to Eternity: The author employs all three principles for producing conflict. Prewitt comes into conflict with opponents (superior officers who want him to fight again), with obstacles (the drinking, sex, and brutality of his environment), with a disaster which he fails to avert, resulting in the complete disintegration of his character.

To Kill a Mockingbird: The author employs all three principles in this novel. Scout is in conflict with her teacher, some of her relatives, and other adults who she believes put restraints on her personality. She is also in conflict with the children of adults who have turned against her father for defending an African-American. Atticus is in conflict with some of the white citizens of Maycomb, especially Ewell, who makes threats against him, and with some of his relatives. Both Scout and her father come into conflict with obstacles such as the racial bigotry in Maycomb. Atticus faces and fails to avert a disaster when Tom Robinson is found guilty. These conflicts of Atticus's are a focal point for the major conflict of the novel, which concerns Scout's maturing. All that her father is involved in is filtered through the consciousness of Scout so that her father's conflicts become the means whereby her character is tested and through which it develops.

The Spy Who Came in from the Cold: In this novel the author employs only principle 1; Leamas engages in a battle of wits with his opponents.

Let us now look at the difference between creating a minor complication in a novel with a plot and in a novel with a story line.

In a novel with a plot, each event that causes a minor complication must result in conflict for the protagonist by hindering or preventing his chief motivating force from reaching its tangible objective.

In writing a novel with a plot the author must at all times be aware that the reader is more interested in *what happens* than he is in *why it happens*. Each minor complication must result in conflict between the protagonist and opponents, obstacles, or a disaster he faces. A careful reading of *Tom Jones* and *The Spy Who Came in from the Cold* reveals that each causally related event creates a

minor complication that produces conflict. In writing a novel with a plot the author begins and ends with static characters. Before he starts writing the novel he is well aware of all the character traits of his protagonist and other characters; consequently he can plot events that cause minor complications for his characters, knowing in advance just how they will react.

In a novel with a story line the following principle applies:

The causally related events that create minor complications must result from the dominant character traits of the protagonist or other characters.

The reason for this is that in a novel of character analysis the reader is much more interested in *why things happen* than he is in *what happens*. The causes of events that make minor complications in a novel with a story line lie in the responses of the leading characters to the world around them. Let us look at some examples of this.

Madame Bovary: In Chapter 1 Flaubert convinces us of the unimaginative dullness of Charles Bovary. And yet, ironically, it is this man Emma marries. How does this occur? It happens through Emma's character traits. In her early adolescence, she had been placed in a convent, where she delighted in mysteries and sentimental feelings and did not like the discipline of theology. She filled her head with romantic fiction smuggled into the convent. As she grew older, she felt her definition of religion to be better than that of the nuns. Emma wanted passion, music, flowers, and the atmosphere of the church but not its rigorous duties. When her father took her from school, she thought of herself as disillusioned "with nothing more to learn, and nothing more to feel." She became attracted to Charles because, in effect, he was better than the emptiness she felt. Emma's desire for love and passion is not intrinsically evil and is in fact quite normal for a young, maturing woman. But this dominant character trait led her into an inept marriage and on to the causally related events producing minor complications that ultimately resulted in her death.

From Here to Eternity: A dislike for his father causes Prewitt to leave Harlan after the death of his mother, bringing him face to face with the minor complication of earning a living. A desire for economic security during the Depression leads him to join the Army as a career soldier and presents him with the minor complication

of adjusting to Army life. A personal trait, his talent for playing the bugle, is responsible for his getting into the Bugle Corps, which, in turn, produces a minor complication in the form of opponents over whom he must excel as a bugler to further his Army career. A leave of absence during which he meets a society girl who gives him gonorrhea creates a minor complication resulting in his losing his service record and being kicked out of the Bugle Corps. And so on.

In Chapter 9 we will discuss and illustrate in detail how to characterize. At this point we are concerned only with how to create minor complications within the framework of the major complication in developing a story line. Which brings us to a principle:

In a novel with a story line begin with cause (character traits) to produce events (things that happen) which result in effects (minor complications).

This is sometimes confusing to students in creative writing classes because they don't fully understand the difference between a novel with a plot and a novel with a story line. They create events to show that a character is selfish, which is all right in a novel with a plot, but in a novel with a story line the character's selfishness must create the event that causes the minor complication.

Let us briefly illustrate this. In *The Grapes of Wrath* a minor complication occurs during the trek to California when the con-rod on the old '25 Dodge burns out. How did this event occur? It happened because of the determination of the Joad family to seek a better life in California (character trait).[1] It could not have happened if the Joad family had remained in Oklahoma. We move from cause to event which causes the minor complication. When Al and Tom try to get Ma Joad to continue with the rest of the family in the Wilsons' car, the author reveals something about Ma's character the reader didn't know by having her threaten them with a jack handle.

Every day of our lives we meet with minor complications. We miss the bus and are late for work. Our kid breaks a neighbor's window playing ball. But these everyday minor complications aren't

[1] Characterization is fully explained in Chapter 9. As we use the term *character trait*, we may mean more than a distinguishing feature acquired through heredity. It may refer also, as here, to the chief motivating force of the group protagonist, and it may be acquired as the result of conflict.

interesting or exciting enough to use in a novel. Thus the following principle:

To make a minor complication more interesting and exciting than real life the author must exaggerate it.

We have found many students laboring under the mistaken idea that a novel must be true to life. If this were true, novelists would simply turn reporters and record everyday happenings. Let us look at *Madame Bovary* as an example of how a novelist exaggerates complications to make them more interesting and exciting. In real life many married women are bored with their husbands and with the lives they lead, and yet how many of them take on a lover like Rudolphe as Emma does, and then another lover like Leon? And how many of them waste their economic resources, rush into prostitution trying to stave off financial ruin, allow their own degradation, and finally end up committing suicide? Flaubert certainly exaggerates the complications in this novel. In real life how many peacetime soldiers let the military environment degrade their characters the way Prewitt does in *From Here to Eternity?* An objective examination of any of the novels selected for study, or any novel for that matter, will show that all novelists exaggerate the complications in their novels to make them more interesting.

This brings us to a corollary principle.

The protagonist must stand to lose or gain something of value if the complication is solved or unsolved. To make certain something of value is at stake, the author must make the complication deep enough by exaggeration.

This is no problem with the major complication because something of value must be at stake to have a major complication. We are speaking here of minor complications. For example: An event in *To Kill a Mockingbird* that results in a minor complication occurs when Scout Finch starts school. Scout has already learned how to read and reads with her father every night, although he does not formally teach her. This produces conflict between Scout and her teacher, who says Scout must give up being taught to read by her father and learn all over again under a systematic plan the new teacher will use. The author makes the complication deep enough by exaggerating the teacher's annoyance on finding that a pupil in her class can already read better than students in the grade ahead.

Miss Caroline's insistence that Scout give up learning to read with her father means that Scout must lose something of value to her because reading with her father is one of her childhood joys.

In *The Grapes of Wrath* the author, by exaggerating Ma Joad's attitude, puts something of value at stake if the complication isn't solved. It is not the delay in getting to California that is at stake, but for Ma Joad, the threat of breaking up the family even temporarily. In this minor complication Ma loses something valuable to her as Al and Tom finally persuade her to go on without them.

Often in writing a novel the author will create an event that results in a minor complication which the author cannot resolve. When this happens the following principle applies:

When the solution to the minor complication cannot be found within the complication itself, employ the principle of discovery and change: let a character discover something he did not know or did not realize before that makes him change his mind.

This principle is often used in novels. For example, in *Madame Bovary* one of Emma's minor complications is that she is a married woman having an affair with Rudolphe. There is no solution to the complication within the complication itself. She is married. She can't get a divorce. But the complication must be resolved. Flaubert does this by employing the foregoing principle. When Emma discovers that Rudolphe has jilted her, this forces her to change her mind about going on with the love affair and thus resolves the minor complication.

Traditional novels must communicate emotion to the reader. One cannot communicate emotion by writing about people who live peaceful and contented lives. The novelist knows he must drop a monkey wrench into the lives of his characters to arouse an emotional response in them that the reader can experience vicariously. The only structural way of doing this is by using complications. (Style, imagery, description, and other means of arousing an emotional response in a reader will be discussed in later chapters.) By complicating the lives of his characters a novelist can make a reader feel heartache, sorrow, hate, anger, jealousy, sacrifice, frustration, disappointment, love, admiration, fear—the whole gamut of human emotions. If a complication doesn't bother the protagonist in some way, it should be deleted.

We have omitted one important principle for creating major and

minor complications. This is known as the "time bomb." We prefer to deal with time bomb complications in Chapter 11 on "How to Hold a Reader's Interest." We suggest that the reader now turn to Chapter 11 and read the discussion and illustrations of this principle.

We come now to another common element of structure in the traditional novel.

All traditional novels have a time element into which the story is telescoped.

A novel may begin and end in an hour, a day, a week, a month, a year, several years, one generation, or several generations depending on the material. A novel is a flow of causally related events in a time sequence that begins at a certain period of time and ends at a certain period of time. We do not believe the would-be novelist is going to have any problem in knowing when to begin a novel because there is a clue in his idea and statement of purpose. Fielding's idea and purpose told him that he should start his novel with the first appearance of Tom in the world so that the reader can see the conditions of his life at Allworthy's and understand why Tom is his own worst enemy. Jones had to begin his novel with Robert E. Lee Prewitt old enough to be in the Army, and Harper Lee had to begin hers at a time when Scout was a small girl. Le Carré's novel had to begin during the Cold War and with a protagonist old enough to be a spy. Flaubert's idea and purpose told him that he must begin his novel when Emma is old enough to get married. But Flaubert added an extra dimension to his novel by making the life of Charles the frame of reference initially so that the reader can see and judge Emma's destiny.

The common element of structure, *All traditional novels portray a struggle between good and evil,* will be discussed in Chapter 5 because of its relationship to theme. But we refer to it here because it will help the would-be novelist in deciding when to end his novel.

In a novel with a plot, when the point of recognition is reached by the reader, the novel must end soon after.

We have previously stated why the point of recognition must be delayed until near the end of a plotted novel. What we did not say was that the struggle between good and evil ends with either one triumphant when the point of recognition is reached. The

time element, therefore, of a novel with a plot is the time period between its beginning, as determined by the novelist's idea and purpose, and the point of recognition.

In a novel with a story line, when the struggle between good and evil ends, the novel must end soon after.

This principle may need some clarifying. We will discuss it in detail in Chapter 5. For our purposes here we can state that the time element of a novel with a story line is the time period between its beginning and the point at which the struggle between good and evil comes to an end.

In our definitions of a plot and a story line we stated that causally related events give continuity, pace, and thematic significance to a novel.

Continuity is a quality or state of being continuous.

The causally related events in a novel must have a continuity of parts, one event leading naturally into another. In other words, one cannot digress and record an event that has nothing to do with the plot or story line. To put it another way, each event must have bearing on the major complication or the protagonist or both. To test good continuity in a novel, employ the following principle:

Each causally related event must in some way affect the protagonist.

We will illustrate continuity with the major events in *Madame Bovary*.

Event: Charles goes to set the leg of Monsieur Rouault. *Effect:* Emma meets Charles. *Event:* Charles's wife Héloise dies. *Effect:* Emma marries Charles. *Event:* Emma becomes bored with her life as the wife of a village doctor. *Effect:* She tries desperately to please her husband and overcome her boredom. *Event:* Charles becomes all the more self-satisfied. *Effect:* Emma becomes all the more bored with her life. *Event:* Emma prevails upon Charles to move away from Tostes. *Effect:* They move to Yonville where Emma meets Leon.

The reader can follow the ensuing causally related events and their effect on Emma. Inexorably the novel moves on to provide Emma with substitutes for her longings: the affairs with Rudolphe and Leon, the mismanagement of her money to provide herself

with transportation, lodging, and food. These events lead directly to her bankruptcy and suicide. Everything is linked in one chain of events, each one of which has some effect on the protagonist, forcing her into a spiraling path of degradation and ruin.

Pace in a novel is what moves the story forward.

A novel can have continuity without pace because the author can add one continuous event after another and have a story that stands still. For example, in *The Grapes of Wrath,* Steinbeck could have prolonged the trek of the Joad family to California for another couple of hundred pages by continuing the chain of causally related events causing minor complications that hindered their progress. The result would have been lack of pace despite good continuity because the story would stand still and the reader would get bored. A novel will always lack pace when an author overwrites or rambles away from the plot or story line. One way to avoid this is to delete any event that doesn't move a story forward.

In concluding this chapter we wish to stress how the creative processes of an author will work in developing a plot or a story line for a novel. Once the causally related chain of events is begun, the author is going to be pleasantly surprised to find his conscious and subconscious minds working for him in creating succeeding events. An event that causes a minor complication will give birth to another event that will cause another minor complication, and so on, until the causally related events become irreversible. The result is a vision of truth for the author that becomes the ante-climax complication resolving the major complication. This book is designed practically to force the would-be novelist to finish a novel once it is begun.

Exercises for Chapter 3

Part I

1. Is your novel going to have a plot or a story line? Explain your choice.
2. Which of the two basic structures for a plot or a story line are you going to use? What determined your choice?
3. Do you know when the point of recognition will be reached in your novel? If not, why?

4. State the major complication of your novel in the form of a question.
5. Which one or more of the three principles for producing conflict are you going to employ?
6. What event outside the character of your protagonist are you going to use to begin your novel?

Part II

1. Does *The Grapes of Wrath* have a plot or a story line?
2. Does *The Pearl* have a plot or a story line?
3. In *The Grapes of Wrath*, do the two chief motivating forces succeed or fail to reach their tangible objectives?
4. In *The Pearl*, does the chief motivating force succeed or fail to reach its tangible objective?
5. Where is the point of recognition by the reader reached in *The Pearl*?
 (a) After Coyotito is killed.
 (b) After Kino throws the pearl back into the sea.
 (c) After Kino kills the pursuers.
6. Which of the following questions states the major complication of *The Pearl*?
 (a) Will Kino's marriage dissolve if he sells the pearl and becomes wealthy?
 (b) Will Kino succeed in selling the pearl before opponents cheat him out of it or steal it from him?
 (c) Will Kino succeed in bringing his opponents to justice?
7. Which one or more of the following principles for producing conflict does the author employ in *The Grapes of Wrath*?
 (a) Conflict to overcome opponents.
 (b) Conflict to overcome obstacles.
 (c) Conflict to avert a disaster.
8. Which one or more of the following principles for producing conflict does the author employ in *The Pearl*?
 (a) Conflict to overcome opponents.
 (b) Conflict to overcome obstacles.
 (c) Conflict to avert a disaster.
9. Which of the following is the ante-climax complication in *The Pearl*?
 (a) When Coyotito is killed.
 (b) When Kino discovers that he and his wife and son are being followed after escaping from the village.

(c) When Kino returns to the village and casts the pearl into the sea.
10. Which of the following events outside the character of the Joad family started the chain of causally related events?
 (a) The dust bowl of Oklahoma.
 (b) The truck driver stopping to eat at the roadside cafe.
 (c) Tom Joad meeting Preacher Casy.

4

How to Select the Right Viewpoint

*All traditional novels are narrated from one,
or sometimes more than one, of eight possible
viewpoints.*

Let us begin this chapter with a definition of omniscient powers.

Omniscient powers are used by the author to convey information to the reader about character, environment, and events so that the reader may understand and better appreciate the story.

When a novelist writes, "It was raining that morning," and there is clearly no other narrator to ascribe the statement to, then the novelist himself is using omniscient powers to convey information to the reader about the weather. These are called omniscient powers because the novelist is playing God. Using these powers he can record conversations that took place in the past, enter through locked doors, control the weather, record what is going on in more than one place at a particular time, and enter into the thoughts and feelings of a character, even telling a reader what a dying man was thinking and feeling just a moment before his death, as le Carré does in *The Spy Who Came in from the Cold*.

The first question, and perhaps the most important one, facing the novelist is whether he is going to use restricted or unrestricted omniscient powers. The choice of viewpoint will determine this to some extent. If a novelist is going to tell the story in the first person, his omniscient powers are going to be restricted because the editorial rule governing viewpoint must be observed:

Only that portion of the action, narration, and description can be covered which the narrator can personally observe or deduce from the five senses, and no material beyond the ken of the narrator can be included in the novel.

We will assume the reader knows enough about grammatical form to understand what is meant by first person and third person. But for the sake of complete clarity let us look at some examples.

First person singular:	I went for a walk.
First person plural:	We went for a walk.
Third person singular:	He went for a walk.
Third person plural:	They went for a walk.

The verb tense used conventionally in novels is the past tense: I *went* for a walk. The reason for the past tense is that presumably the story must have happened before the author could write about it. There are exceptions such as *Rabbit Run* by John Updike in which the present tense is used throughout. But the would-be novelist should stick to the past tense until his writing matures enough for him to experiment.

In selecting the right viewpoint, the novelist should ask himself:

Is the story best told in the first person or the third person?

If the novelist tells his story in the first person, his omniscient powers are going to be restricted. If he tells the story in the third person, he may or may not decide to use restricted omniscient powers. The first person is an internal viewpoint that forces restricted omniscience. The third person is an external viewpoint adaptable to either restricted or unrestricted omniscient powers depending on the story the novelist has to tell.

The great majority of first novels are written in the first person for two reasons. First, it is a much easier grammatical form to handle; we communicate with each other in our daily lives in the first person. Second, the great majority of first novels are autobiographical to a great extent and as such must be narrated in the first person. In our selection of novels for study we find that *To Kill a Mockingbird* is narrated in the first person with the author using restricted omniscient powers.

Most novels, however, are narrated in the third person. *From Here to Eternity* and *Tom Jones* are narrated in the third person with the author using unrestricted omniscient powers. *The Spy Who*

Came in from the Cold is narrated in the third person but with restricted omniscient powers.

Madame Bovary is one of the few novels that is narrated in both the first and third persons. It was the custom of novelists in Flaubert's time to intrude into a novel as a minor character in the first person. Flaubert does just this in the first chapter of the novel, which begins: *"We were* in class when the head-master came in, followed by a 'new fellow . . . ' "

Here the plural first person is used in the first sentence and for the rest of the chapter. The reader assumes that Charles must have told Flaubert the things Flaubert reveals about Charles in this chapter—things that Flaubert himself could not possibly observe or deduce. Beginning with the second chapter Flaubert goes to the third person and maintains it almost exclusively to the end of the novel with the exception of the first person plural *we* in Chapter 1 of Part II, and again in Chapter 6 of Part III. This use of both first and third persons in a novel is rare today, and the would-be novelist should stick strictly to the first person *or* the third person. However, *Madame Bovary* is one of the best novels for studying the use of unrestricted omniscient powers by a novelist. Flaubert gives these powers complete sway by entering into the thoughts and feelings of even minor characters.

The writer using omniscient powers in his novel should keep the following principle in mind:

The use of omniscient powers must be consistent throughout the novel.

A novelist can't use restricted omniscient powers in one part of a novel and then suddenly change and begin using unrestricted omniscient powers in another part. The decision must be made by the author before he begins a novel. He should ask himself the following question:

Am I going to enter into the thoughts and feelings of just one character or into the thoughts and feelings of more than one character?

A general rule, although there are exceptions, is that when an author enters into the thoughts and feelings of just one character his powers of omniscience are restricted, and when he enters into the thoughts and feelings of more than one character his powers of

omniscience are unrestricted. To help the would-be novelist make this decision we will discuss the advantages and disadvantages of the eight possible viewpoints. We will illustrate these viewpoints by creating a situation involving a character named Jim Harding and writing it using each viewpoint in turn.

VP I: First-Person Protagonist Narrator

The narrator in this viewpoint is the protagonist singular. This viewpoint has many advantages, particularly for a person who has never written a novel. In the following illustration, the first-person protagonist narrator, Jim Harding, is talking about his trip to an old abandoned mine.

> I finally found the trail leading to the old mine. It was over-grown with bushes and weeds. I felt my heart pound with excitement. I wanted to go on but it would soon be dark. I smothered my excitement with prudence. I decided to stop and make camp.

The advantages of this viewpoint are as follows:

(1) Writing in the first person comes fairly easily to the young writer since it is the most common form of our communication with each other. Out of this grows a specific advantage: it helps avoid faulty exposition. There is a self-imposed discipline in the first person that the author consciously or subconsciously obeys. The use of the pronoun *I* tends to confine the author to the protagonist's thoughts, feelings, and attitudes, and when he does stray into faulty exposition, he is going to ask himself: How would the protagonist know this?

(2) This viewpoint makes the protagonist the center of attraction, and the reader can, therefore, participate vicariously in all the events.

(3) The reader shares the innermost thoughts, feelings, and attitudes of the protagonist with a sense of recognition and identity.

(4) This viewpoint enables the narrator to speak with the voice of conviction and gives realism to the story. The sharing of a personal experience practically nullifies any reader resistance as to the credibility of the story. When the narrator says, "I was there. I saw it happen. I did this. I did that," who is going to argue with him or doubt his word?

Let us now look at some disadvantages.

(1) The omniscient powers of the author are restricted. He must

confine himself to the personal frame of reference of the protagonist, with the editorial rule governing viewpoint applying throughout the novel. The restriction is physical as well as mental. The narrator can be in only one place at a time. We will discuss this in more detail in Chapter 7.

(2) The narrator is forced to be modest. He can do brave and generous things but cannot say that he is a brave and generous person.

(3) This viewpoint presents the problem of sustaining reader interest. Readers do get tired, even bored, living vicariously the life of just a single character in a novel. The author must make his protagonist so colorful and exciting that the reader doesn't lose interest.

(4) The description of the protagonist is confined. We cannot see the anticipatory look of excitement on Jim Harding's face as he stares at the trail leading to the old mine. In a first-person protagonist narrator war novel, for example, the hero cannot tell the reader his face was haggard and twisted with horror after the battle.

In summary, the advantages of this viewpoint far outweigh the disadvantages, which is why more novelists employ this viewpoint than any other. This is the viewpoint used in the majority of mystery novels. An excellent illustration is Robert Traver's *Anatomy of a Murder*. It is the only viewpoint for writing a confession novel, such as Defoe's *Moll Flanders*. It lends itself to humorous novels such as Hyman's *No Time for Sergeants*. We find it used frequently for adventure novels and for war novels such as Hemingway's *A Farewell to Arms*.

At this point we wish to answer a question students often bring up about the autobiographical novel. In many such novels, the narrator relates conversations or records events that took place in the past, even before he was born. The question students pose is this: Is not the author using unrestricted omniscient powers? The answer is no. The reader can accept without question that at some period in the narrator's life, his parents, grandparents, or some other relative told him these things. But when the narrator himself enters the novel at the age of reason, he must account to the reader for his knowledge of everything that happens in the present.

VP II: Third-Person Protagonist Narrator

Let us now write about Jim Harding's trip to the abandoned mine using this viewpoint.

Jim Harding finally found the trail leading to the old mine. He stared at the bushes and weeds that had overgrown the trail. His face held a look of intense excitement. He felt restless and wanted to go on. But he knew he couldn't reach the mine before nightfall. He decided to make camp and wait until morning.

This viewpoint has all the advantages of VP I except that the conviction and intimacy of the pronoun *I* are lost. A further advantage is that the author can use either restricted or unrestricted omniscient powers. He can describe the protagonist and indicate things to the reader that the protagonist doesn't know.

Let us now look at the disadvantages.

(1) The loss of the intimacy of the pronoun *I*.

(2) All the disadvantages of VP I.

(3) A risk of faulty exposition for the novice writer.

Of these, the last is the most disadvantageous for the would-be novelist. He is more apt to slip into faulty exposition using this viewpoint than when using VP I. It is a matter of projection. If the author can truly project himself into the character of the narrator when using this viewpoint with restricted omniscience, he can avoid faulty exposition. If not, he must use unrestricted omniscient powers with this viewpoint.

Examples of this viewpoint can be found in Henry James's *The Ambassadors,* Stephen Crane's *The Red Badge of Courage,* and a contemporary novel for study, *Naked Came I* by David Weiss. These three novels illustrate the range of omniscience that can be utilized in this viewpoint.

VP III: First-Person Supporting Character Narrator

To write our example using this viewpoint we will have to give Jim Harding a companion who functions as narrator.

Jim Harding and I found the trail leading to the old mine. I watched his face glow with excitement as he looked at the weeds and bushes that had grown over the trail. I knew we couldn't reach the mine before nightfall but kept silent.

"I guess we'd better camp here," Jim said, "and wait until morning before trying it."

A supporting character narrator can be a relative, a friend, or an associate of the protagonist who is sympathetic or unsympathetic toward him. An example of a novel employing an unsympa-

thetic supporting character narrator would be a war novel written about a sergeant by a private who hates him. Since the narrator participates in most of the action, the first person singular *I* is used less frequently than the first person plural *we*. Let us examine some of the advantages of this viewpoint.

(1) It can help make realistic and believable a story that would be unrealistic and unbelievable if narrated by the protagonist. A supporting character narrator can say that the protagonist is the greatest detective, the bravest soldier, the greatest lover, or what have you, and the reader will believe him. If the protagonist as narrator said these things about himself, the reader would consider him boastful and incredible. A supporting character narrator can relate events about the protagonist that the reader will find credible which, if related by the protagonist, would be difficult to believe.

(2) This viewpoint enables the narrator to describe the protagonist. He can say that the protagonist's face was "haggard and twisted with horror after the battle."

(3) A supporting character narrator is never called upon by the reader to account for his knowledge about the protagonist. He can reveal intimate and personal things about the protagonist's life since childhood. The reader assumes that at some period during the narrator's acquaintance with the hero, the hero told him these things.

(4) This viewpoint helps to sustain reader interest. At any point in the novel when the author thinks the reader might be getting a little bored with the protagonist, the narrator can shift away from him and relate something interesting or exciting about some other character.

(5) Because the first-person supporting character narrator has freer expression than a first-person protagonist narrator, he is less restricted in the use of omniscient powers.

Let us now look at some of the disadvantages of this viewpoint.

(1) The reader can participate in the action only to the extent the narrator does. This is a big disadvantage because many exciting and dramatic scenes cannot be written in action. For example:

> Harry looked disturbed and unhappy when I met him that afternoon. I asked what was troubling him. He told me that he and Ruth had quarreled, and she had broken off their engagement.

It would have been much more interesting and exciting for the

reader if he could have participated vicariously in this scene between Ruth and Harry. When this viewpoint is used the narrator tends constantly to fall back on, "He told me," or "She told me," or "They told me."

(2) The reader is to some degree detached from the protagonist, whereas he identifies with the protagonist when VP I and VP II are used.

This viewpoint is used in *The Great Gatsby* by F. Scott Fitzgerald, a novel that has become a classic for study. It lends itself to humorous novels such as *Auntie Mame* by Patrick Dennis and *The Great Brain* by one of the authors of this book. We find Flaubert using this viewpoint in the first chapter of *Madame Bovary*. And in *To Kill a Mockingbird*, Harper Lee uses VP III in relationship to Scout's father, Atticus Finch, shifting to VP I in relationship to Scout as the co-protagonist of the novel. This use of both viewpoints is necessary in the novel because two chief motivating forces and two tangible objectives are involved.

We strongly suggest again that the would-be novelist stick to just one chief motivating force, one tangible objective, and one viewpoint.

VP IV: Third-Person Supporting Character Narrator

Let us now write our example using this viewpoint. To do so, we will have to give the narrator a name, Fred James.

> Fred James was tired as he and Jim Harding found the trail leading to the old mine. He knew they couldn't reach the mine before nightfall. He watched Jim stare at the weeds and bushes that had grown over the trail. *He* asked Jim if *he* would mind camping where they were overnight.

We have purposely written the last sentence in this manner to illustrate the difficulty this viewpoint presents in grammatical form. The first *he* is Fred James and the second *he* is Jim Harding. The author must refer to the narrator as *he* while the narrator in turn must refer to the protagonist as *he*.

We are unable to find any real advantages in using this viewpoint in a novel although Conrad employs it from the fifth chapter to the end of *Lord Jim*. In the hands of a novice, however, this viewpoint could be disastrous. For that reason, we suggest that the would-be novelist use VP III instead.

VP V: First-Person Minor Character Narrator

These are novels in which the narrator assumes a rather detached point of view in telling the story. Some of the advantages are:

(1) It can make a story realistic and believable that would otherwise strain the credulity of the reader if told from the viewpoint of the protagonist. The Sherlock Holmes novels by A. Conan Doyle are excellent examples of this. If Sherlock Holmes had narrated these adventures himself, they would be unbelievable and the characterization of Holmes would become that of a ridiculous braggart. Using this viewpoint the author was able to make these novels interesting and credible and Sherlock Holmes a colorful and exciting character.

(2) This viewpoint enables the narrator to describe the protagonist.

(3) The narrator is never called upon by the reader to account for his knowledge about the protagonist. The reader assumes that at some period of time the protagonist revealed these things to the narrator.

(4) This viewpoint makes it easier to sustain reader interest. At any point where the author believes the reader might be getting bored with the protagonist he can leave the protagonist and relate something interesting or exciting about the narrator or some other character.

(5) This viewpoint enables the author to present a philosophy of life that would be presumptuous if presented from any other viewpoint. Maugham and Proust do just this in their novels using this viewpoint.

Some of the disadvantages of this viewpoint are:

(1) The use of omniscient powers is ordinarily restricted.

(2) The reader can participate in the action only to the extent that the minor character narrator does.

(3) The viewpoint is more detached than either VP I or VP III. Let us now rewrite our example using this viewpoint.

When I met Jim Harding a week later, he told me that he had found the trail leading to the old mine about two days after leaving town. He said that he hadn't found the trail until almost nightfall because it was overgrown with bushes and weeds. He told me he had camped overnight and went up to the mine the next morning.

One of the difficulties of this viewpoint is apparent in this example: "He told me. . . . He said. . . . He told me. . . ." Examples of novels using this viewpoint are Maugham's *The Moon and Sixpence,* Sterne's *Tristram Shandy,* and Day's *Life with Father.*

VP VI: Third-Person Minor Character Narrator

This viewpoint is seldom used in novels because of the difficulty it presents in grammatical form. The difficulty comes in having to use proper names instead of pronouns to make it clear to the reader who is talking. In rewriting our example using this viewpoint, we will have to give our narrator a name, Ben Stanton.

> Ben Stanton didn't see Jim Harding until a week later when Jim had returned to town. Jim told Ben that he had found the trail leading to the old mine two days after leaving town. Jim said to Ben that he knew he couldn't reach the mine before it got dark that day and so he had camped overnight.

Maugham's *The Razor's Edge* is a novel that successfully uses this viewpoint. But the would-be novelist should by all means avoid VP VI.

VP VII: First-Person Shifting Viewpoint Narrators

Here the viewpoint shifts from one narrator to another and lets more than one character tell the story. Changing first-person narrators in a novel presents many problems and unless handled expertly can create a great deal of confusion for the reader. The would-be novelist should exhaust all other possibilities before attempting to use this viewpoint. For example, let us assume that the would-be novelist wants to write a novel about six men in the Deep South who murder a civil rights worker. He can have each of the six men tell the story in the first person by changing narrators. However, he will avoid a lot of repetition and problems of grammatical form by making his narrator a third-person protagonist narrator, an FBI agent, for example, who tracks down the six men and obtains a confession from each. The confession can be told as quoted statements, but the novelist can select from each one only the highlights that haven't been told by any of the others. To illustrate the tremendous problem in using this viewpoint let us now rewrite our example.

I was tired as Jim Harding and I found the trail leading to the old mine. I decided to ask Jim to stop there and camp overnight.

"It will soon be dark," I said. "How about camping here overnight and going on to the mine in the morning?"

I didn't think I was hearing right when Fred asked me to camp here overnight. I was anxious to get to the mine as soon as possible. But Fred had a point.

"Okay," I said.

I was relieved when Jim agreed to camp overnight.

Novels for study of this viewpoint include Emily Brontë's *Wuthering Heights*, Wilkie Collins's *The Woman in White*, and William March's *Company K*.

VP VIII: Third-Person Shifting Viewpoint Narrators

This is the next most popular viewpoint after VP I. Some novels are best told by one narrator, others by more than one. Fortunately the shifting of narrators in the third person presents no problems in grammatical form and punctuation as does VP VII. Before discussing the advantages and disadvantages of this viewpoint there are a few principles for the use of shifting narrators that must be considered.

1. The introduction of a new viewpoint narrator should mark the beginning of a chapter when possible.

The complete chapter break helps the reader to adjust mentally to the new angle from which the story is being viewed. Let us assume we are writing a novel in which the viewpoint is going to shift back and forth from the hero to the heroine; also that we have begun the novel with the hero as narrator for the first two or three chapters. The reader's only acquaintance with the heroine is what he has been able to observe and deduce in vicariously living the role of the hero. Consequently when the reader is forced to uproot himself from the hero and reorient himself to the entirely different point of view of the heroine, a chapter break helps him to adjust. The author should devote enough wordage to the heroine, other than what the hero thinks and feels about her, to let the reader get acquainted with her. To understand her viewpoint and thus be able to interpret it the reader should know what her temperament is; what her thoughts, feelings, and attitudes are toward the hero; what are her dreams, ambitions, and dislikes.

Now there are exceptions to this principle—the novelist sometimes shifts the viewpoint by entering into the thoughts and feelings of characters as they are introduced to the reader. Flaubert does this with minor characters in *Madame Bovary,* using unrestricted omniscient powers, but for a first novel this can be dangerous and cause a great deal of confusion for the reader. We suggest, therefore, that the would-be novelist let the reader become sufficiently acquainted with a character to be able to adjust to the new viewpoint before shifting narrators.

2. Once the reader has become acquainted with the different narrators and can interpret their point of view correctly, the viewpoint can be shifted back and forth between narrators even in the middle of a scene.

Here is an example:

"I don't want you to go out with Stanley Hawkins again," Jim said, unable to keep the anger out of his voice.

"Don't you go ordering me around," Ruth said, feeling a sudden resentment toward Jim that she hadn't thought possible. Who did he think he was, telling her what she could and could not do? "We aren't married yet," she said, flinging the words at him like a challenge.

He didn't want to hurt her but there was no alternative now. "Stanley Hawkins is a married man," he said.

Jim's VP: Only Jim would know that he had tried to keep the anger out of his voice. Only Jim would know that he didn't want to hurt Ruth but had no alternative now.

Ruth's VP: Only Ruth would know that she felt a sudden resentment toward Jim that she hadn't thought possible. Only Ruth would know her unspoken thoughts: "Who did Jim think he was, telling her what she could and could not do?"

Let us now look at some of the advantages of this viewpoint.

(1) This viewpoint gives the author a choice between restricted and unrestricted omniscient powers.

(2) Using more than one narrator gives a novel greater perspective.

(3) Shifting the viewpoint provides relief and variety for the reader. It helps the author sustain reader interest. The reader gets the impression of an interplay of personalities. The author can

leave one narrator at any point in the novel he wishes in order to enlarge the scope of interest.

(4) Shifting the viewpoint enables the author to communicate more emotion to the reader because the reader can vicariously live the role of each narrator.

(5) Shifting the viewpoint gives the author much greater scope in characterizing the narrators themselves and other characters through the five senses of the narrators.

This viewpoint has one outstanding disadvantage, or perhaps it should be called a pitfall, for the novice writer, that is, it offers the opportunity of minute character analysis. This is the viewpoint of James's *The Princess Casamassima,* surely one of his most interesting novels and at the same time rather preciously analytical of the sensibilities of a young man who has consecrated himself to murder for a cause.

Here is our rewritten example using this viewpoint:

> Fred was tired when he and Jim found the trail leading to the old mine. He decided to ask Jim to stop and camp overnight. It wasn't just being tired that made him want to stop. It would soon be dark. He was afraid of trying to go up that dangerous trail in the darkness.
>
> "How about staying here overnight and going on in the morning?" he asked.
>
> Jim didn't think he was hearing right. He was anxious to get to the old mine as quickly as possible. He looked at the trail now overgrown with weeds and bushes. It would be dangerous going up the trail in the darkness. Maybe Fred was right.
>
> "Okay," he said.

From our selection of novels, the following use this viewpoint: *Madame Bovary* except for the first chapter, as Flaubert shifts the viewpoint often, even to minor characters; *Tom Jones,* with Tom the focal character; and *The Spy Who Came in from the Cold,* in which le Carré enters into the thoughts and feelings of both Leamas and Liz Gold, with Leamas the focal character.

Assuming that the beginning writer will first try to write an autobiographical novel, we have some words of advice on selecting a viewpoint. If the novel is going to deal with the author's personal experiences, he should use a first-person protagonist narrator. If the novel is going to be mainly concerned with the experi-

ences of a relative, friend, or associate, the author should use a first-person supporting character narrator. If the novel's theme is the social significance of the protagonist's conflict and the times in which he lived, the author should use a first-person minor character narrator. However, the choice of any viewpoint is to be weighed in the delicate balance of the author's statement of purpose and vision.

Before concluding this chapter on selecting a viewpoint, we would like to warn the reader about a common misconception. Some instructors of creative writing teach that there is a relationship between the viewpoint chosen and the subjectivity or objectivity of the writing. Let us first define the terms.

A novel contains subjective writing when the novelist seeks to record the feelings and sensibilities behind his characters' thoughts, statements, and actions.

A novel contains objective writing when the novelist leaves to the reader's imagination the feelings and sensibilities behind his characters' thoughts, statements, and actions.

In the novels selected for study the writing is subjective in *Madame Bovary, From Here to Eternity,* and *To Kill a Mockingbird.* It is objective in *Tom Jones. The Spy Who Came in from the Cold* contains both subjective and objective writing.

Let us briefly illustrate the difference.

Subjective:

He hit me and knocked me down. It stunned me for a moment but the surprise was worse than the pain. I could feel the blood running from my nose and down over my lips. I touched my tongue to my lips and could taste the salt in my blood. At that moment, I hated him more than I had ever imagined I could hate anybody.

Objective:

He hit me and knocked me down. The punch caught me flat on the nose and made it bleed. I hated him.

In the first example the author enters into the thoughts and feelings of the character; in the second, what the character is think-

ing and feeling is left to the imagination of the reader. We have purposely made the two examples rough and unfinished in order to demonstrate that the amount of sensibility does not depend on the viewpoint. We find ourselves in complete disagreement with books on writing that state that the viewpoint will determine whether the writing is to be subjective or objective. This misconception, a post hoc fallacy, seems to derive from the idea that the more detached from the protagonist the viewpoint is, the less subjective the writing will be. Presumably, then, the viewpoint of a third-person minor character narrator would lead to objective writing, whereas the viewpoint of a first-person protagonist narrator would lead to subjective writing. This just isn't true. A reader lives a novel within the personal frame of reference of the narrator and the author can make the writing subjective or objective no matter who the narrator happens to be. It is a choice the author makes. If Hemingway had written *From Here to Eternity,* the writing would have been objective. By the same token, Jones would have written *The Sun Also Rises* in a subjective manner. We have one principle to guide the reader:

Write naturally, as it comes most easily for you. If you are naturally a subjective writer, your writing will be subjective. If you are naturally an objective writer, your writing will be objective.

The great majority of would-be novelists are going to discover that it is much more natural for them to write subjectively than it is to write objectively.

Exercises for Chapter 4

Part I

1. Is your novel going to use the first person or third person? Explain your choice.
2. Are you going to use restricted or unrestricted omniscient powers? Explain your choice.
3. Which of the eight possible viewpoints are you going to use? Explain your choice.
4. Is your writing going to be subjective or objective? Explain your choice.

Part II

1. In which person is *The Grapes of Wrath* written?
2. In which person is *The Pearl* written?
3. What omniscient powers does the author use in *The Grapes of Wrath?*
4. What omniscient powers does the author use in *The Pearl?*
5. Which of the eight viewpoints does the author use in *The Grapes of Wrath?*
6. Which of the eight viewpoints does the author use in *The Pearl?*
7. Is the writing in *The Grapes of Wrath* subjective or objective?
8. Is the writing in *The Pearl* subjective or objective?

5

How to Develop a Theme

All traditional novels portray a struggle between good and evil.

All traditional novels demonstrate that certain people have had certain experiences, and these experiences comment on life, leaving the reader with some conclusion about the nature of existence that can be factually verified. This conclusion is the theme of the novel.

We want to clarify the second common element above. After reading a novel, the reader must come to some sort of conclusion about life as the author has shown it to be in the novel. In other words, he makes a discovery about existence that he may or may not have known before. And he can apply this discovery to life and test it for validity. To give a simple example, a reader may come to the conclusion, after reading a war novel, that war is hell. Or after reading a mystery novel, he may come to the conclusion that crime does not pay. Some conclusions about the nature of life may be very complex, however, and will require the reader to bring to the novel a good deal of intelligence and literary skill. As an illustration, the conclusion that crime does not pay is not a very adequate interpretation of Dostoevsky's *Crime and Punishment*. But in any event, whether simple or complex, the conclusion that the reader reaches is what we are calling the theme of the novel.

In this chapter we are going to discuss theme and thematic significance. Again we go back to our statement of purpose in which

we will always find some indication of theme because it involves good and evil. The novelist is therefore aware of theme from the moment he makes a statement of purpose.

Should a novelist force himself to state his theme fully before, or indeed during, the writing of his novel? It is our belief that to do so makes both the author and his characters the prisoners of such a thematic statement.

We are aware that some instructors and books on writing advise the student to begin with theme. We are aware, too, that for a novelist employing the unrestricted omniscient viewpoint the temptation is very great to state a novel's theme directly. It is our contention, however, that the working novelist should be content with a statement of purpose if the statement of purpose is clear, strong, and meaningful. The reason is that the author's interpretation of his statement of purpose—reflected in story line or plot, locale, characterization, and all the other fictional elements—will result in a theme that is clear, strong, and meaningful. Thus the following principle:

A novelist's interpretation of his statement of purpose results in the theme of the novel.

In every statement of purpose the author is going to *prove* something about life and the only way he can do this is to *prove that something is good or evil about life*. Now it is a matter of logic that to prove something good or evil, one must have a set of principles to use as a guide. What principles should the novelist adopt? There have been many guides in the past: the teachings of Christ, the modifications given those teachings by various religions, the manners of a culture, the development of habits by means of law, tradition, and so on. But the safest and most productive guide for a novelist lies in his own determination of the nature of good and evil. It may be that he will reflect the traditional past, as, for example, Jane Austen did. Or he may challenge the very bases of his society, as did D. H. Lawrence. In any event, it is of considerable importance that a novelist define good and evil for himself. Let us use these terms, therefore, to mean the dramatic poles of thought a novelist employs in order to create conflict and to indicate something about the destructive or creative outcome of conflict. The following principle states the source of a theme in a novel:

The theme of a traditional novel is derived from the struggle between good and evil in the novel.

When we place a protagonist in conflict with his own environment or the environment of others the struggle between good and evil begins, and consequently the theme begins to emerge. The novelist is responding to the following principle:

The environment itself or something within the environment must generate good or evil as the author defines these terms. When the environment generates good, the protagonist must ordinarily represent what is evil. When the environment generates evil, the protagonist must ordinarily represent what is good.

Let us illustrate this principle with some of the novels we have selected for study. Before we do, however, we must remind the reader that we are using the terms good and evil not as absolutes but as each author, working in terms of his particular vision, has defined them. Furthermore, there is a problem here that we would like to touch upon very briefly. A considerable body of literary criticism exists for most of the novels we have selected for study, especially *Tom Jones* and *Madame Bovary*. To make a concise summary of the complex issues discussed that would please every critic is impossible. But from our viewpoint this is not really necessary. If authors confine themselves to working definitions of good and evil, one can be certain that such working definitions do not have the density and complexity that critics have arrived at.

Madame Bovary: The small French villages where Emma lives with her husband, Charles, generate a form of *good*. People go to church, are hardworking, have enough to eat and a roof over their heads, raise families. The great majority of husbands and wives are faithful to each other. Flaubert knew that Emma would have to represent what was *evil* in the novel in order to portray the struggle between good and evil. At the same time, Flaubert revealed that these small French villages and the lives led in them formed a vacuum to a person like Emma, who wished for more out of life than monotonous routines, provincial vistas, unenlightened conversations, dry and sour emotions. Emma wanted life to be enriched, varied, and invigorating. If the good of the novel was normalcy, then Emma's evil was a desire to substitute something

else for it. Emma commits evil in Christian terms—adultery—and pays the Christian price for such evil. Yet the irony of the novel is that it reestablishes as the norm of good the idea that life should have been richer than it was, and that Emma is indeed the sacrifice to an environment whose basic goodness is marked by apathy and emotional death.

Tom Jones: Fielding portrays the environment formed of human nature as essentially animalistic and self-centered, or consequently as evil. In such an environment there occur from time to time, almost accidentally, men of good heart. Squire Allworthy is such a person. So is Tom Jones. But Squire Allworthy is mature, prudent, fashioned in the ways of the world. Tom's good nature is discovered in youth and consequently in imprudence and impulsiveness. Thus, while the environment around Tom generates the evil of selfishness, and while Tom depicts the virtues of the goodhearted, nevertheless, he has a measure of potential evil in himself. The threat to his nature (goodness) is that he will have to become selfish (evil) like the majority of mankind in order to survive. That such a threat does not materialize is developed throughout the novel in terms of a metaphorical statement that goodheartedness and good fortune go hand in hand. Tom at length proves himself innocent of many of the charges hurled at him, his legitimacy is testified to, and he marries Sophia, whose name symbolizes wisdom. Tom, therefore, marries a symbolic extension of the quality he has lacked to make him whole, namely, prudence.

In both of the foregoing novels the authors have been aware that while the environments generate evil, nevertheless the greater threat (and consequently the greater evil) to the protagonists lies in their own nature. This complicates our principle that when an environment generates good, the protagonist must ordinarily represent what is evil, and vice versa. In the other novels we have selected for study the problem of good and evil is not strained by the appearance of these qualities in both environment and protagonist.

From Here to Eternity: The environment of the novel, located within a military context of bureaucracies, forms, customs, and codes of behavior lacking human dimension and humane purposes, where sex, drinking, and brutality are a way of life, is *evil*. The attempts to escape it are ranked in terms of good. In Karen Holmes's case, it is the supposed good of a pathetic attempt to

live for the moment. To Milt Warden, who has mastered the system and makes it work for him, there is a kind of good that lies in cynicism. It has survival value. However, to the protagonist, Prewitt, who represents the *good* of individual talent, self-respect, and search for identity, the conflict of values represented in himself and those of the system is at its highest. Jones believed that the fundamental absurdity of life is its attempt to systematize characteristics in human beings that are the more precious for being unsystematic, and the tragedy is that life (for the military model becomes for him an example of life in its crudest and most pertinent form) cannot generate another model. Prewitt's individualism (good) is trapped, suffers, and is lost because the very forces meant to defend it end by crushing it.

We have mentioned the working definitions of good and evil that a novelist might employ. In the preceding examples, we have stated these working definitions in even greater length than a novelist might. Let us now pare down two examples to a brief form a novelist might use.

To Kill a Mockingbird: The environment of a small town in the Deep South generates evil because of racial bigotry. Atticus Finch represents what is good because he is willing to stand up against this racial bigotry, and Scout represents good because of her defense of her father and her pride and love for him.

The Spy Who Came in from the Cold: The environment of international espionage generates evil because it uses human beings as pawns. Leamas, the protagonist, represents good because he is willing to sacrifice his life trying to save Liz Gold.

In all traditional novels, either good or evil is triumphant, and the result of the struggle between good and evil is the theme of the novel.

As soon as a novelist interprets his statement of purpose the theme of a novel begins to grow, but it isn't until the struggle between good and evil is resolved that the theme becomes full blown. Let us look at some examples. The themes will be simplified for easy understanding.

Madame Bovary: In this novel, good triumphs, the good of normal marriages, of thrift, and even of a certain meanness of spirit. The novel is ironic in its conclusion since the traditional Christian condemnation of adultery is a condemnation as well of

those very qualities of existence that may be quite innocent and yet may make adultery tragically desirable.

Tom Jones: In this novel, good is triumphant when Tom is revealed as the legitimate nephew of Squire Allworthy, when Blifil is unmasked, and when Tom marries Sophia, having promised her that he will curb his headstrong and impulsive nature. The reader is left with the conclusion that one's greatest enemy may not be the selfishness and hypocrisy of others, but one's own irrational goodheartedness.

From Here to Eternity: In this novel, evil is triumphant because the absurd bureaucratic system and enervating environment bring about the complete disintegration of the character of Robert E. Lee Prewitt, leaving the reader with the conclusion that men must suffer character degradation when they serve as peacetime career soldiers.

To Kill a Mockingbird: The twin role of good and evil in this novel is one of the reasons why it won a Pulitzer Prize. Good is triumphant when Bob Ewell, who personifies evil, is killed by Boo Radley, and Scout Finch becomes a humane and compassionate young southern lady. But the evil generated by the environment is triumphant over good when an innocent man is found guilty of a crime he did not commit just because he is black, leaving the reader with the conclusion that there is no justice for the African-American in the Deep South. We would, however, recommend that the would-be novelist confine himself to a single role for good and evil until he establishes himself.

In our definition of plot and story line we stated that the chain of causally related events is what gives a novel continuity, pace, and thematic significance. We have postponed discussing thematic significance until this chapter because of its relationship to theme. There are two generic themes in literature: man's relationship with good, and man's relationship with evil.

Now in order to give a novel thematic significance an author must exploit one of these two generic themes. He begins by selecting a viewpoint and a narrator that will bring him closer to the meaning of his work. For example, *Tom Sawyer* by Mark Twain is a light-hearted boy's adventure story narrated by Tom from Tom's point of view having little thematic significance. But when Twain made Huck Finn the narrator in *The Adventures of Huckleberry Finn* the dark elements that were minor details in the idyllic

scene of Hannibal began to emerge, to assert their significance, and to compel reappraisal. The result is one of the most significant works in American literature. Mark Twain accomplished this by using the following principle:

Thematic significance in a novel arises from an exaggerated impression of life.

Here is a principle that is certain to cause controversy because of the myth that a novel must be true to life. If this were so, novelists would simply turn reporters and record the exact truth about life. Exact truth, however, usually makes very dull reading. The novelist must make his characters and the things that happen to them more interesting than in real life in order to hold the reader's interest. He must also make one central significance emerge. He does this by exaggerating complications (which we have discussed in Chapter 3) and by exaggerating characterization (which we will discuss in Chapter 9). The novelist brings into focus dominant, exaggerated impressions about people, motivations, environment, and concepts. And from this exaggerated impression of life, he achieves thematic significance. Let us look at some of the novels selected for study and ask if they are true to life or exaggerated.

Was it common for Norman French women living in the nineteenth century to commit suicide because they could not live in the stilted monotony of French provincial life, as did Emma in *Madame Bovary?* Did young men of uncertain birth often achieve legitimacy in the eighteenth century because they were essentially goodhearted, as did Tom Jones? Do many young men who enlist as career soldiers suffer degradation of character through military service, as Prewitt does in *From Here to Eternity?* Do all blacks in the Deep South become the victims of a miscarriage of justice, as Tom Robinson does in *To Kill a Mockingbird?* Do British intelligence agents in the espionage business usually end up outwitting Communist agents and sacrificing their lives trying to save a girl friend as Leamas does in *The Spy Who Came in from the Cold?*

The answer to all these questions is, of course, no. Readers will agree that the central themes of these novels are all derived from an exaggerated impression of life, just as the cartoons on the editorial pages of newspapers exaggerate current events to drive home their basic significance. The reader may well ask, If this is true,

how can a reader come to some conclusion about life after reading a novel? He does this in the same way he would arrive at some conclusion about current events by studying an editorial page cartoon. Behind the cartoon is the cartoonist's insight into the truth about the current event. Behind the novel's exaggerated impression of life is the novelist's insight into the truth about character and life. It is through the fictional existence of the novel with its exaggerated impression of life that the reader comes to some kind of conclusion that may be verified in the factual realm of existence.

If one fault stands out above all others in the writing of novels by the young and inexperienced, it is the tendency to sermonize and editorialize to drive home the theme. Such a novelist is convinced of the validity of his wisdom, gained from experience, and he wants most sincerely to persuade others about the truth of his conception. As a result he begins to lecture the reader, completely ignorant of the fact that there is no quicker and surer kiss-of-death for a novel. That is why we have stated that the would-be novelist's major effort should be the interpretation of his statement of purpose. If he follows this advice, and searches for the clear opposition and struggle between the poles of good and evil, he may rest assured that the theme of his novel will be a principal result.

Exercises for Chapter 5

Part I

1. In your statement of purpose of the novel you are going to write, what indication do you find of good or evil or both?
2. In the environment in which you've placed your protagonists, what is there that generates good or evil?
3. Does your protagonist represent good or evil?
4. In your novel is good or evil going to be triumphant? Why?

Part II

1. In this statement of purpose for *The Grapes of Wrath,* what indication do you find of evil?

"To prove that migrant workers during the 1930's were forced to live under poverty-stricken conditions no matter where they went."

2. In this statement of purpose for *The Pearl*, what indication do you find of evil?

"To prove that dreams of wealth for a poor but happy man will corrupt his happiness and tend to destroy his family."

3. California in *The Grapes of Wrath* generates evil because
 (a) it denies human beings the right to make a decent living.
 (b) there is not sufficient land for those wanting to farm it.
 (c) there is plenty to eat but people are hungry.

4. The natural environment of Kino as a pearl fisherman generates evil because
 (a) the discovery of a priceless pearl can arouse envy and greed in men.
 (b) the work is hazardous and dangerous.
 (c) most pearl fishermen are poor.

5. Does the Joad family in *The Grapes of Wrath* represent good or evil?

6. Does Kino in *The Pearl* represent good or evil?

7. Which is triumphant in *The Grapes of Wrath*, good or evil?

8. Which is triumphant in *The Pearl*, good or evil?

9. Which of the following is the correct theme for *The Grapes of Wrath*?
 (a) Some people are born to live out their lives in poverty.
 (b) Both migrant workers and fruit growers were the victims of the profit system during the 1930's.
 (c) Nature controls man's destiny.

10. Which of the following themes is correct for *The Pearl*?
 (a) A dream of wealth can lead to disaster for a stable family group.
 (b) Pearls always bring bad luck to their owners.
 (c) The less you own, the happier you will be.

6

How to Employ Exposition

All traditional novels employ exposition.

With this chapter, we begin to study the basic elements of prose composition in the writing of novels. If a person who knew very little about writing were to write a novel, he would employ the basic elements of exposition, description, narration, and action (dialogue and movement). But the exposition might be faulty, the description overblown, the narration bulky, and the action unconvincing. The purpose of this chapter is to help the reader overcome these weaknesses by teaching him the techniques professional novelists use to convey information, pictures, sights, sounds, sense of time, action, and speech.

We are aware, of course, that a good many "techniques" rest in the area of untaught individual talent. A person's skill in writing may be a matter of gift. Nonetheless there are certain principles for employing exposition, description, narration, and action that can be taught and will be of great help to the would-be novelist. In this chapter we are going to deal only with exposition. (Two subsidiary elements of writing, style and symbolism, that have a direct bearing on the uses of exposition, description, narration, and action will be discussed and illustrated in later chapters.)

What, then is exposition?

The basic purpose of exposition is to inform the reader about something. In a novel it is the imparting of information to the

73

reader which he must know in order to understand and believe in the characters and the story.

Exposition appeals primarily to the mind, to the understanding. In writing it is a way of dealing with information, of understanding things, for exposition analyzes, defines, compares and contrasts, illustrates, and classifies such information.

Rarely does exposition exist in a pure state. It is often combined with narration, description, persuasion, and dialogue. But we would, nevertheless, call any passage whose fundamental purpose was to impart information and understanding to the reader an expository passage. This presents a problem for the novelist because he employs narration and action as the chief modes of discourse. He does this because long passages of expository writing and description are considered obsolete in contemporary fiction by novelists, critics, reviewers, and publishers. And yet, it is impossible to write a novel without employing exposition. The novelist, therefore, tries to make the exposition a part of the "narrative flow" of the novel by employing the principles in this chapter.

The manner in which expository information can be given to the reader will depend almost entirely on the viewpoint selected by the author. The more restricted the viewpoint, the more an author has to beware of faulty exposition because the editorial rule governing restricted viewpoint must be obeyed. Let us repeat that rule.

Only that portion of the action, narrative, and description can be covered which the viewpoint character or characters can personally observe or deduce, and no material beyond the ken of the viewpoint character or characters can be included in the novel.

The violation of this rule burdens the story with needless detail and explanation; the characters become unrealistic and the story unbelievable. Let us use a simple example to illustrate this. Assume we are writing a novel with a first-person protagonist narrator using restricted omniscient powers, and we write:

> I stood beside Sam Jones as we watched his house burn down. Sam felt like crying. He thought at first the firemen could save it but knew it was hopeless as the roof caved in.

This is faulty exposition at its worst. How would the narrator know Sam Jones "felt like crying?" How would the narrator know

Sam "thought at first the firemen could save it"? How would the narrator know Sam Jones "knew it was hopeless as the roof caved in"?

Faulty exposition like this is one of the chief weaknesses of student writers. Fortunately, there are certain techniques for avoiding it. The first of these principles is:

1. Let the character impart the information to the viewpoint character by dialogue.

Let us now apply this principle to our example.

> I felt sorry for Sam Jones as we watched his house burn down. "I feel like crying," Sam said. "At first I thought the firemen could save it, but now the roof's caving in, and I know it's hopeless."

Here is an example of this principle at work in *To Kill a Mockingbird*. Scout Finch, the narrator, is reporting on a conversation she had with Miss Stephanie, who in her own turn was witness to a conversation between Atticus and Bob Ewell.

> Mr. Ewell was a veteran of an obscure war; that plus Atticus's peaceful reaction probably prompted him to inquire, "Too proud to fight, you nigger-lovin' bastard?" Miss Stephanie said Atticus said, "No, too old," put his hands in his pockets and strolled on. Miss Stephanie said you had to hand it to Atticus Finch, he could be right dry sometimes.
> Jem and I didn't think it entertaining.
> "After all, though," I said, "he was the deadest shot in the county one time. He could—"
> "You know he wouldn't carry a gun, Scout. He ain't even got one—" said Jem. "You know he didn't even have one down at the jail that night. He told me havin' a gun around's an invitation to somebody to shoot you."

From this exchange we learn a great deal about Atticus Finch, about his past, about his values.

Another principle for avoiding faulty exposition is:

2. Let the viewpoint character narrate the expository information in such a way as to indicate that another character has given him the information.

For example:

Sam Jones told me that he felt like crying while he watched his house burn down. He said that at first he thought the firemen could save it, but he knew it was hopeless when the roof caved in.

Here is an example of this principle at work in *The Spy Who Came in from the Cold*. The restricted viewpoint narrator, Leamas, has obtained from various sources a great deal of information about an East German spy named Fiedler. The author imparts this information to the reader by means of the above principle.

Leamas knew Fiedler, all right. He knew him from the photographs on the file and the account of his former subordinates. A slim, neat man, quite young, smooth-faced. Dark hair, bright brown eyes; intelligent and savage, as Leamas had said. A lithe, quick body containing a patient, retentive mind, a man seemingly without ambition for himself but remorseless in the destruction of others. Fiedler was a rarity in the Abteilung—he took no part in its intrigues, seemed content to live in Mundt's shadow without prospect of promotion.

Rather than narrate this kind of expository material, an author can employ the following principle:

3. Information the viewpoint narrator wants to convey to the reader about a character who is not present in the scene can be presented through dialogue with still another character.

For example:

I met Charlie Bates the day after Sam Jones's house had burned down.

"How did Sam take it?" I asked.

"Oh," Charlie said, screwing up his mouth like a purse, "he was pretty jarred. Told me he felt like crying. And when the roof caved in on 'er, he said he knew it was hopeless and the firemen couldn't save it."

Here is an example of this principle from *The Spy Who Came in from the Cold*. The author wants to convey some information to the reader about a character named Sam Kiever who is not present in this scene between Leamas and Ashe.

Ashe fell silent for a moment.

"You don't know Sam, do you?" he asked.

"Sam?"

A note of irritation entered Ashe's voice.

"Sam Kiever, my boss. The chap I was telling you about."

"Was he in Berlin too?"

"No. He knows Germany well, but he's never lived in Berlin. He did a bit of deviling in Bonn, free-lance stuff. You might have met him. He's a dear."

"Don't think so." A pause.

Let us now look at still another principle for avoiding faulty exposition.

4. When two characters are both aware of information the reader does not know, convey this information to the reader by bringing it out during an argument.

The word "argument" is perhaps too strong to be applied to all situations in novels that depend on differences of opinion between characters. But there must be at least a difference of opinion or attitude, for otherwise the passage will exist only for the sake of exposition and thus weaken the narrative flow. Let us apply this principle to our example.

I met Steve Barbich, who was chief of our volunteer fire department, outside the Post Office.

"If you and your men had got to the fire sooner you could have saved Sam Jones's house," I said, putting the blame right where I thought it should be.

"We got there as soon as we could," Steve said defensively.

"But not soon enough," I said. "Poor old Sam told me that he felt like crying watching his house burn down, and he thought the firemen could save it until the roof caved in."

"I know," Steve said. "He told me. And if just one more person makes a crack about us getting there late, I'm quitting as chief."

"You won't have to quit," I said. "People will demand you resign."

Here is an example from the novel *From Here to Eternity*. The passage contains unconventional spelling and punctuation which help to characterize. Although the author uses unrestricted omniscient powers and third-person shifting viewpoint narrators in this novel, the passage points up the fact that no matter what the viewpoint, great care must be taken to avoid faulty exposition. It all depends on the author's presentation of his material. The information Jones wishes to convey is: (1) That Prew and Red are both buglers. (2) That Prew is the best bugler in the regiment, and

probably the best in Schofield Barracks. (3) That Prew is being transferred out of the Bugle Corps because he shot off his mouth to a superior officer named Houston. The author employs principle 4 to do this.

> "I still think you're makin a bad mistake," the man behind him said.
>
> "Yeah I know; you told me. Every day for two weeks now. You just dont understand it, Red."
>
> "Maybe not," the other said. "I aint no tempermental genius. But I understand somethin else. I'm a good bugler and I know it. But I cant touch you on a bugle. You're the best bugler in this Regiment, bar none. Probly the best in Schofield Barricks."
>
> The young man thoughtfully agreed. "Thats true."
>
> "Well. Then why you want to quit and transfer?"
>
> "I dont want to, Red."
>
> "But you are."
>
> "Oh no I'm not. You forget. I'm being transferred. Theres a difference."
>
> "Now listen," Red said hotly.
>
> "You listen, Red. Lets go over to Choy's and get some breakfast. Before this crowd gets over there and eats up all his stock." He jerked his head back at the awakening squadroom.
>
> "You're actin like a kid," Red said. "You're not bein transferred, any more than I am. If you hadnt of gone and shot your mouth off to Houston none of this would ever happened."

The next principle for avoiding faulty exposition is:

5. Convey information about the past which the reader must know through the reminiscences of two or more characters who have such knowledge.

We have all done this. We go to a football game and when we get home we hold a postmortem on the game. And very often we meet an old friend we haven't seen for some time and find ourselves reminiscing about a past we both know.

For example:

> I met Bill Jones coming out of a hotel in Capitol City. He was the first person from my home town I'd seen since moving to the city. I was on my way to have lunch and invited him to join me. We talked about what had happened to each of us during the past months and then began to reminisce about home.

"How is your Uncle Sam?" I asked.

"He's never been the same since that night the old family home burned down," Bill answered. "Does nothing but complain about that new house."

"I'll never forget that night," I said. "Remember how we were standing there beside him and he told us he felt like crying?"

Bill nodded. "Yes," he said, "and how he told us he kept hoping the firemen would save the house until the roof finally caved in."

Let us now look at an example of this principle in *From Here to Eternity*. In order for the reader to know what pressures exist in the system in which Prewitt has trapped himself, he must understand how heavily the military "brass" emphasizes athletic prowess. This example illustrates the use of reminiscence for the sake of information in an exchange between Colonel Delbert and Captain Holmes.

"We certainly looked bad last Sunday in baseball." The Col clipped the words. "You see the game? A rout. A veritable rout. The 21st ran over us roughshod, I say. It'd've been much worse if 't hadn't been for Big Chief Choate. Best first-baseman ever saw. Really ought to transfer him to Hq Company and give him a Staff Sergeancy." Col Delbert beamed and the short mustache bent sharply in the middle like a distant bird in flight. "Fact, I would if we had a team at all in baseball, but he's the only thing we've got."

Capt Holmes debated in the pause whether the Col intended to go on, or whether he could go ahead with what he wanted. He decided it would be better to wait than interrupt him if he did go on.

"We wont do anything in baseball this year," the Col went on. Holmes chalked up a hit. "Your boxing squad was only athletic championship we won all year last year. Looks like the only one we'll have a chance of winning this year. I've taken some mighty strong ribbing about our athletic prowess lately."

"Yes Sir," Capt Holmes said in the next pause. "Thank you, Sir."

In this passage Colonel Delbert hasn't said a single thing that Captain Holmes didn't already know, but principle 5 was employed to convey this information to the reader. Now for another principle:

6. Convey information about the past to the reader through the unspoken thoughts of the narrator.

For example:

> It was a hot night without a breath of wind blowing. The kind of night people said was made to order for a fire. It reminded me of the night Sam Jones's house had burned to the ground. I remembered standing beside Sam as we watched his house burn and him telling me he felt like crying, and how he kept hoping the firemen would save the house until the roof finally caved in.

Here is an illustration of this principle from *To Kill a Mockingbird*, with the narrator, Scout Finch, summing up her past life in unspoken thoughts.

> We lived on the main residential street in town—Atticus, Jem and I, plus Calpurnia our cook. Jem and I found our father satisfactory; he played with us, read to us, and treated us with courteous detachment.
> Calpurnia was something else again. She was all angles and bones; she was nearsighted; she squinted; her hand was wide as a bed slat and twice as hard. She was always ordering me out of the kitchen. . . .
> Our mother died when I was two, so I never felt her absence. She was a Graham from Montgomery; Atticus met her when he was first elected to the state legislature. He was middle-aged then, she was fifteen years his junior. Jem was the product of their first year of marriage; four years later I was born, and two years later our mother died from a sudden heart attack.

In employing these principles for avoiding faulty exposition, the writer must keep uppermost in mind the fact that when an expository purpose reveals itself for just what it is, he may face a breakdown in fictional communication with the reader. The reader is interested in the plot or story line. Whatever contributes to that is good; whatever detracts from it by asserting an importance quite apart from it is harmful. For this reason, the author must weigh carefully just which one of the principles for conveying information to the reader is best suited to sustain the narrative flow of his novel. His aim should be to convey this information without the reader's suspecting that this is precisely what he is doing.

We have one final principle for avoiding faulty exposition.

7. The author should test his novel for faulty exposition before writing the final draft by asking himself the following questions each time information is imparted to the reader:

(a) Is this information absolutely essential so that the reader may understand and believe in the characters and story?

(b) How would the viewpoint narrator know this information?

The first question obviously prohibits devoting too much attention to past events and curbs overwriting. The second question is a familiar one to almost every author who has had his first novel accepted. In asking for revisions the editor will probably write this question on the margin of the manuscript in several places. This is especially likely for first-person autobiographical novels. The would-be novelist can greatly enhance the chances for an acceptance of his first novel by asking himself this question before an editor does.

Readers who will question everything an author writes using restricted omniscient powers will readily accept almost anything an author writes using unrestricted omniscient powers, so long as the narrative flow is sustained. For example:

> Sam Jones felt like crying as he watched his house burn down. He stood there feeling helpless as the firemen staggered around with hoses and axes. For a time, he thought they could save it, but now, as he saw the roof cave in, he knew it was hopeless. Each flaming ember seemed to him a symbol of the work and effort of a lifetime, all now rapidly passing into black, dead cinders.

Let us look at some other examples of conveying information to a reader using unrestricted omniscient powers. First a passage from *Tom Jones* by Fielding:

> This gentleman had in his youth married a very worthy and beautiful woman, of whom he had been extremely fond: by her he had three children, all of whom died in their infancy. He had likewise had the misfortune of burying this beloved wife herself, about five years before the time in which this history chuses [*sic*] to set out. This loss, however great, he bore like a man of sense and constancy, though it must be confest he would often talk a little whimsically on this head; for he sometimes said he looked on himself as still married, and considered his wife as only gone a little before him, a journey which he should most

certainly, sooner or later, take after her; and that he had not the least doubt of meeting her again in a place where he should never part with her more—sentiments for which his sense was arraigned by one part of his neighbours, his religion by a second, and his sincerity by a third.

It is quite obvious in this passage that someone is speaking about the worthy squire, judging and evaluating him, informing about him, locating him in relationship to past and present events and current gossip. And that someone is the author using unrestricted omniscient powers to convey information about Allworthy to the reader.

The following example is from *Madame Bovary:*

Sometimes she would draw; and it was great amusement to Charles to stand there bolt upright and watch her bend over her cardboard, with eyes half-closed the better to see her work, or rolling, between her fingers, little bread-pellets. As to the piano, the more quickly her fingers glided over it the more he wondered. She struck the notes with aplomb, and ran from top to bottom of the keyboard without a break. Thus shaken up, the old instrument, whose strings buzzed, could be heard at the other end of the village when the window was open, and often the bailiff's clerk, passing along the highroad bare-headed and in list slippers, stopped to listen, his sheet of paper in his hand.

From these examples it would appear that one way for a would-be novelist to avoid faulty exposition is to write a novel using unrestricted omniscient powers. Such an assumption would be false for the following reason:

The type of novel an author wishes to write and the material he is going to use must determine whether restricted or unrestricted omniscient powers are to be employed.

A first-person narrator demands restricted omniscient powers, as, for example, in *To Kill a Mockingbird.* Many types of third-person novels with protagonist narrator, supporting character narrator, or minor character narrator are best told using restricted omniscient powers, for example, *The Spy Who Came in from the Cold.* Novels with shifting viewpoint narrators demand that unrestricted omniscient powers be used, for example, *Madame Bovary.*

We will conclude this chapter by reminding the reader that one of the greatest weaknesses found in the prose composition of first

novels is faulty exposition. We therefore suggest that the would-be novelist attach the greatest importance to the principles discussed in this chapter.

Exercises for Chapter 6

Part I

Let us assume that you want to convey the following information to your reader in a novel you are writing: Jim Harkins lost his job at the Peerless Manufacturing Company because of automation. Convey this expository information in the following ways:

1. By dialogue between Jim and the restricted viewpoint narrator.
2. By narration in such a way as to indicate that another character has given that information to the viewpoint narrator.
3. By dialogue with another character (not Jim Harkins) and the viewpoint narrator.
4. By an argument between the viewpoint narrator and another character (not Jim Harkins).
5. By having the viewpoint narrator reminisce about the past with another character (not Jim Harkins).
6. Through the unspoken thoughts of the viewpoint narrator.
7. By using unrestricted omniscient powers as author.

Part II

1. Appendix III reprints Chapter 5 of *The Grapes of Wrath*. Each paragraph is numbered. Write down the numbers of the paragraphs in which the author has employed exposition to convey information to the reader.

7

How to Employ Description

All traditional novels employ description.

Fiction must communicate emotion to the reader. The novelist does this to a great extent by employing description. We begin, therefore, with a definition of description.

Description appeals to the reader's five senses. It arouses an emotional response in the reader and makes the characters and environment of the novel realistic and believable.

The novelist employs description to make a reader live the story vicariously by appealing to his senses—sight, hearing, smell, touch, and taste. Description plays a more important role than exposition in novel writing because of its fictional importance in terms of reader experience. Through exposition, for example, we can convey the information to the reader that the protagonist is lost in the desert by writing: "(Name of protagonist) became lost in the desert." The reader's reaction is a mental one. But if we use description, the reader can live the experience vicariously. We describe the color and conformation of the sand so that he can see it, its dry, dusty odor so he can smell it, its gritty taste in the protagonist's mouth so he can taste it. We describe the feeling of thousands of searing needles of flame on the protagonist's skin as the wind blows so the reader can feel it. We describe the terrible silence of the desert so that the reader can live under this oppression. We give a sense of the desert's extraordinary immensity and the incredible isolation of the protagonist so that the reader can

identify with him. Thus we have communicated to the reader the sensations experienced by a person lost in the desert.

With exposition we appeal to a reader's understanding, his mind; with description we appeal to the reader's senses. From description we get what is called "body" in novel writing. Which brings us to our first principle:

1. To give body to a character, a setting, a place, or a thing in a novel is to make it a matter of one or more of the five senses.

Generally, when a *character* is first introduced in a novel, the reader is made to see him. For example, this is how Steinbeck introduces Reverend Jim Casy in *The Grapes of Wrath:*

> It was a long head, bony, tight of skin, and set on a neck as stringy and muscular as a celery stalk. His eyeballs were heavy and protruding; the lids stretched to cover them, and the lids were raw and red. His cheeks were brown and shiny and hairless and his mouth full—humorous or sensual. The nose, beaked and hard, stretched the skin so tightly that the bridge showed white. There was no perspiration on the face, not even on the tall pale forehead. It was an abnormally high forehead, lined with delicate blue veins at the temples. Fully half of the face was above the eyes. His stiff gray hair was mussed back from his brow as though he had combed it back with his fingers. For clothes he wore overalls and a blue shirt. A denim coat with brass buttons and a spotted brown hat creased like a pork pie lay on the ground beside him. Canvas sneakers, gray with dust, lay nearby where they had fallen when they were kicked off.

Similarly, when a *setting* is introduced in a novel, the reader is made to see it. This is how Harper Lee introduces the reader to the town of Maycomb in *To Kill a Mockingbird:*

> Maycomb was an old town, but it was a tired old town when I first knew it. In rainy weather the streets turned to red slop; grass grew on the sidewalks, the courthouse sagged in the square. Somehow, it was hotter then: a black dog suffered on a summer's day; bony mules hitched to Hoover carts flicked flies in the sweltering shade of the live oaks on the square.

When a *place* is introduced in a novel, the reader must see it with sufficient clarity to be able to form a mental image of it. Here is Flaubert's description of the church at Yonville in *Madame Bovary:*

The daylight coming through the plain glass windows falls obliquely upon the pews ranged along the walls, which are adorned here and there with a straw mat bearing beneath it the words in large letters, "Mr. So-and-so's pew." Farther on, at a spot where the building narrows, the confessional forms a pendant to a statuette of the Virgin, clothed in a satin robe, coifed with a tulle veil sprinkled with silver stars, and with red cheeks, like an idol of the Sandwich Islands; and finally, a copy of the "Holy Family, presented by the Minister of the Interior," overlooking the high altar, between four candlesticks, closes in the perspective. The choir stalls, of deal wood, have been left unpainted.

When we introduce a *thing* in a novel, the reader must be given a clear picture of it. This is how Harper Lee describes a costume representing a ham that Scout Finch is going to wear at the pageant honoring Maycomb County in *To Kill a Mockingbird:*

My costume was not much of a problem. Mrs. Crenshaw, the local seamstress, had as much imagination as Mrs. Merriweather. Mrs. Crenshaw took some chicken wire and bent it into the shape of a cured ham. This she covered with brown cloth, and painted it to resemble the original. I could duck under and someone would pull the contraption down over my head. It came almost to my knees. Mrs. Crenshaw thoughtfully left two peepholes for me. She did a fine job; Jem said I looked exactly like a ham with legs. There were several discomforts, though: it was hot, it was a close fit; if my nose itched I couldn't scratch, and once inside I could not get out of it alone.

The amount of wordage a novelist devotes to describing a character, a setting, a place, or a thing depends on their importance to the plot or story line. Steinbeck used a great many words in describing Reverend Jim Casy because he wanted to emphasize the fact that Casy, a religious figure, was of the common man—he belonged with the uprooted and disenfranchised. The reader cannot fail to recall what Casy looks like throughout the novel because of the striking physical portrait of him presented at the beginning. Harper Lee devotes considerable wordage to describing Scout's costume because the costume assumes great importance when Ewell attempts to murder Scout and Jem later in the novel.

In the foregoing examples the authors have made the reader *see* a character, a setting, a place, and a thing. In some of the

examples the authors have employed other sensory impressions as well. The town of Maycomb is *hot* in the summer. The church at Yonville is *silent, empty*. The ham costume of Scout Finch is *uncomfortable*. Here are a few examples from the first chapter of *The Pearl*:

Sight:

> The dawn came quickly now, a wash, a glow, a lightness, and then an explosion of fire as the sun arose out of the Gulf.

Hearing and Smell:

> He could hear the pat of the corncakes in the house and the rich smell of them on the cooking plate.

Taste:

> Kino squatted by the fire pit and rolled a hot corncake and dipped it in sauce and ate it. And he drank a little pulque and that was breakfast.

Touch:

> Then, snarling, Kino had it, had it in his fingers, rubbing it to a paste in his hands. He threw it down and beat it into the earth floor with his fist, and Coyotito screamed with pain in his box.

The Pearl and *The Grapes of Wrath* are two of the best novels we could recommend for study on how to give body to characters, settings, places, and things by appealing to the reader's five senses.

2. To give body to an event in a novel, make the event a matter of one or more of the five senses.

In an event, a character is moving through an action or actions that follow a time sequence. Descriptive details, in other words, do not deal only with the static and fixed, but also with things changing, with motion. The details must convey in sensory ways both the sense of reality and the author's idea, intention, attitude, and purpose. In war novels, for example, the leading characters have arrived at a mental understanding of what war is, but to give body to the war, the novelist must appeal to the five senses of the reader. Through the personal frame of reference of the protago-

nist, the reader is made to *see* the war, to *hear* its sounds; to *smell* the odors of gunpowder, of death, of rotting flesh; to *feel* the grease of guns, the heat or the cold, the dry stiffness of cold canvas; to *taste* the C rations and the saltiness of blood in the mouth.

Let us now look at an example of the use of several sensory impressions from the beginning of Chapter 15, Part II, of *Madame Bovary*. The event shows Charles taking Emma to see the opera *Lucia di Lammermoor:*

> She involuntarily smiled with vanity on seeing the crowd rushing to the right by the other corridor while she went up rushing to the staircase to the reserved seats. [Sight] She was as pleased as a child to push with her finger the large tapestried door. [Touch] She breathed in with all her might the dusty smell of the lobbies, and when she was seated in her box she bent forward with the air of a duchess. [Smell]

The following is an example of appealing to the reader's sense of both hearing and sight to give body to an event. The event in *From Here to Eternity* is Prewitt's first meal in the mess hall after being transferred to G Company.

> G Company was a single personality formed by many men, but he was not part of it. Amid the gnash and clash of cutlery on china and the humming conversation he ate in silence, feeling from time to time the many curious eyes inspecting him.

3. Description is used to give body to any portion of a novel that calls upon the protagonist or other characters to use one or more of their five senses.

This principle is a broad restatement of principles 1 and 2. Practically everything in a novel can be given body, including thematic ideas, time, abstract concepts, and mental fantasies of the characters. Even boredom and vacuity can be made real for a reader by description. Here is an example of this from *Madame Bovary:*

> But it was above all the meal-times that were unbearable to her, in this small room on the ground-floor, with its smoking stove, its creaking door, the walls that sweated, the damp flags; all the bitterness in life seemed served up on her plate, and with the smoke of the boiled beef there rose from her secret soul whiffs of sickliness. Charles was a slow eater; she played with

a few nuts, or, leaning on her elbow, amused herself with drawing lines along the oilcloth table-cover with the point of her knife.

4. Brevity, selectivity, precision, and imaginative appeal are key terms in description.

Readers today will not stand for long passages of description. Publishers are well aware of this. The would-be novelist must use description sparingly and yet effectively. Brevity implies selectivity. If out of ten words, a novelist is allowed only two descriptive terms, he is going to have to choose them with great care. An author should think long and hard about his idea, intention, attitude, purpose, and plot or story line when employing description and select his words with discrimination. The passage from *Madame Bovary* quoted above is an excellent example of this. It is quite striking how much of Emma's life and fate are suggested in the concrete descriptive details, concluding with her unconscious use of a symbol of violence as a plaything.

Precision is a key consideration in choosing sense images. Rose colors vary from angry and hateful to delicate blushes; sounds clang or thud or gently ring; odors may evoke the charnel house or "houris and fleshly joys beyond the grave"; touch may slide on silk or grate on tweeds; and tastes range from acid to loathsome sweet. A writer has to have his senses working with qualitative precision if he is to appeal to the senses of a reader. As an illustration of just what we mean by precision, here is how Steinbeck describes Ma Joad as she appears to Tom when he is released from prison:

> She wore a loose Mother Hubbard of gray cloth in which there had once been colored flowers, but the color was washed out now, so that the small flowered pattern was only a little lighter gray than the background.

Things have changed since Tom went to prison. Ma has grown older, times have gotten harder, the gaiety of Ma has met the strain of keeping the family together. All of this is conveyed in a flowered pattern that is "only a little lighter gray."

Finally, description that works well in a novel has imaginative appeal, as in the last passage quoted. For good description conveys a mood and atmosphere as the sensory equivalents of attitude and understanding. It is here that the author's inherent familiarity

with his subject matter reveals itself as well as the power of his observations; for while he will record the impressions that almost any observer can make, he will also set down sensory impressions that most would overlook and thus gain what the reader will then most readily grant, a sense of authenticity.

A beautiful illustration of this occurs in *Madame Bovary*. On one of the many visits made by Charles to the farm of M. Rouault, he sees his future wife, and Flaubert sets down sensory impressions most would overlook.

> Once, during a thaw, the bark of the trees in the yard was oozing, the snow on the roofs of the outbuildings was melting; she stood on the threshold, and went to fetch her sunshade and opened it. The sunshade, of silk of the colour of pigeons' breasts, through which the sun shone, lighted up with shifting hues the white skin of her face. She smiled under the tender warmth, and drops of water could be heard falling one by one on the stretched silk.

Let us now look at some principles that will help the reader handle description.

5. Establish the viewpoint and motivation of the observer.

A restricted viewpoint forces the author to record sensory impressions from the motivation of the narrator. It is not just how anybody will see, hear, smell, touch, and taste, but how the character who is the narrator will do so. The responses of Leamas's five senses in *The Spy Who Came in from the Cold* are entirely different from the responses of a minister's five senses, for example.

When using an unrestricted omniscient viewpoint the author has to record his own perceptions in terms of an all-embracing vision, but it is vital that the author fully understand this vision.

6. Keep explanation to a minimum.

One accurate descriptive term is worth more than a paragraph of less meaningful descriptive terms. If a single word will do— use it. Sometimes a single word can cause multiple impressions of the senses. For example: The newly plowed earth *glistened*. Such a word arouses more than one sensory impression. It makes the reader see the newly plowed earth glistening in the sunlight. It reminds him of the sweet odor of newly plowed earth, and how he may well have dug his fingers into it as a child. There is the

imaginative appeal of crops to be planted and grown as the reader responds to the obscure forces that make the earth seem, and be, the source of life itself.

7. Enlarge the arena of your own five senses.

We live in a vision-oriented society, but to use only one's eyes is to be only one-fifth alive. One way of enlarging one's senses is to get into the habit of making all five senses work. Take a walk around the block. When you return write down everything you've seen, heard, touched, smelled, and tasted. Then imagine you are someone else, a character in a novel you are going to write, and take the same walk around the block. When you return, write down all the sensory impressions you had within this character's personal frame of reference. Observe people where you work and write down the dominant impression you have of each person. When you ride a crowded bus in the wintertime with its windows closed, smell the odor of human bodies packed close together and think of just the right word to describe that odor. You may well use it in a novel some day. No matter where you are make your five senses work and store up in your memory these sensory impressions.

8. Employ description to arouse an emotional response in the reader.

This point has been partially covered in other principles but is of such importance we will discuss it further. When we *see* something funny, it makes us laugh. When we *see* something tragic, it makes us feel sad. When we *hear* something that pleases us, it gives us a feeling of pleasure. When we hear something that displeases us, it makes us feel angry. When we *smell* something cooking that we like, it arouses our appetite. When we *smell* something malodorous, it makes us feel nauseated. When we *touch* someone we love, it gives us a feeling of joy. When we *touch* something we dislike, it gives us a feeling of repugnance. When we *taste* something we like, it gives us a feeling of enjoyment. When we *taste* something we dislike, it makes us sick to our stomach.

These are our five senses conveying impressions to our brain. A novelist by appealing to the reader's five senses through the written word can make him angry, happy, sad, afraid, horrified, thrilled, and so on, through the whole gamut of human emotions.

9. Classify active descriptive words in the order of their importance.

Many would-be novelists mistakenly place adjectives at the head of the list of descriptive words. The proper place is last. Verbs, nouns, verbals, and adverbs come first. The pressure to find the active word, the tangibly concrete object to represent a frequently intangible state of mind or feeling—this is what leads us to classify adjectives last. For adjectives, by their very nature, are qualities added to things rather than things in their own right. Nouns and verbs are a blend of things, qualities, and actions. Notice, as an illustration, how many nonverbal adjectives occur in the last passage quoted from *Madame Bovary* under principle 4. There are two: white, and tender. Of verbal adjectives, there are four: oozing, melting, shifting, stretched. Of nouns there are nineteen: thaw, bark, trees, yard, snow, roofs, outbuildings, threshold, sunshade, silk, colour, breasts, sun, hues, skin, face, warmth, drops, water. Of verbs, there are eight: was, stood, went, opened, shone, lighted up, smiled, could be heard.

10. In description, always try to establish a dominant impression.

The dominant impression of any person, setting, place, thing, or event is the one salient feature that strikes the viewer, or it is the single most important mood or subjective feeling it arouses. If the reader will just think of some of his friends this will become crystal clear. Jake is fat. Clara is skinny. Bill is a lush. Pete is shy. Carl is a loudmouth. Helen bores me. These are your dominant impressions of these people. And how often have you thought of some setting as drab, or a picture you own as angular, or flowing? These are your dominant impressions.

In the examples given earlier in this chapter, the single dominant impression of Reverend Jim Casy is of the man's head. Steinbeck devotes the major number of descriptive details to it, and probably the most important quality of Casy conveyed, apart from his commonness, is his sense of confusion. In the example used for a setting, the dominant impression of Maycomb is its fatigued unchangingness. In the example used for a place, the dominant impression of the church at Yonville is its provincialism. In the

example used for a thing, the dominant impression of the ham costume of Scout Finch is one of comic unwieldiness.

11. Good description often lies in rewriting and revision.

While some authors write excellent description in the first drafts of their novels, many others slight it the first time around. They may simply indicate it in their manuscripts: "Describe this room." The reason authors tend to postpone the writing of description is that they are eager to get on with the story without continually stopping to discover the right descriptive terms. However, once the first draft is written, the author must concern himself with the sensory levels of his novel. Having taken care of the plot or story line, exposition, narration, and action in the first draft, the author must then concentrate on description in the second draft.

We will conclude this chapter by underscoring the fact that long-winded passages of description in novels are passé. If a single word will do instead of a sentence—use it. If a sentence will do instead of a paragraph—use it.

Exercises for Chapter 7

Part I

In the novel you are writing, do the following by means of description:
1. Let the reader see the protagonist.
2. Let the reader see a setting.
3. Let the reader see a place.
4. Let the reader see a thing.
5. Now appeal to as many of the other four senses as possible to give body to the descriptions you have given in the first four questions.
6. Take any descriptive passage in your novel and try to improve it in terms of brevity, selectivity, precision, and imaginative appeal.
7. Take a walk around your block, and with all five senses alert, write down everything you saw, heard, smelled, touched, and tasted during the walk.
8. Find the dominant impression given in each of your answers to questions one through five and write it down.
9. Write a brief descriptive passage that will:
 (a) Make a reader angry because of something he sees.
 (b) Make a reader happy because of something he hears.

(c) Make a reader nauseated because of something he smells.

(d) Give a reader a feeling of pleasure from something he touches.

(e) Describe the taste of your favorite food.

Part II

1. Appendix III reprints Chapter 5 of *The Grapes of Wrath*. Each paragraph is numbered. Write down the numbers of the paragraphs in which the author has employed description.

8

How to Employ Narration
and Action

*All traditional novels employ narration and
action.*

We come now to the two most important elements of prose com-
position in novel writing. In order to make the distinction between
them clear, we will discuss and illustrate them together in this
chapter. Let us begin with a definition of narration in fiction.

**Narration is the rapid covering in relatively few words of a
period of time, with a suggestion of what happened during
that period of time, and with an implication of unity.**

Obviously it would be impossible for a novelist to account for
every minute of every hour of every day. The novelist must use
narration to telescope time and events; otherwise his story could
not be confined within the covers of a single book. He does this
by intruding into the novel as the author, narrating anything that
may have happened and the time that has elapsed since the para-
graph before. This enables him to bridge time in a relatively few
words and bypass the clock.

What is meant by action?

**Any portion of a novel where characters are talking or mov-
ing can be considered action. We call such portions scenes.
Scenes are used so that the reader can participate vicariously by
identification with the protagonist or other characters.**

We find action on almost every page of *The Grapes of Wrath* (except for those chapters that function editorially) and on almost every page of *To Kill a Mockingbird*. Most novels published today contain a great deal of action. Where many would-be novelists go wrong is to put passages into action that should be narrated, and to narrate passages that should be put into action. There are a number of principles for helping the beginning novelist overcome this weakness. Let us look at the first of these.

1. Employ narration to bridge time and events with a minimum of words if during the time period covered, nothing interesting or exciting happens.

In *To Kill a Mockingbird,* for example, Scout Finch describes her first day in school and then states: "The remainder of my schooldays were no more auspicious than the first." In a single sentence, the author has bridged the time of an entire school year. Since nothing interesting or exciting happened during that school year, the author employed narration.

2. Employ narration to keep a story moving.

This is a corollary to principle 1. After writing the first draft of a novel and having laid it aside for a few weeks, the author should try to read it objectively. Any portion of the novel that is written in action that seems to drag or to slow down the story should be transposed into narration. For example, if an author sees he has devoted four or five hundred words to a scene in which the hero and heroine do nothing but go out to dinner and indulge in small talk, he should transpose into narration as follows:

> Jim took Helen out for dinner that night to a small Italian restaurant in the neighborhood. After eating they returned to her apartment.

3. Employ narration to characterize.

We will postpone the discussion of this principle until Chapter 9.

4. Any portion of a novel that sounds unbelievable in action should be transposed into narration.

Because of its rapidity, narration allows a reader to believe something that he would reject as implausible if portrayed in action.

Action involves the use of details. The more details there are, the more danger there is of expressing something that might not be true to character, to logic, or to the event. For example, if we were to write the following in a novel, the reader would believe it because narration allows the writer to suppress the details.

> The Reverend Kendall had an argument with his wife that night, left his home in a rage, went to a neighborhood bar, and proceeded to get drunk.

If we were to put this into action, giving the argument in detail between the minister and his wife, the reader might find reason not to believe it. The reader might, for example, hear the minister's wife reminding her husband of his social standing in the community, of his commitment to his church's teachings, of his long-standing reputation as a man of prudence and sanity in the community. If the minister were to act in the face of these arguments and go to a neighborhood bar and get drunk, it would be unbelievable to the reader.

An illustration of this principle occurs in Chapter 2 of *Madame Bovary*. When the first Madame Charles Bovary is discovered to have lied about her fortune, the parents of Charles come to Tostes.

> Explanations followed. There were scenes. Héloise in tears, throwing her arms about her husband, implored him to defend her from his parents, Charles tried to speak up for her. They grew angry and left the house.

As a result of this confrontation between Héloise and Charles's parents, a week later, we are told in the next paragraph, she began spitting up blood and the day after that she died. Had Flaubert put the argument into action, he would have had to make it unnaturally violent in order for it to have the result it does. This would have been difficult for the reader to believe. The use of narration makes it quite plausible.

5. Employ narration to transport the reader into the past.

We will discuss and illustrate flashbacks and transitions employing this principle in Chapter 13. For our purposes here, a brief example from *Madame Bovary* will suffice. After telling the reader

of Emma's first troubled awareness that her married life was not fulfilling her longing for passion and rapture, Flaubert employs this principle to transport the reader into Emma's past: "When she was thirteen, her father himself took her to town to place her in the convent."

Let us now turn to the uses of action in the novel.

6. Employ action to characterize.

We will discuss and illustrate this principle in Chapter 9.

7. Employ action scenes only during those time periods in the novel when something interesting, important, or exciting is happening.

In our example from *To Kill a Mockingbird* for principle 1, the author used narration to cover an entire school year in a single sentence. Let us assume that during that school year Scout had been expelled from school. This would have been interesting enough to portray in action. From the same novel here is an action scene:

> Miss Caroline inspected her roll-book. "I have a Ewell here, but I don't have a first name . . . would you spell your first name for me?"
>
> "Don't know how. They call me Burris't home."
>
> "Well, Burris," said Miss Caroline, "I think we'd better excuse you for the rest of the afternoon. I want you to go home and wash your hair."
>
> From her desk she produced a thick volume, leafed through its pages and read for a moment. "A good home remedy for—Burris, I want you to go home and wash your hair with lye soap. When you've done that, treat your scalp with kerosene."
>
> "What fer, missus?"
>
> "To get rid of the—er, cooties. You see, Burris, the other children might catch them, and you wouldn't want that, would you?"
>
> The boy stood up. He was the filthiest human I had ever seen. His neck was dark gray, the backs of his hands were rusty, and his fingernails were black deep into the quick.

This is not an exciting scene but it is an important one. We are introduced to the kind of white human being who will make the

accusation, jailing, and death of Tom Robinson later seem cruelly ironic.

8. Employ action in a novel for big scenes and small scenes.

We will discuss big scenes first.

9. Dramatize in big scenes only those portions of a novel where opposing forces meet.

Conflict must always be present in a big scene. A big scene is composed of the following elements:

(a) A meeting between two opposing forces.

(b) An exploitation of the conflict inherent in the meeting.

(c) A suggestion as to the result of the meeting.

(d) The result of the meeting, which is either a resolution or a deepening of the conflict, sets up the transition to the next scene or a scene later in the novel.

The reason for bringing two opposing forces together in a big scene is to create conflict. As a result of the conflict, somebody wins, loses, concedes a point, is forced to make a decision, is made to realize something about himself or another character he did not know, or is made to understand something about the minor complication which produced the big scene.

It should not be difficult for the would-be novelist to decide which portions of a novel to portray in big scenes. And yet, we find in many novels written by students portions which should be written as big scenes narrated instead. For example:

> Henry knew that because he was coming home so late he was going to have an argument with his father. He took a deep breath as he entered the living room where his father was waiting for him. They argued for several minutes before his father let him go up to his room.

In this example the student put into narration a portion of his novel that had all the ingredients for a big scene—a meeting between two opposing forces. The reader loses the interest, importance, and excitement of the meeting because the writer failed to employ principle 9.

There are three types of big scenes in novels: those in which only movement is present, those in which both movement and

dialogue are present, and those in which dialogue alone is present. Let us look at some examples.

Movement Only: In *From Here to Eternity,* Prewitt has engaged in a poker game with Milton Warden and several other people. He has lost $200 to Warden and has quit the game in disgust, leaving O'Hayer's shack. Here is the scene that follows:

> Outside the air free of smoke and the moisture of exhaled breath smote Prew like cold water and he inhaled deeply, suddenly awake again, then let it out, trying to let out with it the weary tired unrest that was urging him to go back. He could not escape the belief that he had just lost $200 of his own hard-earned money to that bastard Warden. Come on, cut it out, he told himself, you didn't lose a cent, you're twenty to the good, you got enough for tonight, lets me and you walk from this place.
>
> The air had wakened him and he saw clearly that this was no personal feud, this was a poker game, and you cant break them all, eventually they'll break you. He walked around the sheds and down to the sidewalk. Then he walked across the street. He even got so far his hand was on the doorknob of the dayroom door and the door half open. Before he finally decided to quit kidding himself and slammed the door angrily and turned around and went irritably back to O'Hayer's.

Movement and Dialogue: In *Madame Bovary,* Emma contrives to meet Rudolphe at night at the end of the garden, but this requires her to stay up past her husband's bedtime.

> All through the winter, three or four times a week, in the dead of night he came to the garden. Emma had on purpose taken away the key of the gate, which Charles thought lost.
>
> To call her, Rudolphe threw a sprinkle of sand at the shutters. She jumped up with a start; but sometimes he had to wait, for Charles had a mania for chatting by the fireside, and he would not stop. She was wild with impatience; if her eyes could have done it, she would have hurled him out at the window. At last she would begin to undress, then take up a book, and go on reading very quietly as if the book amused her. But Charles, who was in bed, called to her to come too.
>
> "Come, now, Emma," he said. "It is time."
>
> "Yes, I am coming," she answered.
>
> Then, as the candles dazzled him, he turned to the wall and fell asleep. She escaped, smiling, palpitating, undressed.

Dialogue Only: It is often difficult to single out a scene that occurs in pure dialogue since the scene has to be set, and frequently movement occurs. But in *From Here to Eternity,* when Berry dies from the beating Sergeant Judson gives him, Prewitt joins Jack Malloy in such a scene.

> "I'm going to kill him," Prew said. "I'm going to wait till I get out of here and then I'm going to hunt him up and kill him. But I'm not going to be stupid like Berry was and go around advertising it. I'll keep my mouth shut and wait till I get my chance."
>
> "He needs to be killed," Malloy said. "He ought to be killed. But it wont do a damned bit of good to kill him."
>
> "It'll do some good," Prew said. "It'll do me a lot of good. It may even make me into a man again."
>
> "You couldn't kill a man in cold blood," Malloy said. "Even if you wanted to."
>
> "I dont aim to kill Fatso in cold blood," Prew said. "He'll get an even break. Theres a bar he hangs out at downtown all the time; I've heard some of the guys talk about it, and about how he always carries a knife. I'll kill him with a knife. He'll have as good a chance at me with his knife as I'll have at him with mine. Only—he wont kill me; I'll kill him. And nobody'll ever know who did it and I'll go back home to the Compny [*sic*] and forget it just like you forget other carrion."
>
> "It wont do any good to kill him," Malloy said.

In each of these three examples we have all the ingredients of a big scene. In the first one, conflict is present between two opposing forces: the Prewitt who wants to go back to the poker game and his other self who doesn't want to go back. The author exploits the conflict inherent in the meeting. There is a definite suggestion of the result of the meeting—Prewitt's other self loses and he goes back to the poker game.

In the second example, conflict is present between Emma and Charles. The author exploits the inherent conflict. There is a definite suggestion of the result of the meeting. Charles loses as he falls asleep and Emma wins as she leaves to keep a rendezvous with Rudolphe. This sets up the transition to the next scene.

In the third example, conflict is present between Prewitt and Malloy. Malloy tries to talk Prewitt out of a plan to kill Fatso. The inherent conflict is exploited. There is a definite suggestion

as to the result of the meeting. Malloy loses the argument and fails to talk Prewitt out of the plan. This big scene sets up a transition to another big scene later in the novel when Prewitt actually carries out his plan and kills Fatso.

Note that the big scene in each of the three illustrations makes the conflict apparent, produces emotion in the reader, helps to characterize by revealing the springs of motivation, and makes concrete, specific, and disharmonious what in narration would have appeared so only by implication.

10. Any minor complication within the framework of the major complication where two opposing forces meet should be put into action in a big scene.

We include this principle, although it has been covered in previous principles, as a reminder to the would-be novelist that his selection of portions of his novel to portray in big scenes must be based on the conflict inherent in each scene. The conflict can take various forms, and it can involve a variety of levels within man's nature and of his society—the physical, psychological, social, ethical, political, economic, spiritual, and philosophical.

11. The opponents in conflict must want to eliminate, overcome, subdue, or pacify the force opposing them.

This principle is again repetitive, but it is essential for the student writer to recognize the various objectives of opponents in conflict. In the first illustration of the psychological conflict Prew has with himself, his other self tries to *subdue* the desire to return to the poker game. In the second illustration Emma *overcomes* Charles by staying up and not going to bed until he falls asleep. In the third example, Malloy fails to *pacify* Prew.

Now there are many portions of a novel where conflict is not present, but where the necessity for dialogue, or movement, or both, exists. It is to fulfill this necessity that we have small scenes in novels. Small scenes do not have the same shape as big scenes do in terms of a clearly definable beginning, middle, and ending. Nevertheless small scenes are very important.

12. Employ small scenes to characterize.

We will postpone discussion of this principle until Chapter 9.

13. Employ small scenes to convey to the reader information that he must know in order to understand the story.

We have covered this principle in the chapter on exposition. We would, however, like to point out that big scenes also may convey information to the reader. For example, in the big scene between Prew and Malloy a great deal of information is imparted.

14. Employ small scenes to express a philosophy, to indicate where the real conflict is located, or to help advance the story.

Here is an example from *To Kill a Mockingbird* of a small scene that employs principles 12, 13, and 14. The scene is between the narrator, Scout Finch, and her father, whom she addresses as Atticus.

> "Atticus," I said one evening, "what exactly is a nigger-lover?"
>
> Atticus's face was grave. "Has somebody been calling you that?"
>
> "No sir, Mrs. Dubose calls you that. She warms up every afternoon calling you that. Francis called me that last Christmas, that's where I first heard it."
>
> "Is that the reason you jumped on him?" asked Atticus.
>
> "Yes sir . . ."
>
> "Then why are you asking me what it means?"
>
> I tried to explain to Atticus that it wasn't so much what Francis said that had infuriated me as the way he had said it. "It was like he'd said snot-nose or somethin'."
>
> "Scout," said Atticus, "nigger-lover is just one of those terms that don't mean anything—like snot-nose. It's hard to explain—ignorant, trashy people use it when they think somebody's favoring Negroes over and above themselves. It's slipped into usage with some people like ourselves, when they want a common, ugly term to label somebody."
>
> "You aren't really a nigger-lover, then, are you?"
>
> "I certainly am. I do my best to love everybody . . ."

In this small scene there is no conflict between opposing forces, but it accomplishes many things. It conveys information to the reader to help him understand the story. It helps to characterize Atticus. It tells the reader, indirectly, of the opposition to Atticus which is apparent in the community. It helps to underscore where the conflict is located. It establishes an ethical norm whereby the reader is to judge the action, and it helps to advance the story.

And finally, it expresses some of Atticus's philosophy. This is an excellent example of the importance and value of a small scene.

Today, the practice in fiction places far more emphasis on the author's ability to handle action in big scenes and small scenes than on his ability to handle exposition and description. Motion pictures and television have changed the nation's reading habits. In a motion picture or a television drama all is dialogue and movement. This has built up an appetite in readers for more and more action in novels. For this reason the novelist must make his action convincing and authentic and strive to make it impinge meaningfully on his characters. But action slows down the time periods in a novel and requires hundreds of words. To portray in action what could be told in narration in a few words, the would-be novelist must abide by the principles given in this chapter if he hopes to write a salable novel.

Exercises for Chapter 8

Part I

1. By this time you should have developed several minor complications within the framework of the major complication for your novel. Take one of these minor complications and do the following:
 (a) Write down what the two opposing forces are in this minor complication.
 (b) Write down the conflict inherent in these two forces.
 (c) Write down what the result of the conflict is to be.
 (d) Does this result resolve the complication or deepen it?
 (e) Does the result of the conflict set up a transition to the next scene or to a scene later in the novel?

2. Write a big scene using the minor complication dealt with in question 1.

3. What does this big scene reveal about the character of the protagonist?

4. What does this big scene reveal about the force opposing the protagonist?

5. Take a small scene you've written for your novel, or if you have not yet done so, write a small scene. What is the purpose of the small scene? Have you used principle 12? 13? 14?

6. Think of a portion of your novel where nothing interesting, ex-

citing, or important happens and bridge time and events with narration.

7. Take any portion of your novel you've written in action that upon reflection seems implausible and transpose it into narration.

Part II

1. Study the chapter from *The Grapes of Wrath* reprinted in Appendix III. Then write down the numbers of the paragraphs in which the author has employed narration; action; big scenes; small scenes.

9

How to Characterize

*All traditional novels use characters to dram-
atize the story.*

If one were to read all the letters of rejection by editors of book
publishing companies to authors and agents over any period of
time, he would find a major reason for rejection stated in one of
the following ways:

"The characters are not well-rounded."

"The characters are not well-developed."

"The author fails to show all four sides of his leading characters."

"The leading characters are one-dimensional."

What these editors are saying in different ways is that the author
has failed to make the characters come alive for the reader. The
purpose of this chapter is to teach the reader the techniques of
characterization used by professional novelists. Let us begin with
a definition of characterization in the novel and underscore one of
its key words.

**Characterization in the traditional novel is the *use* to which
each character puts the traits with which he or she is endowed.**

In a short story it is usually sufficient to show just "one side" of
a character, such as his selfishness. In novel writing the author
must show all "four sides" of the leading character by revealing the
character's general, physical, personal, and emotional traits. The
novelist must combine insight with richness in characterization.

The richness comes in making use of the character traits which are associated together in the personage and make up an identity. The insight must come from the novelist's knowing what his leading characters want from life. The novelist employs four groups of traits to characterize:

(1) Those formed by heredity and environment: *general traits*.

(2) Those expressed in the physical make-up of the person: *physical traits*.

(3) Those found in the social or ethical aspect of the individual: *personal traits*.

(4) Those discovered in the mental or psychological cast of the individual: *emotional traits*.

Let us examine each of these groups. General traits fall into four separate categories: universal, nationalistic, regional, and group traits.

Universal General Traits: These are traits common to all human beings. We are born either male or female. Most of us have two arms, two legs, two eyes, and so on. We all have automatic reflexes such as breathing, crying, and moving. We all learn how to walk and talk. We all grow from babies to adults. Because these traits are universal to mankind, they are readily accepted by the reader. The novelist does not have to tell the reader that his characters share these universal traits. It is only when a character does not share them that a novelist mentions the difference, for example, a character who has only one leg or is blind in one eye.

Nationalistic General Traits: The citizens of each nation may possess certain nationalistic traits that are the result of the nation's geography, culture, language, history, and psychology. Many of the nationalistic traits that find their way into fiction have become stereotypes: the industrious German, the thrifty Scotchman, the phlegmatic Englishman, the Latin lover, and so on. The novelist is under greater pressure than the short story writer to probe nationalistic influences on his main characters since he has greater length in which to explore character.

Le Carré makes use of nationalistic traits to characterize the protagonist, Leamas, in *The Spy Who Came in from the Cold:* he is phlegmatic, stoical, fatalistic, and not given to abstruse or philosophical thought. Thus Leamas in some ways is very much the

Britisher. The minor character whom we know only as Control in the same novel is described in terms of "affected detachment," "fusty conceits," "courteous according to a formula," with an "apologetic adherence to a code of behavior which he pretended to find ridiculous," banal. These, too, are rather typical nationalistic general traits used in portraits of Englishmen.

The novelist, then, must be alive to the way a nation's geography, culture, language, history, and psychology may have contributed to the formation of his characters.

Regional General Traits: People who live in specific geographical locations acquire and exhibit certain regional traits. Examples from the novels selected for study are the rural squirearchy of Allworthy and Western in *Tom Jones,* the Kentucky background of Prewitt in *From Here to Eternity,* the Southern tribalisms of *To Kill a Mockingbird,* the narrow French provinciality of Emma's life in *Madame Bovary,* and the north-of-England qualities of Leamas in *The Spy Who Came in from the Cold.*

As a specific example of how an author employs regional general traits to characterize, here is Harper Lee's presentation of Scout's new teacher, Miss Caroline Fisher, in *To Kill a Mockingbird:*

> Miss Caroline printed her name on the blackboard and said, "This says I am Miss Caroline Fisher. I am from North Alabama, from Winston County." The class murmured apprehensively, should she prove to harbor her share of the peculiarities indigenous to that region. (When Alabama seceded from the Union on January 11, 1861, Winston County seceded from Alabama, and every child in Maycomb County knew it.) North Alabama was full of Liquor Interests, Big Mules, steel companies, Republicans, professors, and other persons of no background.

Group General Traits: These are traits that arise from various groupings of people, chiefly the grouping of profession, vocation, job, or trade. We associate ministers with such group traits as being God-fearing and above reproach, criminals with an antisocial cast of mind, big-business tycoons with a lust for power, and so on. While a novelist may employ a stereotype group trait for a minor character, he tends to get at the deeper significance of his leading characters' group traits as they interact with the world the novel

depicts. The novelist cannot care how much he disturbs our association with group traits, for he knows there have been ministers convicted of everything from larceny to rape, criminals who are not motivated by antisocial malice but deep-seated psychopathic tendencies, and big-business tycoons who take positions in government out of patriotic motives for a pittance of what they could earn in private industry.

In searching for the truth about group traits, then, the novelist tends to reject many of our conventional associations between these traits and the groups from which they derive. For example, we think of international spies as being handsome, debonair, and daring young men. John le Carré defies this stereotype in *The Spy Who Came in from the Cold* by making Leamas middle-aged and far from handsome, a man capable of fear and psychological breakdown.

Physical Traits: We associate certain physical characteristics with mental, moral, and emotional traits. Like Shakespeare's Caesar, to us lean and hungry-looking men may seem untrustworthy. However, the novelist knows that physical appearance is a very unsatisfactory guide to character. He employs physical traits for only two reasons. (1) If the novel is to have verisimilitude, readers must be able to picture the characters. (2) The physical trait is an effective and concrete way of indicating other traits, such as general, personal, or emotional ones. If, during a novel, a character is going to perform some feat of strength which would reveal him as being a brave man, the novelist would let the reader know beforehand that the character is physically able to perform such a feat. If a female character is going to have men falling in love with her, as Emma does in *Madame Bovary,* the novelist must endow her with physical attractiveness.

Personal Traits: These are traits that permit us to distinguish individuals from one another. They identify men or women as possessing certain social and ethical qualities. In any group of people we are going to find:

> Some brave—some cowardly.
> Some selfish—some unselfish.
> Some bold—some meek.

> Some loyal—some two-faced.
> Some argumentative—some passive.
> Some ambitious—some lazy.
> Some faithful—some fickle.

The list is endless. There is a median position for every extreme, as Aristotle indicated in his *Ethics*. Such personal traits can be arranged in triads with a median quality between the two extremes, as for example: humble—modest—proud or brave—prudent—cowardly. In characterizing, the novelist will concern himself not only with the two extremes, but also with the median quality. For example, Fielding sets Tom Jones's extreme of character against the median quality of Blifil's:

> The vices of this young man [Tom] were, moreover, heightened by the disadvantageous light in which they appeared when opposed to the virtues of Master Blifil, his companion; a youth of so different a cast from little Jones, that not only the family but all the neighbourhood resounded his praises. He was, indeed, a lad of a remarkable disposition; sober, discreet, and pious beyond his age; qualities which gained him the love of every one who knew him: while Tom Jones was universally disliked; and many expressed their wonder that Mr. Allworthy would suffer such a lad to be educated with his nephew, lest the morals of the latter should be corrupted by his example.

In this example the author not only helps to characterize Blifil by extolling some of his personal traits but also by implication helps to characterize Tom. After reading the passage the reader by suggestion knows that Tom has a "bad" disposition and is intemperate, indiscreet, and irreligious.

Emotional Traits: Our emotional traits stem from our general, physical, and personal traits. We know the feeling of pain because it is a universal trait of our bodies. We know the emotion of patriotism because it is a nationalistic trait. We cannot help but have feelings about where we live, for these are regional traits. If we belong to the Republican party, we have feelings of loyalty toward it. If we are born ugly, we must have some emotional attitude about it as a physical trait.

Miss Maudie in *To Kill a Mockingbird* hated the inside of a house and preferred to work outside in her flower beds. Note in

the following passage how the author helps to characterize Miss Maudie using emotional traits.

> She loved everything that grew in God's earth, even the weeds. With one exception. If she found a blade of nut grass in her yard it was like the Second Battle of the Marne: she swooped down upon it with a tin tub and subjected it to blasts from beneath with a poisonous substance she said was so powerful it'd kill us all if we didn't stand out of the way.

We will conclude our discussion of how authors characterize by use of traits with an example from *The Spy Who Came in from the Cold*. In the following passage le Carré reveals a number of general, physical, and personal traits possessed by Leamas which serve to characterize him.

> Leamas was a short man with close-cropped, iron-gray hair, and the physique of a swimmer. He was very strong. This strength was discernible in his back and shoulders, in his neck, and in the stubby formation of his hands and fingers. [Physical traits]
>
> He had a utilitarian approach to clothes, as he did to most other things, and even the spectacles he occasionally wore had steel rims. Most of his suits were of artificial fiber, none of them had waistcoats. He favored shirts of the American kind with buttons on the points of the collars, and suede shoes with rubber soles. [Physical and personal traits]
>
> He had an attractive face, muscular, and a stubborn line to his thin mouth. [Personal and physical traits] His eyes were brown and small; Irish, some said. [Physical traits] It was hard to place Leamas. [General traits] If he were to walk into a London club the porter would certainly not mistake him for a member; [General traits] in a Berlin night club they usually gave him the best table. [General traits] He looked like a man who could make trouble, a man who looked after his money; a man who was not quite a gentleman. [General group, physical, and personal traits]

Before we begin studying how novelists reveal character, let us look at some of the sources for characters in a novel. Many, if not most, characters are drawn from real life—always with the stipulation which Thomas Wolfe made "that it was all right to write about a horse thief if one wanted to, but that it wasn't necessary to give his street address and telephone number."

Micawber in *David Copperfield* was a portrait of Dickens's father; Mrs. Nickleby in *Nicholas Nickleby* was a portrait of

Dickens's mother; Minnie Temple, the cousin of Henry James, was the inspiration for Isabel Archer; Adrian Harley, "the wise youth" in Meredith's *The Ordeal of Richard Feverel,* was modeled after one of Meredith's acquaintances, Maurice Fitzgerald. The source for Emma Bovary in *Madame Bovary* was the actual wife of a Norman physician. In all the novels we have selected for study the authors have used characters drawn from real life. One could cite hundreds of fictional characters based on actual people. Even when an author creates what he thinks is a purely fictional character, that character will have traits the author has observed in people in real life, the fictional character becoming a composite of many people.

Thus the prime source for fictional characters is life—real people who have been observed, studied, understood, and, in the way novelists embrace character, loved. The more one tries to understand people and the more one listens to the conflicts within the human heart, the more one will know about character and life.

Another source for characters is fiction or art itself. Holden Caulfield of Salinger's *The Catcher in the Rye* has his roots, one suspects strongly, in Huck Finn; similarly, Lieutenant Henry of Hemingway's *A Farewell to Arms* is an extension of Crane's Henry Fleming in *The Red Badge of Courage.* Sophia, in *Tom Jones,* takes her lineage from the mythical Aphrodite and from the idealized woman celebrated by the lyric poets of the seventeenth century, as well as being modeled after Fielding's first wife, Charlotte Craddock. The likelihood that fictional characters will prove to be the source for other fictional characters is increased when one recalls the use of thematic patterns in writing a novel. If one had to name a handful of novelists who have provided a manifold understanding of human behavior which has been the source for characters by other novelists, one would probably include Dickens, Balzac, Proust, and Dostoevsky.

The other source of characters for fiction lies in nonfictional works—biographies, histories, chronicles, psychological studies, and the like. Defoe based his *Robinson Crusoe* on the adventures of Alexander Selkirk, an account of whose struggles and rescue from an island appeared in several editions before Defoe wrote his first fictional masterpiece. Sinclair Lewis based his *Elmer Gantry* on Dr. William L. (Big Bill) Stidger as outlined in Stidger's

Standing Room Only. He then went on to draw the citified Gantry, visible in the latter third of *Elmer Gantry,* from an article in *The American Mercury* called "The Fundamentalist Pope."

Of all the sources for fictional characters, psychological studies, whether formal or informal, are the least trustworthy for the would-be novelist. They may well provoke the writing about pathological characters in terms of the case history instead of fictionally realized characters in terms of narrative. Instead of using five thousand words to analyze why a character has been jealous of her younger sister, the novelist contents himself with relating what happens as a result of the character's jealousy.

No matter what the source, the author's statement of purpose always gives him a clue as to what his protagonist must be like. James Jones's statement of purpose for writing *From Here to Eternity*—as we have expressed it and interpreted it—reveals that his protagonist must be a peacetime soldier on an Army base and a man of good character when the novel begins. Going back to Chapter 1 of this book and reading the statements of purpose for the other novels selected for study will reveal a great deal about what the protagonist must be like when the novel begins.

Now we are ready to examine the techniques novelists employ for revealing character and making characters well-rounded and three-dimensional.

1. Conflict with environment reveals character.

In Chapter 2 we learned the importance of placing a protagonist in conflict with his own environment or the environment of others. The protagonist's response to the stimulus of that environment becomes his chief motivating force. Everything the protagonist does to try to reach the tangible objective, and everything any other character or characters do to try to prevent it, reveals something about the character of the protagonist and the participating characters.

Let us look at an example of this. Emma Bovary's response to the stimulus of her environment engages almost every aspect of her character: her dreams and longings for escape, her sullen withdrawal, her attempts to pretend that life can be endured if one does not think, her longing for religious weaponry to drive out her ardor. There is also her refusal of Leon at first through fear, her

growing impatience with her child, her increasing inability to manage her finances, her transformation through Rudolphe, and so on. This continuous conflict with her environment reveals a great deal about Emma's character.

2. True character can only be revealed by action. At the same time, the reader must be aware of the mental and emotional responses of the character prior to the action.

This is perhaps the most significant way of revealing character. It is not uncommon for there to be a great discrepancy between what a character thinks and feels and what he actually does. We may think and feel we would respond to a certain set of circumstances in a certain way only to discover when the chips are down that we cannot bring ourselves to do so. We may think and feel, for example, that if we saw a child at the upstairs window of a burning house we would dash into the house and try to save him. But should such an event occur we may well find ourselves so paralyzed with fright that we cannot move.

Our actions under such circumstances are controlled by impulse, fear, and reflection. If we act on impulse and dash into the burning house to try to save the child, we do not necessarily reveal that we are brave; we more than likely reveal an instability of character. If we stand paralyzed with fear instead of trying to save the little girl, we do not necessarily reveal cowardice. Perhaps our fear is not for ourselves, but for those we love. However, if we act upon reflection and overcome our fear, then we reveal ourselves to be truly brave. It is the nature of the reflection which precedes the action that indicates the truth of our character.

Let us look at an illustration of this from *The Spy Who Came in from the Cold*. Control expresses fear that the aging Leamas is "slowing down." The phrase in its context suggests that Leamas is acquiring an unwonted reflectiveness and tends to be overly concerned about people. In one of his spy missions, Leamas narrowly misses hitting a car containing four waving children in the back and a frightened father hunched over the steering wheel. Leamas experiences shock at the event—a nightmare vision of the smashed bodies of the children. This vision becomes a part of his memory, and it occurs at the very end of the novel when he is being shot. The impulsiveness of the dedicated spy has given way to the fear and shock of a man who reflects on the meaning of the individual.

Thus Leamas becomes capable of making his decision at the end to turn away from his own side and join the fallen Liz, to come in from the "cold."

Another example occurs in *From Here to Eternity* when Prewitt makes up his mind to kill Fatso. Prewitt has plenty of time to think about the consequences of his act but goes through with his plan when the opportunity presents itself. This reveals a great deal about his character.

3. Self-discovery and self-realization reveal character.

This is a corollary of principle 2. Here again, we reveal character by action, but add to it the ability of the character to judge himself. A soldier going into battle may think and feel that he is going to conduct himself bravely only to discover when the fighting starts that he is terrified and a coward. Conversely, a soldier may think and feel that he is a coward only to discover when the battle starts that he has courage he had not realized he possessed.

An illustration of this principle occurs in *From Here to Eternity* when Prewitt meets Maggio in the stockade. The grim discipline of the stockade has turned the mild and essentially harmless Maggio into a murderous, wolfish plotter and rebel. Prewitt becomes aware of this as he studies Maggio's face, and particularly the way Maggio grins. But Prewitt also becomes aware that in his own face a change is taking place: ". . . you started out to smile and it turned itself into this grin, stiff, wolfish, feverish, wild."

4. Motivated action reveals character.

This is a corollary of principles 2 and 3. When a character does something that is clearly motivated, it reveals something about his character. This principle for indicating character is widely used in all types of traditional novels.

Atticus Finch in *To Kill a Mockingbird* is motivated to defend Tom Robinson by his belief in the sanctity of the law and his strong desire to prevent a miscarriage of justice. In the action scenes that follow, including the trial, the reader learns a great deal about Atticus's character.

Tom Jones provides another illustration of this principle. When the infant Tom is first discovered in Allworthy's bed, Mrs. Deborah Wilkins wants the mother to be found out, sent to Bridewell, and publicly whipped. The infant itself, she thinks, should be set out

of doors. It is not bad weather, "only a little rainy and windy," and she even lays odds of two to one that the infant will live "till it is found in the morning." But Allworthy pays no attention to her speech. His finger has been seized by the baby's hand, and when he commands her to take care of the infant with food and clothes, she instantly obeys. Mrs. Wilkins is urged into this compliance, as Fielding makes us aware, by the thought that she holds an excellent job and should perhaps do as her master bids her. And by being thus motivated, she reveals her character.

5. Character tags help to characterize.

Character tags help to bring characters alive by isolating a dominant quality of character and repeating it. When a motive can be found behind the tag, the characterization will be all the more meaningful. For example, let us create a character who has the habit of cracking his knuckles. This adds to his identity by making him different from other characters:

> Frank began cracking his knuckles as his Aunt Edith entered the room.

But when we supply motivation to the character tag, we reveal a great deal more about the character:

> Frank began cracking his knuckles as his Aunt Edith entered the room *because he knew how much it annoyed her.*

Let us now look at the various types of character tags novelists use.

Physical Character Tags: In the first chapter of *To Kill a Mockingbird,* the author employs a physical tag to help characterize Charles Baker Harris, and by repetition of the tag isolates a dominant physical trait—*the seven-year-old boy is very small for his age.*

> Sitting down, he wasn't much higher than the collards.
> "You look right puny for goin' on seven."
> "Your name's longer'n you are. Bet it's a foot longer."

Appearance Character Tags: This type of tag is not associated with the physique of the character so much as with some aspect of

his appearance, usually determined by his clothes. *To Kill a Mockingbird* again provides an example; here the author employs an appearance tag to help characterize Miss Maudie.

> Miss Maudie hated her house: time spent indoors was time wasted. She was a widow, a chameleon lady who worked in her flower beds in an old straw hat and men's coveralls. . . .

In this example there is motivation behind the tag.

Mannerism Character Tags: In *From Here to Eternity,* the author uses a mannerism tag with motivation behind it to help characterize Warden. Milton Warden is quite conscious of his own separateness from and paradoxical identification with the Army, and he expresses this frequently by *grinning*.

> He [Warden] grinned down at the other, his brows hooked up his forehead.
> Warden grinned, it felt as if his face was cracking, and waited till he left.

Habit Character Tags: There is a self-conscious quality about a mannerism that is lacking about a habit which may be acquired, quite thoughtlessly, through the events of one's existence. This is evident in Charles's habit of falling asleep after eating in *Madame Bovary.* The motivation behind the tag is his lack of reflectiveness and interest in life when his appetite has been satiated.

> He [Charles] read . . . a little after dinner, but in about five minutes the warmth of the room added to the effect of his dinner sent him to sleep; and he sat there, his chin on his two hands and his hair spreading like a mane to the foot of the lamp.

Favorite Expression Character Tags: We all know people who have a favorite expression they use constantly. A maiden aunt who continually says, "For heaven's sake." A man who when told something exciting or interesting will always respond with, "You don't say." Novelists often employ a favorite expression to help characterize minor characters. We find Fielding doing this with Thwackum and Square in *Tom Jones.*

> In one point only they agreed, which was, in all their discourses on morality never to mention the word goodness. The favourite

phrase of the former, was the natural beauty of virtue; that of the latter, was the divine power of grace.

The motivation behind these favorite expressions is that both Thwackum and Square are mindful that they owe their board and lodging to the generosity of Squire Allworthy, and hence they try continually to impress upon him the fact that they are men of considerable principle and knowledge.

6. Emphasizing a single dominant character trait for minor characters helps to reveal character.

In a novel, there just is not room enough to make all characters, beyond the major ones, well-rounded. The novelist must content himself with emphasizing a single dominant character trait for minor characters. One prolific author of some forty-odd novels never gave a minor character a name until the final draft. During the writing he used a personal character trait instead of a name, for example, "Miss Fickle," "Mr. Loquacious," "Mr. Shiftless," and so on. This alerted him to emphasize the particular personal trait whenever any minor character appeared on the scene.

In *From Here to Eternity* we find continual emphasis on Maggio's quick temper. In *To Kill a Mockingbird,* the author refers repeatedly, by implication, to Boo Radley's shyness. When Boo Radley finally does appear on the scene, this single dominant character trait is stressed.

> . . . Atticus had not brought a chair for the man in the corner, but Atticus knew the ways of country people far better than I. Some of his rural clients would park their long-eared steeds under the chinaberry trees in the back yard, and Atticus would often keep appointments on the back steps. This one was probably more comfortable where he was.

The "man in the corner" and "this one" is, of course, Boo Radley.

7. Contrasting characters help reveal character.

By using contrasting characters, the novelist is able to strengthen those characteristics he wants to emphasize. For example, the *selfishness* of Blifil in *Tom Jones* accentuates the *unselfishness* of Tom himself.

Contrasts, however, do not always depend on extremes. Two

soldiers in a novel may both be brave, but the bravery of one is tempered by caution whereas the bravery of the other may be reckless. Two women in a novel may both be loyal, but the loyalty of one is a passionate, outspoken loyalty whereas the loyalty of the other is subdued and quiet.

One is impressed throughout *Madame Bovary* by the contrasting characters of Charles and Emma. Charles is torpid and indifferent; Emma is volatile, secretive, and full of visions. Charles is rooted to the familiar, the routine; Emma is impulsive, unmethodical, and flighty. Charles hardly ever sees colors, hears sounds, or responds to odors; Emma's senses palpitate. Indeed, Charles does not seem to have any emotional existence, whereas Emma is constantly under the attack of an emotional life that overwhelms her with its intensity. Charles is without ambition and would like to nest in the parochial life; Emma wishes to fly away to scenes of grandeur and luxury in the metropolis. Charles sees the externals of life as the fulfillment of existence; Emma sees those same externals as constituting a suffocating void. All these contrasts help to reveal a great deal about both their characters.

We find this principle for characterization used in almost all traditional novels. Other examples from the novels we have selected for study are: Atticus Finch and Bob Ewell in *To Kill a Mockingbird;* Captain Holmes and his wife, Karen, in *From Here to Eternity;* Tom and Blifil in *Tom Jones;* and Leamas and Liz in *The Spy Who Came in from the Cold.*

8. Names help to reveal character.

The selection of the right name helps to characterize since we form many kinds of associations with names. For example, the name Sally we usually associate with a wholesome American girl, no doubt as the result of a popular song. Daniel suggests strength, a Biblical association, as Ruth, also Biblical, suggests faithfulness. The name Harkness has a harsh sound, and in a novel we would use such a name for an unsympathetic character. One of Evelyn Waugh's minor characters, an American, in *A Handful of Dust* is named Souki de Foucauld-Esterhazy, a perfect name to carry out Waugh's intention to satirize the uprootedness of the American woman.

In the novels we have used for study, the name of Emma in

Madame Bovary is a common name given by her peasant parents and is meant to be ironic for a girl with so many inclinations toward the aristocratic. The name of Allworthy in *Tom Jones,* through its direct meaning as well as through its long vowel sounds, suggests the "all good" man, even-tempered and mild. The classic and patrician name of Atticus Finch is ranged against the plebian and sinister name of Bob Ewell in *To Kill a Mockingbird.* The epithet Dynamite for Captain Holmes in *From Here to Eternity* is an ironic one since Captain Holmes is not the dynamic individual such a name suggests though he seeks, of course, to be forceful. One of the minor characters of *The Spy Who Came in from the Cold* is named Fawley, a club man, a wearer of old school ties, a pontificator on athletes and their skills. Leamas regards him as a fool. And the name spoken aloud says just that.

9. Conflict reveals character.

This has been partially covered in principles 1, 2, 3, and 4. When a person comes into conflict with anything, including other human beings, the conflict generates an emotional response. Each complication in a novel that produces conflict tests and thereby reveals the characters of the participants,

For illustration of this principle, one has to read only the first few chapters of *From Here to Eternity.* Prewitt's transfer out of the Bugle Corps lands him in a situation where he is pressured to box although he has given up boxing. He wants simply to "soldier," but he is given sloppy and disgusting chores as his superior officers try to force him to box again. Throughout, his stubbornness, pride, defiance, self-reliance, and hardheadedness are revealed.

10. Moments of truth reveal character.

Unlike a short story which has only one moment of truth, a novel has many including one final moment of truth that supersedes all others, when "good" or "evil" is triumphant. For example, Prewitt in *From Here to Eternity* faces many moments of truth about himself, other characters, Army life, and so on during which he reveals something about his character, but the final moment of truth doesn't occur until just before his death. In this last moment of truth, the protagonist must face up to the truth about his relationship, and that of his group, to the life the novel has presented. It is at this point that the reader gains a sweeping impression about existence,

and this sweeping impression culminates in his penetration into the character of the protagonist.

Let us look at another example of how the moment of truth reveals character. In *The Spy Who Came in from the Cold*, Leamas experiences his final moment of truth at the Berlin Wall when he realizes that Control has duped him into making Mundt's position invulnerable. Then when Liz Gold is killed, Leamas understands that moment to have far-reaching implications about a life spent in bitter and remorseful ease, and he steps down from the wall toward death. Thus the moment of truth reveals that his character has become fully matured and responsible to intangible human values.

11. Confession reveals character.

This is an important principle for revealing character. In the character's confession about himself, we get a direct and very intimate revelation about his character. A classic example is Defoe's *Moll Flanders*. All first-person novels employ this principle to characterize. A reading of *To Kill a Mockingbird* shows this principle at work throughout, as Scout Finch confides many things about herself to the reader.

This principle is not confined to first-person novels, however. Novels employing the third-person viewpoint can employ this principle by having one character confess something to another character. For example, the things Reverend Jim Casy confesses to Tom Joad and others about himself reveal a lot about his character.

12. Giving a person a choice to make reveals character.

This principle has been covered somewhat by other principles but we wish to emphasize its importance in characterization. All traditional novels employ this principle. Tom Jones makes many decisions that reveal something about his character. The same is true of Prewitt in *From Here to Eternity*, Kino in *The Pearl*, the Joad family in *The Grapes of Wrath*, Scout and Atticus Finch in *To Kill a Mockingbird*, and Leamas in *The Spy Who Came in from the Cold*. Let us now look at one specific example of this principle from *Madame Bovary*. Very early in the married life of Emma and Charles, a way could have been found of solving Emma's problems through an exchange between herself and Charles that promised some kind of understanding.

If Charles had but wished it, if he had guessed it, if his look had but once met her thought, it seemed to her that a sudden plenty would have gone out from her heart, as the fruit falls from a tree when shaken by a hand. But as the intimacy of their life became deeper, the greater became the gulf that separated her from him.

Emma had, in those early days of her marriage, a choice to speak or remain silent. She chose to remain silent, and thus to this breakdown between them can be attributed the great conflicts of the novel. The choice Emma made revealed a character too easily intimidated by honest emotions.

13. Reveal character by exposition.

This is the most direct form of characterization, and novelists resort to it in those places where only exposition can be used. In the first chapter of *From Here to Eternity* we see this principle at work to help to characterize Milton Warden, who is not present in the scene.

> "Yeah?" Red said. "You think so? You know who the top kicker of George Co is?"
> "Sure," Prew said. "I know. Warden."
> "Thats right man," Red said. "Milton Anthony Warden. Who used to be our Staff in A Compny. The meanest son of a bitch in Schofield Barricks. And who hates you worse than poison."

14. Reveal character by description.

This principle brings the character home to the reader's senses. Here is an example from *To Kill a Mockingbird*:

> Miss Caroline was no more than twenty-one. She had bright auburn hair, pink cheeks, and wore crimson fingernail polish. She also wore high-heeled pumps and a red-and-white-striped dress. She looked and smelled like a peppermint drop.

15. Reveal character by narration.

An illustration of this principle may be found in *Tom Jones*. Doctor Blifil had plotted to have his brother, Captain Blifil, invited into the family of Squire Allworthy, where the good Captain could then proceed to bring Miss Bridget to marry him. Captain Blifil is characterized by narration in the following passage:

He [Captain Blifil] had purchased the post of lieutenant of dragoons, and afterwards came to be a captain; but having quarrelled with his colonel, was by his interest obliged to sell; from which time he had entirely rusticated himself, had betaken himself to studying the Scriptures, and was not a little suspected of an inclination to Methodism.

16. Reveal character by action.

It is obvious that the novel as a dense and compact form tends toward the use of action rather than narration to characterize, for it is essential that the reader see the details of character rather than the mere outline. Exposition, description, narration, and action rarely occur in pure form, but are intermixed with one another. The would-be novelist will find himself intermixing them, as the following example from *To Kill a Mockingbird* will illustrate:

> To our amazement, Reverend Sykes emptied the can onto the table and raked the coins into his hand. He straightened up and said, "This is not enough, we must have ten dollars."
>
> The congregation stirred. "You all know what it's for—Helen can't leave those children to work while Tom's in jail. If everybody gives one more dime, we'll have it—" Reverend Sykes waved his hand and called to someone in the back of the church. "Alec, shut the doors. Nobody leaves here till we have ten dollars."
>
> Calpurnia scratched in her handbag and brought forth a battered leather coin purse. "Naw Cal," Jem whispered, when she handed him a shiny quarter, "we can put ours in. Gimme your dime, Scout."
>
> The church was becoming stuffy, and it occurred to me that Reverend Sykes intended to sweat the amount due out of his flock. Fans crackled, feet shuffled, tobacco-chewers were in agony.

This action scene employing movement and dialogue is intermixed with exposition, description, and narration as it helps to characterize Reverend Sykes, the congregation, Calpurnia, Jem, and Scout.

As a summary of this chapter, we will ask the would-be novelist to consider what interests people most. The answer is human behavior. We will then ask him what controls human behavior. The answer is the general, physical, personal, and emotional traits of a person. The novelist must probe these traits, and the deeper he probes, the more well-rounded, the better developed, and the more three-dimensional his characters will be.

Exercises for Chapter 9

Part I

1. Write down the general traits of your protagonist.
2. Write down the physical traits of your protagonist.
3. Write down as many personal traits of your protagonist as you can think of.
4. What is the source of the character of your protagonist?
5. Write an action scene for your novel that reveals a side of your protagonist's character.
6. Write a scene for your novel in which you reveal a side of your protagonist's character by self-discovery or self-realization.
7. Write a motivated action scene for your novel employing what you learned in principle 4.
8. Write a physical character tag for one of your characters.
9. Write an appearance tag.
10. Write a mannerism tag.
11. Write a habit tag.
12. Write a favorite expression tag.
13. Emphasize a single dominant character trait for one of your minor characters using principle 6.
14. If you have not already done so, create a contrasting character to your protagonist employing what you learned in principle 7.
15. Do the names you have given your protagonist and other characters help to reveal character?
16. Write a scene in which conflict is present between your protagonist and another character that reveals something about the character of your protagonist.
17. Write a scene in which confession reveals character.
18. Create a situation for your novel in which the protagonist has to make a choice that reveals something about his character.
19. Reveal something about one of the characters in your novel by exposition.
20. Reveal something about a character by description.
21. Reveal something about a character by narration.
22. Reveal something about a character by action intermixed as taught in principle 16.

Part II

Study Chapter 5 of *The Grapes of Wrath* reprinted in Appendix III. Then answer the following questions.

1. What principles of characterization are employed in paragraphs 1, 42, 44–51 of this chapter?
2. Write down the general, physical, personal, and emotional traits of the owners of the land.
3. Write down the general, physical, personal, and emotional traits of the tenant farmers.
4. Write down the general, physical, personal, and emotional traits of the tractor driver. In what way are his traits being tested by his having become a tractor driver?
5. In what way does the problem of choice enter into the characterization of owners, tenants, and tractor drivers in this chapter?

10

How to Write the First Chapter of a Novel

At this point we are going to ask the reader to write the first chapter of his novel for the following reasons:

(1) To test his knowledge of what he has learned in the previous chapters.

(2) To acquaint him with the work expected of a novelist.

(3) To provide him with some of his own writing for appraisal by an instructor or for self-appraisal.

(4) To get him started on his novel.

(5) To put his subconscious mind to work on the project.

The most important of these reasons is to put the reader's subconscious mind to work. The subconscious mind is the writer's best friend. Given a project like a novel, the subconscious mind will work twenty-four hours a day for an author. While the conscious mind is writing the first chapter, the subconscious mind will be writing the second. It will reach out ahead of the conscious mind and create causally related events, complications, characters, situations, scenes, and so on, which it will release to the conscious mind when needed. Once an author has written the first chapter of a novel, the subconscious mind will not let him stop until the novel is finished—unless the subconscious mind rejects the project. In this case the author will know that his idea, intention, attitude, and purpose are not strong, clear, and meaningful enough to make into a salable novel.

We have never met a novelist who did not attach the greatest

importance to the subconscious mind. At any point in writing a novel where the author gets stymied, he should think about his problem just before going to sleep at night. It may take the subconscious mind just one day or several days to solve the problem, but the novelist knows that sooner or later the subconscious mind will release the solution it has worked out to the conscious mind.

We do not claim that the principles for structuring the first chapter of a novel presented in this chapter are used by all novelists. We do claim they apply to the majority of traditional novels published. If the reader of this book sincerely believes that he knows what he wants to say and how to say it in the first chapter of his novel, we would certainly encourage him to go ahead and write it that way. On the other hand, if the reader has any doubts about structuring the first chapter of his novel, we believe our suggestions will be of help.

The principles we will discuss depend very heavily on our analysis of the novel form that we made in the preceding chapters. The novelist has an idea that he subjects to scrutiny in terms of his intention, attitude, and purpose. This leads him to place his protagonist in conflict with his environment and to see that his protagonist has a chief motivating force that seeks some kind of tangible objective. In pursuing his motivating force, the protagonist will necessarily be brought into conflict with his own environment or the environment of others. The conflict concerns "good" and "evil"; and these terms are meaningful not as absolutes, but as principles the author himself believes in. The conflict of the protagonist with his environment may be on many different levels: physical, moral, cultural, psychological, economic, and so on.

In the conflict with his environment or the environment of others, the protagonist may be forced to accept the environment or adjust to it; he may attempt to escape from it and succeed; he may attempt to escape from it and fail; or he may attempt to escape from it and be destroyed. Whatever the resolution of this conflict, the protagonist will follow out a line of action in which his character either remains unchanged, as it does in a novel with a plot, or develops or disintegrates, as it does in a novel with a story line. In writing the first chapter of a novel with a plot, the emphasis should be placed on events happening to a stable character; in writing the first chapter of a novel with a story line, the emphasis should be

on character as it causes events to happen. The first chapter must pick up enough momentum to hold the reader's interest and keep the story moving.

This rapid summary, then, brings us to our first principle for structuring the first chapter of a novel.

1. The event outside the character of the protagonist that starts the chain of causally related events may or may not be presented in the first chapter. If not, this event should be presented no later than the second chapter.

Let us first take a very obvious example. In a murder mystery novel a murder is committed. This event is completely outside the character of the hero-detective because he had no knowledge of the murder until after it happened. The decision as to whether the initial event should come in the first or second chapter will depend on the author and his vision of his material. We will now apply this principle to some of the novels selected for study.

Madame Bovary: The event that starts the chain of causally related events is Charles Bovary's becoming a doctor of medicine, and it is presented in Chapter 1. This event is what brings Charles later to the farm of Emma's father—he has come to set her father's broken leg. As a result of this event outside the character of Emma, the protagonist, she and Charles meet, and this meeting triggers the causally related events that follow.

To Kill a Mockingbird: The event that starts the chain of causally related events is the arrival in Maycomb of Charles Baker Harris, whose nickname is Dill; Dill gives Scout and Jem the idea of trying to make Boo Radley come out. This event triggers the chain of causally related events pertaining to Boo Radley, culminating in his saving Scout and Jem from being murdered by Ewell near the end of the novel. The event is presented in the first chapter. Because we are dealing with two chief motivating forces and two tangible objectives in this particular novel, we also have an event later in the novel outside the character of Atticus Finch—Tom Robinson's arrest for rape. This event starts the chain of causally related events pertaining to Atticus, Tom Robinson, and the trial that follows.

From Here to Eternity: The initiating event is a strike by the coal miners in Harlan, Kentucky, during which Prewitt's father is imprisoned and his mother dies. As a result, Prewitt leaves home and later joins the Army as a career soldier. The event is presented

in the second chapter. If the event had not happened, Prewitt would probably have remained in Harlan and become a coal miner himself.

The Spy Who Came in from the Cold: In this novel the event that starts the chain of causally related events is not presented until Chapter 2. This event is Control's decision to plant Leamas as a supposed defector to the East as part of the complex plot to save the life of Mundt, the double agent. Leamas is completely unaware of the true purpose of Control's decision until near the end of the novel.

Tom Jones: The triggering event here is Tom's supposed birth as a bastard over which he had no control and which was therefore outside his character. This event does not occur until Chapter 3. However, Fielding's introductory chapters to each Book of *Tom Jones* are brief essays in which he sets forth his thoughts on the form of the novel, on human nature, on critics, and so on. Therefore, the event actually is presented in Chapter 2 of the novel proper.

There is a definite advantage for the would-be novelist, when possible, to present in the first chapter the event outside the character of the protagonist that triggers the chain of causally related events. This will enable him to see the initial stages of his protagonist's conflict with his environment and help give momentum for subsequent chapters.

2. Let the reader know what the setting is in the first chapter and set the scene or scenes for the specific action portrayed in the first chapter with an indication of conflict to follow.

Setting means, of course, the physical environment, but it may also function as a symbol of other physical environments if these are necessary in the novel. The protagonist may move from one physical setting to another. It is essential, therefore, that the conflict be implied in the setting as the novel begins. For example:

Madame Bovary: The first chapter of this novel is a rapid narrative summary bringing Charles Bovary from the age of fifteen to his manhood, when he has a profession, has married, and has begun his practice in a provincial town, Tostes. We can see in Charles the same kind of frustration of desires and narrowness of life that will later become the principal conflict of Emma. The settings are the city of Rouen where Charles is educated and the town of

Tostes where he practices after he has obtained his degree. The scene of the schoolroom which opens the novel gives a lasting impression of Charles's slowness of mind and passivity of character, and thus prepares the reader for the specific action that follows.

From Here to Eternity: The author lets the reader know in the first chapter that the setting is Schofield Barracks, an Army post in Hawaii. The opening scene of the first action is A Company barracks where the Bugle Corps is quartered. The scene then shifts to Choy's restaurant and later to the sallyport where Prewitt stops to contemplate. We see in the mixture of idealism, talent, and hardheadedness that characterize Prewitt in this first chapter an indication of the conflict to come.

The Spy Who Came in from the Cold: The setting is West Berlin, at the wall between the two Germanys. The opening scene is inside the hut at the checkpoint between the two zones. The scene shifts several times, outside the hut, in the car, back to the checkpoint, and ends in action as Karl is killed while trying to escape from East Berlin. The setting implies the Cold War, with an indication of conflict to follow.

To Kill a Mockingbird: The reader learns in the first chapter that the setting is the town of Maycomb in the Deep South. The scene for the first specific action is the backyard of the Finch home. The scene then shifts for the next action to the light-pole in the street near the Radley home. There is a strong indication of conflict to follow as the reader concludes that Scout, Jem, and Dill are not going to give up trying to find out what Boo Radley looks like.

3. The first chapter should contain at least one big scene where conflict is present.

This principle is a restatement of one aspect of principle 2. In *Madame Bovary,* the author employs one big scene in the first chapter—the conflict between Charles and the headmaster in the afternoon class session. In *From Here to Eternity* the one big scene in the first chapter is the argument between Red and Prewitt over the latter's decision to leave the Bugle Corps; in *To Kill a Mockingbird,* it is the conflict present between Jem and Dill. Almost the whole first chapter of *The Spy Who Came in from the Cold* consists of big scenes in which Leamas is in conflict with the CIA man and the German sentries, and in which the larger conflict between West and East is apparent.

The big scene in the first chapter serves two purposes. First, it satisfies the reader's appetite for immediate action. And second, any big scene reveals something about character, and therefore it helps to characterize. Reading any of the big scenes mentioned will reveal something about the character of the participants.

4. The first chapter should have at least one small scene to serve two purposes: to help to characterize, and to convey information to the reader that he must know in order to understand and believe that portion of the story in the first chapter.

In *Madame Bovary,* the novel begins with a small scene in which we are introduced to a "new fellow," a country bumpkin, whose awkwardness, earnestness, and dim intelligence in a classroom convey information to the reader about Charles Bovary. In *From Here to Eternity,* the author employs a small scene in Choy's restaurant to help to characterize Prew, Red, and Young Choy. In *The Spy Who Came in from the Cold,* a small scene occurs in the form of a flashback in Leamas's mind to the time when he discovered that Karl had kept a mistress to whom he revealed all their secrets. This information helps the reader understand the story and reveals Leamas as exceedingly "cold" in his attitude toward women. In *To Kill a Mockingbird,* Harper Lee uses a great deal of exposition and description in her first chaper—but one small scene occurs after the death of Mr. Radley, when Dill's curiosity about Boo leads him to ask all kinds of questions about him. This small scene imparts information and helps to characterize Scout, Jem, and Dill.

5. Introduce in the first chapter the protagonist or one or more of the leading characters and indicate their exact or approximate age and physical appearance.

For example:

Madame Bovary: Flaubert introduces one of the leading characters, Charles Bovary, and indicates he is "about fifteen" as the chapter opens and old enough to get married as the chapter ends. Flaubert describes Charles's appearance in some detail.

From Here to Eternity: Jones introduces the protagonist, Prewitt, with an indication of his approximate age: "a very neat and deceptively slim young man." The appearance and approximate ages of Young Choy, his father, and Red are also indicated.

The Spy Who Came in from the Cold: The author does not give Leamas's age or physical appearance until Chapter 2. The only indication of age is that Leamas and all the other characters presented in the first chapter are adults. It is not unusual in some mystery novels for an author to leave to the reader's imagination the ages and appearances of the leading characters introduced in the first chapter. This builds up suspense as to just what the characters do look like. It comes as a surprise to the reader later to learn that Leamas is about fifty, and that he is very self-possessed, muscular, and interesting-looking.

To Kill a Mockingbird: The author introduces in the first chapter the plural protagonist—Scout, Jem, and Atticus Finch—and also Calpurnia and Dill with exact ages or an indication of age, along with their physical appearance.

6. Let the reader know who is narrating the first chapter and whether the author is using restricted or unrestricted omniscient powers.

Madame Bovary: This novel is peculiar in that the viewpoint used in Chapter 1—the author intruding as a minor character-narrator using restricted omniscient powers—is not sustained throughout. This intrusion by the author is rarely used today. A contemporary novelist writing the same novel would begin with Chapter 2 using third-person shifting viewpoint narrators and unrestricted omniscient powers and would convey the information contained in Chapter 1 by means of flashbacks.

From Here to Eternity: The narrator in the first chapter is Prewitt, the author using unrestricted omniscient powers as he also enters into the thoughts and feelings of Red at times. As the novel develops the author employs third-person shifting viewpoint narrators and continues using unrestricted omniscient powers.

The Spy Who Came in from the Cold: Leamas is the narrator in the first chapter, with the author using restricted omniscient powers. Subsequently the author employs third-person shifting viewpoint narrators, the narrating being done not only by Leamas but also by Peters, Fiedler, and Liz Gold, with the restricted omniscient powers remaining constant.

To Kill a Mockingbird: Scout Finch is the narrator of the first chapter and the entire novel, with the author using restricted omniscient powers.

7. The use of exposition, description, and narration in the first chapter will depend on how much information about the story and the characters the author wants to reveal.

Madame Bovary: Except for the small and big scenes at the beginning of Chapter 1, the author employs considerable exposition, description, and narration to convey a great deal of information to the reader about Charles Bovary, his father, his mother, his home life, and his marriage to Madame Dubuc. This chapter is an excellent illustration of the achievement of a compact characterization. Flaubert had to imply a whole lifetime up to manhood in the character of Charles for the reader to see the error Emma makes in marrying him.

From Here to Eternity: Unlike Flaubert, Jones uses exposition, description, and narration sparingly in the first chapter because they are not needed for what he wants the reader to know.

The Spy Who Came in from the Cold: An even more extreme example of the sparse use of description, exposition, and narration is provided by the first chapter of this novel. Le Carré wanted to dramatize one particular event, the coming over to West Berlin of a spy, and to capture the taut expectancy of Leamas. This is all he wanted to convey to the reader in this chapter.

To Kill a Mockingbird: In this novel the author employs considerable exposition, description, and narration in the first chapter to give the reader the past history of the Finch family and their past and present environment, to make Maycomb seem like a real place, and to locate the Finch family within the web of Southern history.

Reading the first chapters of these novels will illustrate how exposition, description, and narration are controlled by the story the author wants to tell, as well as by his vision of his material.

8. If it is plausible, give the reader a clue as to the beginning of the time element of the novel in Chapter 1. If not, do this no later than Chapter 2.

Madame Bovary: Flaubert gives the reader a clue as to the beginning of the time element of the novel by informing him that Charles's father was "compromised about 1812 in certain conscription scandals" and married Charles's mother soon after. If Charles is fifteen when the novel begins and apparently was born

three or four years after his mother and father married and his father had gone through his fortune, the beginning of the time element of the novel is in the early 1830's.

From Here to Eternity: The beginning of the time element of this novel is not made known to the reader until Chapter 2 when it is established as 1936. It is probably 1937 when the events in the first chapter take place.

To Kill a Mockingbird: The beginning of the time element of this novel is indicated in the first chapter as follows: ". . . until well into the twentieth century, when my father, Atticus Finch, went to Montgomery to read law. . . ."

9. Catch the reader's interest in the first chapter by:

(a) Presenting the major complication.

(b) Presenting a minor complication that has some bearing on the major complication.

(c) Presenting a "plant" of interest to a reader.

(d) Arousing an interest in the protagonist's welfare.

This principle is to the novel what a narrative hook is to a short story. Let us look at some examples.

(a) In many mystery and adventure novels the major complication is given in the first chapter—a murder is committed, presenting the hero-detective with the major complication of trying to solve it. War novels also often employ this technique for capturing the reader's interest—for example, the hero-protagonist is faced with the major complication of trying to take an enemy position with his men. We also find it used in other types of novels, such as Taylor Caldwell's *Wicked Angel,* in which it is revealed in the first chapter that Angelo Saint is a psychopathic child; although his parents are blind to this major complication, the reader is aware of it.

(b) Presenting a minor complication that has some bearing on the major complication is another way to capture interest in the first chapter. In *From Here to Eternity* Prewitt is being transferred from the Bugle Corps in A Company because he strongly protested his superior officer's making a "young punk" first bugler over him. Had this minor complication not occurred, the major complication of the novel could not have happened. This principle is also used in *The Spy Who Came in from the Cold.* Karl is killed while trying to escape from East Berlin. Without this minor complication,

Leamas would not have been sent home in disgrace, and the major complication could not have happened to him.

(c) A "plant" in the first chapter serves two purposes. It arouses the reader's interest and also makes something that happens later on believable. For example, in Chapter 1 of *To Kill a Mockingbird,* the author plants in the reader's mind the idea that Boo Radley only comes out at night. This helps to make it believable to the reader in Chapter 28 that Boo Radley was the one who saved Scout and Jem as they were returning home at night from the Halloween party. The reader's interest is, of course, aroused by the mysteriousness surrounding Boo Radley, and the plant therefore serves in its own small way to keep the reader reading on to find out the answer.

It is true, of course, that plants may be unobtrusive and serve a function that may be understood only later on in a novel, well past the opening chapter. This occurs, for example, in *The Spy Who Came in from the Cold.* In the first chapter, we learn how brutally efficient Mundt is as head of the East German Abteilung since a number of agents used by England have been killed by Mundt—Paul, Viereck, Ländser, and Salomon—and we witness the death, as well, of Karl. This plant convinces the reader that Mundt is thoroughly unscrupulous and ruthless. The experienced reader of detective, mystery, or spy fiction knows that it is against such a foe the hero will be pitted in conflict. But it is not until the ending of the novel, with the sacrifice of Liz Gold and Leamas, that the reader becomes aware how coldly brutal the British spy network is since it will sacrifice many individuals in order to keep the double agent Mundt secure and undetected in his sensitive position in the East German spy system. The unobtrusive element of this plant in the novel, the fact that it later acquires a meaning quite different from the significance the reader first attaches to it, does not detract from the reader interest it first arouses.

(d) Arousing concern about the protagonist's welfare in the first chapter is an effective technique for catching reader interest. We find Fielding employing this principle in *Tom Jones* with his introduction of Tom to the reader; it would be a very hardhearted person, indeed, who would not be concerned about the abandoned foundling. The same principle is apparent in *From Here to Eternity.* Interest in Prewitt's welfare is aroused in the first chapter because the reader sees Prewitt as a young, talented, and sensitive

fellow whose values are going to be tested in the rough bureaucracy of Army life.

We come now to our final principle for structuring the first chapter of a novel.

10. In the first chapter, establish the type of novel you are writing from the tone or style of the prose.

While it is true that an author's individual style enters into this, novels of different types have typical "prose tones." By the tone, a reader will know whether he is reading a humorous novel, a satirical novel, a suspense novel, a juvenile novel, an adult novel, an adventure novel, a dramatic novel, and so on.

Madame Bovary: The tone and style of the prose in the first chapter indicate that this is to be a novel probing the social and psychological aspects of character by detailed and realistic observation. One expects literary rewards in reading it.

The Spy Who Came in from the Cold: The tone and style in the first chapter suggest this to be a novel of suspense and intrigue.

From Here to Eternity: Style and tone in the first chapter tell the reader that this is to be an adult dramatic novel that will appeal more to men than to women.

To Kill a Mockingbird: The tone and style in the first chapter indicate that although the novel concerns children, it is not a juvenile novel. The promise of childhood adventure is phrased in terms of a remembrance of early events, and the style adjusts to the deepening and rounding out of those memories.

We wish to conclude this chapter by again stating that what goes into the first chapter of a novel is going to depend on the author's material and his view of it. The principles and illustrations given here are meant only as guidelines for the would-be novelist who can't get his novel started because he has doubts about what should and what should not be included in a first chapter.

Exercises for Chapter 10

Part I

1. Write the first chapter of your novel if you haven't already done so.
2. What is the setting?
3. Who is the narrator?
4. Are you using unrestricted or restricted omniscient powers?

5. Are there indications of conflict to follow?

6. Have you indicated the ages and appearances of leading characters who are introduced in the first chapter?

7. Does the tone of the prose let the reader know what type of novel he is reading?

8. Do you have at least one big scene where conflict is present?

9. Do you have one or more small scenes that convey information to the reader and help to characterize?

10. Have you given the reader an indication of the beginning of the time element of your novel?

11. Did you use principles 9-a, 9-b, 9-c, or 9-d to catch the reader's interest? If you used more than one of these principles, explain why.

Part II

Skip the editorial Chapter 1 in *The Grapes of Wrath*. Study Chapter 2 where the actual story begins and answer the following questions.

1. How many settings does the author use and what are they?

2. Where does the opening scene take place?

3. How many narrators are there?

4. Does the author use restricted or unrestricted omniscient powers?

5. What age is indicated for the truck driver?

6. What age is indicated for Tom Joad?

7. Does the author describe the truck driver's physical appearance?

8. Does the author describe Tom Joad's physical appearance?

9. Is there conflict present in the scene between the waitress and the truck driver?

10. Is there conflict present in the first scene between the truck driver and the hitchhiker?

11. The scene inside the cab of the truck between the driver and Tom Joad conveys information to the reader about truck drivers. How much information is conveyed?

 (a) A great deal.

 (b) Very little.

 (c) Not too much.

12. The scene inside the cab of the truck begins as a small scene and ends as a big scene. Why is this so?

13. Which of the following principles for catching the reader's interest does the author employ?

 9-a

 9-b

 9-c

 9-d

11

How to Hold a Reader's Interest

All traditional novels employ certain techniques to hold the reader's interest.

A novelist knows he must first hold an editor's interest to get his book published. He also knows that if he does hold an editor's interest, the chances are good that he will hold a reader's interest as well. There are certain principles for doing just this which we will discuss and illustrate in this chapter.

In learning how to hold a reader's interest, the first question the would-be novelist must ask himself is which audience of readers he is trying to reach. Readers of novels make up groupings whose characteristics appear as follows. First, there is a small audience composed of critical, intellectual readers whose interest is in *nontraditional* experimental novels. In this book we are not concerned with this type of novel. Second, there is a medium-sized audience of readers with fine literary tastes who enjoy reading literary traditional novels. Third, there is a large audience composed of readers who read solely to be entertained and who therefore read popular traditional novels.

In this book we are dealing only with the *medium-sized* audience which reads literary novels and the *large* audience which reads popular novels. We will show in Chapter 15 how to choose between a literary and a popular novel. It is sufficient to state here that a would-be novelist lacking esthetic, intellectual, and literary qualifications has no business trying to write a literary novel. By the same

token if a would-be novelist does have these qualifications, he has no business trying to write a popular novel.

Here is our first principle for holding interest:

1. Each word, each sentence, each paragraph, each chapter in a novel must be directed solely at the audience the novelist wishes to reach. The language and style must be in harmony with the mind of the reader in that particular audience.

In other words, a novelist cannot write one chapter for a literary audience and the next chapter for a popular audience, altering the language and style throughout the novel. Obviously to do so would mean he would hold the interest of only a part of his proposed audience at a time. There are some literary novels that will attract not only a literary audience but a popular audience as well. All of the four literary novels we selected for study did this. *Madame Bovary* was one of the most widely read novels of the nineteenth century. *The Grapes of Wrath* and *The Pearl* have been read by millions of readers and still sell thousands of copies each year. *To Kill a Mockingbird* attracted a very large audience in both the hardcover and the paperback editions. There is no doubt that as people become more and more educated, the audience of readers of literary novels will grow.

One method of applying our first principle is to select an acquaintance belonging to the audience one wishes to reach and to direct every word in the novel to this person. This technique is successfully used by many novelists.

2. A "time bomb" in a novel is the presentation of a complication facing the protagonist which must be resolved within a certain period of time.

Consideration of the hackneyed use which has been made of the "time bomb" will make its operation clear. For example, in a Western novel, the fate of the wagon train depends upon the hero-scout's reaching a fort and getting help from the U.S. Cavalry. If the scout fails to return with the soldiers within twenty-four hours, all the people on the wagon train will be massacred by Indians. Or again, in a mystery novel, the fate of the protagonist depends on the wounded victim's recovering consciousness before he dies. He is the only person who can prove the protagonist's innocence. Or in a light romantic novel, the fate of a newly married couple de-

pends on their having a baby within a year. If they have a child, the hero will inherit a fortune under his grandfather's will. If they do not, the fortune will go to charity.

These are cliché "time bombs" that have been used in one form or another countless times. We find, however, that this principle for holding a reader's interest is employed in literary and popular novels published each year by novelists who, by giving it a new and fresh treatment, rescue it from being hackneyed.

In some novels the "time bomb" is the major complication, and the entire novel depends on it to hold interest. A classic example is *Robinson Crusoe* by Defoe. Can Robinson Crusoe survive on the island without dying or going insane before he is rescued? *The Spy Who Came in from the Cold* employs this principle. Can Leamas succeed in carrying out his mission for Control before his masquerade as a defector is discovered by East German Intelligence? And in *From Here to Eternity,* can Prewitt prevent his military environment from degrading him before it is too late to preserve his character? In this novel the "time bomb" goes off and the reader sees the result—the complete disintegration of Prewitt's character. A contemporary novel depending on a single "time bomb" to hold the reader's interest throughout is the best seller, *Fail-Safe,* by Burdick and Wheeler. Because of a mechanical failure, an American bomber loaded with nuclear bombs passes the point of no return—called Fail-Safe—and is on its way to drop the bombs on Moscow. If the plane cannot be turned back before it reaches Moscow, this will trigger a nuclear war between the United States and Russia. Can the plane be turned back? This question holds the reader's interest through the novel. The "time bomb" goes off as the protagonist and other leading characters fail in their efforts and Moscow is destroyed. To prevent a nuclear war with Russia the President of the United States agrees to destroy New York City with nuclear bombs dropped from one of our own planes.

Novelists also employ the "time bomb" principle for minor complications. In *Madame Bovary,* Emma has twenty-four hours in which to pay eight thousand francs to M. Lheureux; if she fails to do so by the end of this time, the "time bomb" will go off and all her lies to Charles will be revealed. In *From Here to Eternity,* Maggio has twenty-one to thirty days in which to keep up the pretense that he has gone crazy. If he breaks under Fatso's tormenting and admits he has been acting, the torture meted out to

him in the stockade will either kill him or *really* drive him insane. In *The Spy Who Came in from the Cold,* Leamas and Liz Gold are given exactly ninety seconds to climb over the Berlin Wall or they will be shot.

Closely associated with the "time bomb" for holding a reader's interest is the following principle:

3. The reader is either directly or indirectly promised that exciting, dramatic, interesting, or important things are going to happen in the novel if he just keeps on reading.

The promise may be a direct one as in this example from *Mamma's Boarding House* by John D. Fitzgerald.

> "You've made this a personal thing between you and me," Youngman said. "The next time you set foot in this town be sure you are wearing your gun."
> Beeler laughed as if being threatened by a schoolboy. "I'll not only be wearing my gun, but I'll send word to you when I'm coming," he said.

The reader is made a direct promise that if he keeps on reading he will witness this gunfight.

Let us now look at just a few of the many times this principle is used in the following novels. In *To Kill a Mockingbird* there is a *direct* promise to the reader that Bob Ewell will attempt to get back at Atticus Finch. In *Tom Jones,* there is an *indirect* promise that somehow the real mother of Tom will be revealed. In *From Here to Eternity,* the reader is given a *direct* promise that Prewitt is going to try to kill Fatso. This principle is used several times in all the other novels we have selected for study and in all traditional novels.

4. Preventing the chief motivating force from reaching its tangible objective helps to hold a reader's interest.

We have discussed and illustrated this principle in Chapter 3.

5. Ending a chapter so that it leads dynamically into the next chapter helps to hold a reader's interest.

Let us examine two illustrations of this principle from the many that occur in the novels we have selected. At the conclusion of Chapter 10, Book V, in *Tom Jones,* Tom is surprised in dalliance

with Molly Seagrim by Thwackum and Blifil, and Tom darts forth from the bushes to head them off so that they will not be able to discover just what girl he is concealing. The reader has to continue to see the battle that is going to ensue and to find out if Tom can successfully prevent them from learning whom he is protecting. In *The Spy Who Came in from the Cold,* the second chapter concludes with the plot Control has for Leamas. Leamas must act as if he had been discredited and were "over the hill" so that he can be cashiered from the service and apparently defect to the East. The reader cannot help but wonder whether or not Leamas will be able to keep up the pretense, and if he does, how he will do it. These questions force the reader on to the next chapter.

6. In certain types of novels, the incredible can be made believable to hold the reader's interest.

James Hilton's *Lost Horizon,* the novel about Shangri-La where everyone remains young for hundreds of years, is a good example of the use of this principle. It is, of course, impossible to provide an example of this principle in any of the novels we have selected for study since they all purport to describe the real world with fidelity and truthfulness.

7. The subject matter of certain types of novels helps to hold the reader's interest.

Let us examine some of the types of traditional novels whose appeal is partially gained from their subject matter.

Controversial Novels: Choosing a subject that will force readers to take sides helps to hold interest. Readers who are for or against something the author is either for or against will certainly read the novel with sustained interest. Since conflict is inherent in all traditional novels, one might say that it is characteristic of the traditional novel to be controversial. Some novels are mildly, or partially, or totally controversial. The type of controversy varies widely. *To Kill a Mockingbird* is controversial because it attacks Southern bigotry, *From Here to Eternity* because it condemns the peacetime military system, *The Spy Who Came in from the Cold* because it attacks the cold-blooded sacrifice of human life by all nations engaged in espionage, *Madame Bovary* because it opposes the nineteenth-century march of scientific and technical progress. Even *Tom Jones*

can be said to be a controversial polemic against kinds of religion that tolerate and even encourage selfishness. The controversial is at the very heart of many great novels—Twain's *The Adventures of Huckleberry Finn* attacks the institution of slavery, James's *The Princess Casamassima* attacks the Philistine, Hardy's *Jude the Obscure* attacks, among other things, the social conventions that mutilate the individual, particularly those involved in marriage.

Topical Novels: Using subject matter of great public interest at the time of publication cannot help but hold a reader's interest. A novel may be both topical and controversial, as were *To Kill a Mockingbird, From Here to Eternity, The Spy Who Came in from the Cold,* and *Madame Bovary.* Public interest creates reader interest in topical novels. For example, *The Last Hurrah* by O'Connor was published during an election year; *The Blackboard Jungle* by Hunter came out at a time when our juvenile crime rate was soaring; *Another Country* by Baldwin appeared in the midst of great racial unrest in this country.

Romance Novels: A very popular type, mainly written by women for women readers—though one suspects clever male writers may author some of them—is the romance novel. Often set in exotic locales, they deal with the enduring theme of the discovery and courtship of a mate. A popular line of romance novels is the Harlequin Books series, with such writers as Roberta Leigh and Emma Richmond. A famous novelist of the genre who does a lot of historical research for her works is Barbara Cartland.

Novels about Sex: These are known in the trade as "literary shockers" and depend on sex to hold a reader's interest. A classic is *Lady Chatterley's Lover* by D. H. Lawrence. Contemporary novels of this type include *Peyton Place* by Metalious, *Lolita* by Nabokov, and *One Hundred Dollar Misunderstanding* by Gover.

Historical Novels: These are novels using subject matter that is partly historical fact and partly historical fiction. They appeal to quite a large audience. Examples are *Gone with the Wind* by Mitchell, *Northwest Passage* by Roberts, and *Julian* by Vidal.

Humorous and/or Satiric Novels: These novels use subject matter of a humorous or satirical nature. Examples are *Auntie Mame* by Dennis, *Catch-22* by Heller, and *The Tunnel of Love* by De Vries.

Religious Novels: There are two types of religious novels. One uses real characters from the Bible and weaves a story around them that is a mixture of fact and fiction, for example, *The Robe* by Douglas and *Song of Ruth* by Slaughter. The other type portrays religious people created by the author; examples are *The Edge of Sadness* by Edwin O'Connor and *The Violent Bear It Away* by Flannery O'Connor.

Escapist Novels: We include in this type adventure, mystery, Western, and light romantic novels which hold a reader's interest by satisfying his longing to escape from his everyday life. In some respects, *From Here to Eternity* is an adventure escapist novel and *The Spy Who Came in from the Cold* a mystery escapist novel.

Science-Fiction Novels: This type of novel has a built-in reader interest for those who enjoy the fantastic and imaginative. Novels for study include those by H. G. Wells, Isaac Asimov, and Ray Bradbury.

Novels Dealing with the Soil or the Sea: Novels dealing with the soil have special interest for readers closely associated with the land, but have a general appeal as well. *The Good Earth* by Pearl Buck and *Harvest* by Jean Giono are examples. Novels dealing with the sea hold a great deal of interest for many readers. A classic example is *Moby Dick* by Melville; a contemporary one, Hemingway's *The Old Man and the Sea*.

Juvenile Novels: There are a great many categories of juvenile novels, each of which is geared to the interests of readers of a particular age group.

Horror Novels: These are novels written to shock, terrify, and hold a reader's interest through suspense. A well-known classic is *Dr. Jekyll and Mr. Hyde* by Stevenson.

Novels of Atmosphere: This type of novel is relatively rare today because when characters, situations, and scenes are subordinated to the atmospheric setting, it is difficult to hold a reader's interest. Hudson's *Green Mansions* is an example for study.

Thematic Novels: There is a heavy dependence on theme to hold interest in this type of novel. A classic example is Thackeray's *Vanity Fair,* which is a historical novel as well. More recent examples are *The Pit* by Norris and *Room at the Top* by Braine.

Psychological Novels: These novels appeal especially to readers who are interested in psychology. *Crime and Punishment* by Dostoevsky is a classic example.

Biographical Novels: In these novels the authors weave a partly factual and partly fictional story around characters from real life. What holds the reader's interest here is his awareness that he is reading about a real person. *Lust for Life* by Irving Stone, which is a biographical novel about Vincent Van Gogh, is an example for study.

Autobiographical Novels. Here again, the reader's interest stems from the fact that he is reading about real people. As we pointed out, many traditional novels embrace more than one of the types we have mentioned. For example, *To Kill a Mockingbird* is an autobiographical novel but it is also a controversial and topical novel. *From Here to Eternity,* although written in the third person, is an autobiographical novel; it is also a controversial novel and was a topical novel when published.

We wish to emphasize that a great many novels cannot be limited to one particular type because the subject matter may embrace several of them. For example, *The Grapes of Wrath* was both a controversial and topical novel at time of publication, and it is also a thematic novel and a novel dealing with the soil. Such a novel has a much wider potential audience than one whose subject matter limits it to one type.

We also want to point out that all traditional novels are thematic in the sense that they all have a theme. We have isolated thematic novels only because there is a heavy dependence on theme in this type of novel to hold the reader's interest.

We have excluded episodic novels, picaresque novels, and experimental novels from our list because they are not traditional novels.

8. In some novels the presentation of interesting ideas about life, people, and art help to hold the reader's interest.

Some novelists use their novels as embodiments of ideas that are interesting to the reader. Maugham's nineteenth-century stoicism is modified by his views of the absurd universe; his many remarks throughout his novels show a fascination with the nature of the universe and man's place in it. Conrad attacked idealism, as Maugham did, and found the romantic tending to put all his eggs in one basket. Mann studied the genesis of the artist in bourgeois society. Malraux took as his protagonist the intellectual who had grown weary of the life of the mind and decided to thrust himself into the world of action.

In the novels we have selected for study we find many interesting observations about life, people, and art. *Tom Jones* gives us at the beginning of each Book a running commentary on the nature of novel writing. *To Kill a Mockingbird* is a fascinating study of the manners and mores of tribalism in the Deep South. *Madame Bovary* paints a precise and comprehensive picture of provincial French life in the 1840's. *From Here to Eternity* is an analysis of the kinds of men who live in a bureaucracy. *The Spy Who Came in from the Cold* unmasks a shadowy region, the world of international intrigue, and because it seems so lifelike, the novel gains tremendous interest for the reader.

9. The chief way to hold a reader's interest in a novel is to have plausible and structured characterization.

Novels with a story line use this principle to great advantage. A reader cannot help but be interested in the development or disintegration of character. Making a reader sympathetic toward the protagonist helps to hold his interest because he *cares* about what is going to happen to the protagonist. Conversely, making a reader dislike or hate a character will keep him turning pages to find out if the character gets his comeuppance. Plotted novels also employ this principle; although the emphasis here is on events, the characters who participate in the events are important to the reader.

The key to plausible characterization is giving the reader sufficient insight into the character to make what he says and does

believable. A character is plausible when he secures our belief, and once he secures our belief he holds our interest. In *Madame Bovary,* everything that happens to Emma is plausible because Flaubert has given the reader insight into her character and into the characters of Leon, Rudolphe, and Charles. The same thing is true of the protagonists and leading characters in all the other novels we have selected for study, and in all effective traditional novels.

It is not enough merely to motivate a character's behavior in a novel to secure plausibility—the motivation must be strong enough to give direction, to dislodge action and reaction, to point toward eventualities. *Structured* characterization is one in which the chief motivating force of the protagonist grips the reader and consequently holds his interest. Will the chief motivating force succeed in reaching its tangible objective or will it fail? Will the protagonist succeed in overcoming the opponents, obstacles, and disaster facing him or will they succeed in overcoming him? Within these two questions we find structured characterization which helps to hold a reader's interest.

10. Of the four forms of prose composition—exposition, description, narration, and action—action (movement and dialogue) is the most important for holding a reader's interest in a novel.

We do not mean to scant the importance of the other three forms of prose composition, all of which have their proper and important usage in novel writing, as discussed in previous chapters. However, because action permits a reader to participate vicariously in the novel, his interest is much greater and easier to hold than when information is conveyed to him (exposition), his five senses are appealed to (description), or he is told something (narration). That is why we find contemporary novelists striving for action on almost every page. The reader of this book would do well to remember this in writing his novel. When reading the two contemporary novels we have selected for study, *To Kill a Mockingbird* and *The Spy Who Came in from the Cold,* we find movement or dialogue or both on every page. We find them on almost every page of the other novels selected, with the exception of *Tom Jones.*

In this discussion of holding a reader's interest, we have omitted one principle, and that is style. A colorful writer, a writer whose

observations are vivid and fresh, whose language awakens dormant sensibilities, will command the respect and hold the interest of many readers. The subject of style in writing is important enough to deserve a separate chapter. We will discuss and illustrate how to develop your own style of writing in Chapter 15.

Exercises for Chapter 11

Part I

1. What audience are you trying to reach with your novel?
2. Do you have a friend who represents that audience?
3. Can you honestly say that you are qualified to write for that audience?
4. Is your major complication a "time bomb"? If so, state why.
5. In the portion of your novel you've written so far, have you used the "time bomb" principle for any minor complications?
6. Did you employ principle 5 ending your first chapter?
7. Did you make any direct or indirect promises to the reader in Chapter 1 of your novel as discussed in principle 3?
8. Which of the different types of traditional novels discussed in principle 7 is your novel?
9. Do you have any interesting ideas about life, people, or art that you intend to incorporate into your novel?
10. Are your leading characters plausible and structured?
11. Is there action on almost every page of your first chapter?
12. Write the second chapter of your novel.

Part II

1. Why is the major complication in *The Pearl* a "time bomb"?
2. Why is the trek to California by the Joad family in *The Grapes of Wrath* a "time bomb"?
3. Which of the following audiences was Steinbeck trying to reach with *The Pearl*?
 (a) A small audience of critical, intellectual readers.
 (b) A medium-sized audience of readers with fine literary tastes and judgments.
 (c) A large audience which reads solely to be entertained.
4. In the first chapter of *The Pearl,* the author uses a "time bomb" complication. What is it?

5. In what paragraph of Chapter 4 of *The Grapes of Wrath* does the author employ principle 5?

6. In what way does the description of the pearl when Kino finds it follow principle 3?

7. Name three ways in which Kino's chief motivating force is prevented from reaching its tangible objective in *The Pearl*.

8. Halfway through *The Pearl*, after the night attack on Kino's house, Juana cries to him to throw the pearl away since it will eventually destroy them. Kino refuses. What principle is the author using to hold the reader's interest?

9. Ignoring the chapters that function as editorials in *The Grapes of Wrath*, how much action do you find in the other chapters?

 (a) Very little action in some chapters.

 (b) Action on almost every page.

 (c) Action on an average of about every third page.

12

How to Employ Craftsmanship: Part I

All traditional novels use regional or universal material.

We will begin this chapter with a discussion of the element of structure given above. There are novels that are called "regional novels" and those that are called "universal novels." Whether a novel is one or the other depends on the material the author is using.

Regional novels employ settings that are located in one particular region (locale) and events that could happen only in that one particular region during a certain time in history.

The Grapes of Wrath is a regional novel. The settings are confined to the United States, and the events that happen in the novel could have happened only in the United States during the 1930's. *To Kill a Mockingbird* is a regional novel because the setting is confined to the Deep South and the events in the novel could have happened only in this particular region during a certain period in history.

Universal novels employ settings that are located in one particular region (locale), but they are similar to settings in many places in the world. The events in universal novels could happen in many places in the world at almost any period in history.

Madame Bovary is a universal novel because the settings of the small provincial French villages are similar to settings in many places in the world. The settings could be small New England villages in the United States, for example, and the events that take place could take place in these small New England villages. Emma could have married a stuffy New England physician and taken on two young American lovers. *The Pearl* is a universal novel because the setting of the small fishing village is similar to many fishing villages all over the world, and what happened to Kino could happen to any pearl fisherman in any country at any time. *Tom Jones* is a universal novel because the settings in rural England and London could just as well be in France and Paris, for example, and what happened to Tom could happen to any young man who is good-natured and generous to a fault in any country, at any time. *From Here to Eternity* is a universal novel because the setting could be any peacetime army base in almost any country in the world, and what happened to Prewitt could have happened to any soldier during the past century. *The Spy Who Came in from the Cold* is a universal novel because espionage is so widely practiced.

We wish to emphasize that we have used the terms regional and universal only as they apply to settings, events, and periods of time. A regional novel may have a theme or a significance that is universal. *The Grapes of Wrath* is regional but deals with the plight of the have-nots in the face of the haves, and as the novel progresses, it takes on universal significance: that the brotherhood of man must transcend the isolation of mankind into opposing groups. *To Kill a Mockingbird* is regional but concerns itself with the universal theme of racial tolerance and justice, and with the universal development of children as they learn to carry on the best attributes of humanity.

Obviously novels we have called universal can also be universal in theme. *Madame Bovary* is universal in theme because the adultery of Emma goes against precepts that have been a part of most civilizations. The question of illegitimacy is no longer so pressing as it was in the day of *Tom Jones*. But the fact that an impulsive goodheartedness may lead a young man into evil is a universal theme in this novel. The universal problem of evil is the theme of two of the other novels selected for study. In *The Pearl* the evil is the greed inherent in all men; in *From Here to Eternity* it is the brutality exhibited by the military.

1. In writing a novel using regional material for settings, events, or periods of time, strive for regional impact. In writing a novel using universal material, strive for universal impact.

The author should attempt, in the regional novel, to make the setting or settings of the region as authentic as possible, the events which take place in that setting characteristic and revealing of the locale, and the period accurate in terms of historical and cultural facts. We are constantly aware of this kind of authenticity when we read such novels as *The Grapes of Wrath* and *To Kill a Mockingbird.*

In the universal novel, *Tom Jones,* notice how Fielding constantly emphasizes the social aspect of the environment over its strictly physical aspect. Fielding describes universal human nature in its deceitfulness, its selfishness, and its humor.

We come now to a principle of craftsmanship that is closely related to the use of regional and universal material, and that is panorama.

2. Employ panorama to acquaint the reader with the general aspects of a setting, place, thing, or situation instead of the strictly specific.

In using this principle the author himself enters into the novel either bluntly or subtly by letting the reader know what the general aspects are of a setting, place, thing, or situation. Panorama is an overall omniscient view. Here is an example from *To Kill a Mockingbird:*

> The shutters and doors of the Radley house were closed on Sundays, another thing alien to Maycomb's ways: closed doors meant illness and cold weather only. Of all days Sunday was the day for formal afternoon visiting: ladies wore corsets, men wore coats, children wore shoes. But to climb the Radley front steps and call, "He-y," of a Sunday afternoon was something their neighbors never did. The Radley house had no screen doors. I once asked Atticus if it ever had any; Atticus said yes, but before I was born.
>
> According to neighborhood legend, when the younger Radley boy was in his teens he became acquainted with some of the Cunninghams from Old Sarum, an enormous and confusing tribe domiciled in the northern part of the county, and they formed the nearest thing to a gang ever seen in Maycomb. They did little,

but enough to be discussed by the town and publicly warned from three pulpits: they hung around the barbershop; they rode the bus to Abbottsville on Sundays and went to the picture show; they attended dances at the county's riverside gambling hell, the Dew-Drop Inn & Fishing Camp; they experimented with stump-hole whiskey. Nobody in Maycomb had nerve enough to tell Mr. Radley that his boy was in with the wrong crowd.

Panorama is important in fiction because it enables the author to avoid the narrow specifics and concentrate on an environment's general qualities. Thus the author using panorama tends to see his characters as the representatives of a wide variety of social, cultural, economic, historical, or political forces, or ideas. He need not do so, but can evoke—if he wishes—a place, or a period, in its varieties of amusements or customs; but the general rather than the local and concrete will be evident through his use of plurals and compound words, his avoidance of naming specific characters, or his covering rapidly a stretch of time. We have seen an illustration of panorama in a regional novel. Let us now look at an illustration from *Tom Jones,* a universal novel.

One situation only of the married state is excluded from pleasure: and that is, a state of indifference: but as many of my readers, I hope, know what an exquisite delight there is in conveying pleasure to a beloved object, so some few, I am afraid, may have experienced the satisfaction of tormenting one we hate. It is, I apprehend, to come at this latter pleasure, that we see both sexes often give up that ease in marriage which they might otherwise possess, though their mate was never so disagreeable to them. Hence the wife often puts on fits of love and jealousy, nay, even denies herself any pleasure, to disturb and prevent those of her husband; and he again, in return, puts frequent restraints on himself, and stays at home in company which he dislikes, in order to confine his wife to what she equally detests. Hence, too, must flow those tears which a widow sometimes so plentifully sheds over the ashes of a husband with whom she led a life of constant disquiet and turbulency, and whom now she can never hope to torment any more.

But if ever any couple enjoyed this pleasure, it was at present experienced by the captain and his lady. It was always a sufficient reason to either of them to be obstinate in any opinion, that the other had previously asserted the contrary. If the one proposed any amusement, the other constantly objected to it: they never

> loved or hated, commended or abused, the same person. And for
> this reason, as the captain looked with an evil eye on the little
> foundling, his wife began now to caress it almost equally with her
> own child.

In this passage, Fielding comments on the institution of marriage
from a panoramic view, selecting one example to illustrate exposi-
torily what must apply to a great many married couples. He then
further applies this to the situation between Captain Blifil and his
wife. Again, we see the author using panorama as a device to
show a wide variety of social or cultural forces at work.

We stated previously that in panorama the author can enter the
novel bluntly or subtly. In the example from *Tom Jones,* the
author enters bluntly by addressing the reader directly and ex-
plicitly. This kind of panorama was appropriate in Fielding's time
but contemporary authors avoid it, and enter the novel subtly,
as in the example of panorama from *To Kill a Mockingbird.* The
two examples also point up the difference in panorama when used
in a regional novel and in a universal novel. In the regional novel,
To Kill a Mockingbird, the panoramic view confines itself to the
region with great exclusiveness. In the universal novel, *Tom Jones,*
though the panoramic view uses regional details, it tends always
to generalize upon them and establish the possibility for universal
comparison.

Let us now move on to another element of craftsmanship in
novel writing—*situation. Webster's Seventh New Collegiate Dic-
tionary* defines a situation as the "relative position or combination
of circumstances at a certain moment; a critical, trying, or unusual
state of affairs; a particular or striking complex of affairs at a stage
in the action of a narrative or drama." This is a very satisfactory
definition but we will underscore an element or two of it. The
proper stress in the definition will be obtained if one thinks of a
situation in terms of the issues involved in it rather than in terms
of the fact that it can be defined as momentary. A situation grows
out of the circumstances of life—the collision of circumstance in,
let us say, a man's falling in love with a pretty young woman, her
growing disenchantment with sex, his need for consolation and
contact, her beginning to turn frigid and uncommunicative, his
mounting frustration and anger, her negation of him, his becom-
ing involved with another woman, and so on. At any given moment
in this development, there will be a combination of the circum-

stances of their lives, but obviously what moment one chooses to look at will determine whether such a combination of circumstances can be called ordinary, stressful, unusual, critical, or explosive. This brings us to a principle:

3. A novelist conceives a situation and then breaks it down into exposition, description, narration, and action.

A novelist thinks in terms of situations first. Often a situation will provide the material for a whole chapter. For example, let us assume we are writing a novel about a business tycoon named Frank Cheever, who is forty-three years old, who is married, and who has teenage children. We may well conceive a situation for the novel such as the following: *In the next chapter I am going to have Frank Cheever take as a mistress a girl almost twenty years younger than he is.* Here is a situation that if broken down into exposition, description, narration, and action will make an exciting and interesting chapter provided that we employ the following principle:

4. A novelist must supply the motivation for everything his characters say and do.

The chief motivating force of the protagonist supplies most of the motivation for what the protagonist says and does, and it is primarily directed toward the tangible objective. Let us say that Frank Cheever's chief motivating force is *a determination to build himself a financial empire with the tangible objective of taking over the companies of his competitors.* This has nothing to do with his wanting to take on a mistress. Before writing this chapter we must employ the following principle:

5. To break down a situation into exposition, description, narration, and action, answer the following questions.

(a) *Who* are the characters involved in the situation?
(b) *Where* does the situation take place?
(c) *What* is the main event during the situation?
(d) *When* does this event happen?
(e) *Why* does this event happen?

These are known as the five W's of a situation. Let us now put the principle to work:

(a) The characters involved are Frank Cheever, his wife, Nora, and a girl named Ann Fields who becomes Frank's mistress.

(b) The situation takes place in Frank's home, his office, some meeting place with Ann Fields, and in the apartment he rents for her.

(c) The main event of the situation is Frank Cheever's taking as a mistress a girl twenty years younger than he is.

(d) The situation occurs in the time period of the next chapter.

(e) *Why* does the event occur? This is the key question. We must make the situation believable to the reader by supplying the motivation for it. We can't just say that Frank is oversexed because that would be out of character according to what the reader knows about him. We know that Frank is a strong, virile man. The mere fact that he would want a mistress strongly suggests that his sex life with his wife leaves something to be desired. If we make his wife, Nora, a frigid woman to whom the sexual relationship has become simply a wifely chore without pleasure or joy, and who consequently gives no pleasure or joy to Frank, we have supplied a strong enough motivation for him to take a mistress. But we must now supply the other half of why this event occurs and give the reader a believable motivation for Ann Fields to agree to become Frank's mistress. We could, for example, make her one of Frank's employees—a girl on the make, who wants wealth and position and believes her becoming Frank's mistress will lead to a divorce and to her becoming Mrs. Frank Cheever. The reader would accept this motivation.

By applying principle 5 to the situation, we are now able to visualize the information we will have to convey to the reader by exposition, by description, by narration, and most of all by action. We know from just reading our answers that we will need a scene between Frank and his wife, Nora, to show their unhappy sexual relationship and the wife's frigidity. We know we will need a scene in which Frank communes with his conscience. We know we will need a scene to portray how physically attractive the girl is to Frank and her apparent awareness of this. We know we will need a scene, perhaps in a small restaurant, where Frank propositions Ann to become his mistress and she agrees. We know we will need a scene in the apartment he rents for a love nest where they have their first sexual relationship with each other. And in between these scenes we know we will use exposition,

description, and narration to convey information the reader must know about the situation, to describe the physical attractiveness of the girl and her feelings and his feelings about the matter, and narration to point up the motivation in both as needed to make this a complete chapter.

We cannot stress enough that most novelists first think in terms of a situation and then break it down as we have done with this example.

Let us apply this principle to the first chapter of *From Here to Eternity*.

Situation: The protagonist, Prew, a peacetime soldier, is being transferred from the Bugle Corps of A Company to Company G.

(a) *Who* are the characters involved? Prew, a friend named Red, Young Sam Choy, and his father.

(b) *Where* does the situation take place? At Schofield Barracks in Hawaii, in Company A barracks, and at Choy's restaurant.

(c) *What* is the main event during the situation? Prew's being transferred to G Company.

(d) *When* does this event happen? In the first chapter.

(e) *Why* does this event happen? Prew's superior officer, Chief Bugler Houston, made a "young punk" First Bugler of the Bugle Corps over Prew. Prew, believing himself to be the best bugler in the Corps, is motivated into protesting this show of favoritism and Chief Bugler Houston has him transferred.

By applying the five W's to the situation, the author breaks it down into exposition, description, narration, and action. Rather than portraying the argument between Prew and Chief Bugler Houston in a big scene, he chooses to bring it out with exposition in a scene between Prew and Red.

Thus far we have concerned ourselves only with situations that can be made into a complete chapter. A situation can also be employed as just a portion of a chapter. When an author has a larger design for the chapter than to use one situation for it, he can compress the situation. A good example of this occurs in *Madame Bovary* in Chapter 6 of Part I.

This chapter concerns Emma's religious education. The chapter swiftly recapitulates Emma's early years, from the age of thirteen to the time when, tired of convent life, she is back home "disillusioned, with nothing more to learn, and nothing more to feel." It is mentioned in the chapter that the nuns notice "with

great astonishment that Mademoiselle Rouault seemed to be slipping from them." This situation is developed in one paragraph, and the paragraph ends with the reflection of the Lady Superior, after Emma has been taken home by her father, that Emma "had latterly been somewhat irreverent to the community." No one has been sorry to see Emma leave. Another author might have devoted a whole chapter to this situation instead of just a paragraph within a chapter.

In the foregoing examples, we have been discussing motivation only as it applies to situations. The general principle for motivation is this:

6. The motivation for everything a character says and does in a novel must be established in the reader's mind.

Here is an example from a student's novel in which this principle was ignored:

> "Is Diane Stevens coming to your party?" Helen asked.
> "I invited her," Sally replied.
> "Then I'm not going," Helen said. "I don't like her."

In this example the motivation for Helen's not going to the party is established, but the motivation for her not liking Diane Stevens is not. Failure to employ principle 6 in writing a novel results in puppets and not believable characters.

Let us now look at an example of the use of this principle from *The Spy Who Came in from the Cold*. Leamas is apparently defecting to the East. Kiever, one of the London contact men for East German Intelligence, has picked Leamas up and is making the arrangements for Leamas's defection, but he hides the whole thing under the pretense that Leamas is being asked to sell his story to an "international feature service" that will pay such good money for it that Leamas can retire. Leamas has to provide a motivation for his defection that will convince Kiever that he is sincere.

> Christ, they're rushing their fences, Leamas thought; it's indecent. He remembered some silly music hall joke—"This is an offer no respectable girl could accept—and besides, I don't know what it's worth." Tactically, he reflected, they're right to rush it. I'm down and out, prison experience still fresh, social resentment strong. I'm an old horse, I don't need breaking in; I don't have to pretend they've offended my honor as an English gentleman.

On the other hand they would expect *practical* objections. They would expect him to be afraid; for his Service pursued traitors as the eye of God followed Cain across the desert. And finally, they would know it was a gamble. They would know that inconsistency in human decision can make nonsense of the best-planned espionage approach; that cheats, liars and criminals may resist every blandishment while respectable gentlemen have been moved to appalling treasons by watery cabbage in a departmental canteen.

"They'd have to pay a hell of a lot," Leamas muttered at last. Kiever gave him some more whiskey.

Now there are certain places in a novel where it is impossible for the author to let a character explain the motivation for what he says and does. This is particularly true in novels using a restricted viewpoint. The following principles are used by novelists where this happens:

7. When the motivation for what a character says and does cannot be established by the character himself, let the viewpoint narrator speculate about the motivation.

In the student's example we used above, Sally is the narrator. Let us put this principle to work as Sally speculates about Helen's motivation for not liking Diane Stevens.

> Sally couldn't blame Helen for not liking Diane. Helen had been practically engaged to Tom Warren before Diane came to town. Sally knew that Tom had been seeing more and more of Diane and less and less of Helen during the past two months.

Let us now look at an example of this principle from *To Kill a Mockingbird*. Here Jem speculates on the motivation for Atticus's not helping fight the fire when Miss Maudie's house burns down.

> In a group of neighbors, Atticus was standing with his hands in his overcoat pockets. He might have been watching a football game. Miss Maudie was beside him.
> "See there, he's not worried yet," said Jem.
> "Why ain't he on top of one of the houses?" [Question by Scout]
> "He's too old, he'd break his neck." [Jem speculating]

8. When the motivation cannot be revealed without faulty exposition, let a character simply ask what the motivation is.

Again going back to our student's example, let us apply this

principle after Helen tells Sally she won't attend the party because she doesn't like Diane.

> "Why don't you like Diane?" Sally asked.
> "Because she is trying her best to take Tom Warren away from me," Helen answered.

Here is an example of this principle from *To Kill a Mockingbird*. Scout Finch learns that her father is going to defend the African-American, Tom Robinson. She cannot understand his motivation for wanting to do this.

> "If you shouldn't be defendin' him, then why are you doin' it?" [Question by Scout]
> "For a number of reasons," said Atticus. "The main one is, if I didn't I couldn't hold up my head in town, I couldn't represent this county in the legislature, I couldn't even tell you or Jem not to do something again."

9. There are certain times when an adverb or an adverbial phrase can be used to establish the motivation.

Here is an example of each:

> "I don't drink," he said belligerently.
> "I don't drink," he said, accenting the word *don't* as if he believed that anybody who did drink had to be a drunkard.

We must caution the would-be novelist to use adverbs and adverbial clauses sparingly. The novelist strives to make what the character says express the motivation for saying it. The reason for this is that a repetition of the adverbial form down a page or two quickly attracts attention to itself, and the reader will have lost the sense of imagined experience through a mannerism of style. Here is an example from *From Here to Eternity* of an author using this principle but using it sparingly:

> "When I do," Prew grinned *tautly,* "you won't have no time to take your shirt off."
> "Talk is big," Bloom said, still pulling out his shirt.
> Prew started for him, would have hit him while his arms were still tangled in the shirtsleeves, but Maggio stepped in front of him.
> "Wait a minute. You'll only get yourself in trouble." He opened his arms in front of Prew. "This is over me, not you. Just

take it easy now." He talked *soothingly*, doing for Prew now what Prew had done for him a while ago, still holding his arms outspread.

Prew stood *passively*, his arms hanging straight against his sides now, relaxed. "All right," he said, feeling ashamed now for the cold murderousness that had been in him, for the wild ecstasy, wondering what it was in Bloom that made men want to smash him. "Take your arms down," he said to Maggio, "for Christ's sake. There ain't nothing going to happen."

"That's what I figured," Bloom said, sticking his shirt back in and buttoning it, grinning *triumphantly* as if the stopping of the fight had been his personal victory.

"Take off," Maggio said *disgustedly*. [Italics added.]

In the next chapter we will discuss and illustrate additional techniques of craftsmanship in novel writing.

Exercises for Chapter 12

Part I

1. Does the novel you are writing employ regional or universal material?
2. If regional, explain why you believe it to be regional.
3. If universal, explain why you believe it to be universal.
4. If regional, what regional impact are you striving for?
5. If universal, what universal impact are you striving for?
6. Have you used panorama in your novel so far?
7. What is the situation in your first chapter?
8. Break the situation down using principle 5.
9. Can you see ways of improving your first chapter after breaking the situation down?
10. Is the motivation for the main event in the situation clearly established?
11. Is the motivation for everything the characters say and do in your first chapter established in the reader's mind?
12. Can you improve upon these motivations by employing the principles on motivation in this chapter?
13. Count the adverbs or adverbial clauses in your first chapter and decide if you have used them sparingly.
14. Write Chapter 3 of your novel.

Part II

1. State the situation in the first chapter of *The Pearl* in a single sentence.

2. State the situation in the second chapter of *The Grapes of Wrath* in a single sentence.

3. Break down the situation in the first chapter of *The Pearl* using principle 5.

4. Break down the situation in the second chapter of *The Grapes of Wrath* using principle 5.

5. Is panorama used in the first chapter of *The Pearl?*

6. Is panorama used in the first chapter of *The Grapes of Wrath?*

7. What was the motivation for the truck driver's not wanting to give Tom Joad a ride in the second chapter of *The Grapes of Wrath?*

8. What was the motivation for the doctor's refusing to treat Coyotito's scorpion bite in the first chapter of *The Pearl?*

9. Which of the following motivations moved the truck driver to talk so much during the ride in the truck with Tom Joad in the second chapter of *The Grapes of Wrath?*
 (a) To pass the time.
 (b) To brag about himself.
 (c) Curiosity about Tom and where Tom came from.

13

How to Employ Craftsmanship: Part II

In this chapter, we will discuss a number of important techniques of craftsmanship that usually belong to the stage in novel writing called revision, after the first draft of the novel is completed. A careful, thoughtful revision of the first draft is essential for most novels, even those of some of our greatest novelists.

1. Revision in novel writing means rewriting any portion of the first draft that can be improved.

There are a few novelists whose first draft becomes their final draft but they are the exception. The great majority of novelists admit that they revise their novels, sometimes extensively, anywhere from one to as many as thirty times. Hemingway cited this latter figure to indicate the difficulty the last few pages of *A Farewell to Arms* gave him before he was satisfied with the final draft.

2. The amount of revision needed is going to depend on the critical ability of the author.

This is a key principle. To be a good writer, one has to be an excellent critic of what one writes. First of all, the novelist should go over his work carefully to correct errors in grammar, spelling, and punctuation. True, a copy editor at a publishing house will do this if the novel is accepted. But the chances for acceptance are better without errors of this sort in the manuscript.

Revision, however, means far more than just correcting any such errors—it means the use of one's critical powers to judge the whole

work. One should always lay aside the first draft for three or four weeks to give the conscious and the subconscious mind time to think about it before beginning a revision. When the author does this, he will find himself making notes on the margins of some of the pages of the first draft on how to improve the work. He will also begin to see the manuscript as a whole, and he will once more revisit his idea, intention, attitude, and purpose, this time with a leverage that he did not previously have.

At the end of the waiting period, the author will not only have the marginal notes he has made, but he will also discover as he begins to read each sentence and paragraph of his first draft that his subconscious mind has been at work, and he will find himself making additional marginal notes. Here are a few examples of the marginal notes on the first draft of a novel that later became a best seller:

Faulty exposition. Rewrite.

Scene drags. Cut it.

Motivation weak. Make stronger.

Kill this action scene. Put into narrative.

Good scene. Build it up.

Prose awkward. Rewrite.

Protagonist's dialogue out of character. Rephrase.

Chapter rambles and is overwritten. Tighten.

Dialogue stiff. Rewrite.

Faulty exposition. How would she know this? Rewrite.

Lousy transition. Revise.

Chance for big scene here. Change from narrative to action.

3. Make every word count.

All novelists with few exceptions overwrite the first draft of their novels. This is not apparent to the author at the time, but it will become very obvious to him after the waiting period when he begins revising. The second draft of a novel is the place to become very objective about one's work, cutting from it any portion that doesn't advance the story. An author will usually find that he has done some sermonizing and editorializing in his first draft that must be cut. Any portion of a novel in which it seems as if the author were "sounding off" about anything should be cut. The only people in a traditional novel who have the right to

"sound off" are the characters. Now we realize, because we have written novels of our own, that every author falls in love with his own writing. It therefore becomes almost painful for an author to be strictly objective about his own work. But no matter how much in love a writer is with his own writing, he will know which words should be cut after the waiting period. If he is honest and sincere, he will prune all unnecessary words during revision.

4. Accept cheerfully and even gratefully all revisions suggested by an editor.

Of course, such a principle does not mean that the editor is always right, but the purpose of this book is to help the reader get his first novel published. The time to argue with an editor, if there is any need, is after an author has established himself. It is an editor's job to accept and prepare for publication novels that he believes will be profitable for his company. He is therefore primarily interested in publishing a novel that he believes, based on his experience, will appeal to a large enough audience of readers to make money. Editors are the most objective readers in the world. They will find flaws in a novel that an author, condemned to subjectivity, will not see at all. There must be confidence on the part of the author of any first novel that any editorial recommendations for revision made by an editor are for the sole purpose of improving the novel. That is why before an editor will accept a novel for publication which he believes needs revision, he will contact the author or the author's agent and inquire if the author would be willing to make the revisions. The author can then say yes or no. If he says yes, his novel will be published. If he says no, it only means that the next editor is probably going to see the same flaws in the novel and refuse to accept it unless the author agrees to the revisions.

We will now turn to a discussion of how to avoid clichés in novel writing.

5. A cliché in a novel is anything trite and hackneyed.

The word *cliché* in French means either a photographic negative or a stereotype plate by means of which the same image can be reproduced countless times. In the novel, a cliché can refer to the whole or its many parts. The plot or story line of a novel can be

trite and hackneyed because it has been used so many times before. The same is true of a situation and of a scene. A novel as a whole can be a cliché. A chapter can be a cliché. A paragraph can be a cliché. A word can be a cliché.

A novel loaded with clichés has "the kiss of death" as far as its ever being published is concerned. But it is impossible for a novelist to avoid clichés in the first draft because he is so anxious to finish it. The time to worry about avoiding clichés is during revision.

For two thousand years prior to the seventeenth century, it was not a part of the artistic canon that poets, minstrels, or writers create new stories as a mark of their artistry. Folk tales and myths were the common property of everyone, and stories had their origins in the distant past. However, with the invention of the printing press, the extension of literacy, and the excitement of expanding economic opportunities, the emphasis slowly came to be placed upon a writer's craft. Readers and publishers alike demanded that the writer create something original and fresh. As novelists began to experiment and to learn from each other, they developed certain principles for avoiding clichés. These principles were refined and improved upon until today we find all traditional novelists using them. Let us now look at these principles.

6. When the plot or story line is predicated upon a twice-told tale, create original situations with fresh complications within the framework of the major complication, and update the story to lift it out of the cliché class.

As an illustration let us take the twice-told tale of the faithless wife who commits adultery, which dates back to the time of the ancient Greeks. Flaubert took this tale, and by creating original situations and fresh complications, and by updating it to his own time and place, wrote the much acclaimed *Madame Bovary*.

7. Avoid a cliché plot or story line by creating a major complication around something new in the present that did not exist in the past. Within the framework of this major complication, create probable contemporary minor complications.

This is the principle used by the author of *The Spy Who Came in from the Cold*. The Cold War is something new in the present that did not exist in the past, around which the author created the major complication and probable minor complications.

8. Avoid a cliché plot or story line by creating a major complication around some event that has happened in one particular region at one particular time.

John Steinbeck used this principle for *The Grapes of Wrath;* he wove a story around the dust bowl of the 1930's and the people it affected. This principle was also used in *To Kill a Mockingbird.*

9. Avoid a cliché plot or story line by creating a major complication that exposes something about people and life that is not generally known to readers, or by exposing something about life and people that has been taboo in the past.

From Here to Eternity is a good example of the first part of this principle, as it exposes things about the life of a peacetime soldier that nobody but a peacetime soldier would know. The second part of this principle concerns novels that treat such previously taboo subjects as homosexuality and lesbianism, as well as novels that attack religions and other institutions that have been considered above reproach.

10. Write your novel believing that you have something original and interesting to say.

This is the most important principle of all for avoiding a cliché plot or story line. We discussed in Chapter 1 the sources for ideas that inspire novelists. We also gave the reader the principles for developing his idea into a novel and for testing it. If his idea passed the test, he should have been able to avoid a cliché plot or story line.

Let us now assume that the would-be novelist has the first draft of a novel which he knows doesn't have a cliché plot or story line. The next step is to make certain his novel doesn't contain any cliché situations.

11. To avoid cliché situations in a novel with a story line, make them result from the dominant character traits of the characters involved. To avoid cliché situations in a novel with a plot, create situations that illustrate the dominant character traits.

Let us first look at a couple of examples from novels with a story line. In the first chapter of *From Here to Eternity,* the situation is that Prew, a peacetime soldier, is being transferred from

Company A to Company G. The situation results from Prew's idealism, his stubbornness, and his pride, and hence the transfer interests the reader rather than repels him because of its triteness. In *To Kill a Mockingbird,* a situation occurs when a number of unidentified men, as well as a few who are named, come to the jail to lynch Tom Robinson. The children, primarily through Jem's insistence, sneak to the jail and witness the possibility of Atticus's being attacked. Scout steps forward, without really knowing the situation, and through the dominant character traits of childish naïveté and sense of duty, she gets one of the men to remember his obligations to Atticus. The lynch mob fades away. The situation caused by the traits of bigotry and hatred for the black man among the lynch mob is resolved by character traits we have seen at work in Scout, and hence Miss Lee avoids triteness.

In *Tom Jones,* a plotted novel, Fielding creates a situation revealing the dominant character traits of Tom when Tom saves Mrs. Waters from attack. Her disarray in dress arouses his amatory instincts, and he carries through her salvation by taking her to the Upton Inn, where despite his better judgment, he goes to bed with her. Of course, this becomes known to Sophia later, and we have one fresh instance of Tom's nature and his goals working comically at cross purposes. The situation reveals Tom's dominant character traits, and Fielding successfully exploits its comic qualities without descending into the hackneyed.

Up to this point we have been discussing clichés as they apply to plot or story line or to situations. Let us now look at clichés as they apply to characters.

12. A stereotype is a character whose character traits have been reproduced countless times in fiction without variation.

The reader should have no trouble recognizing stereotypes because of his familiarity with them. There is the love-them-and-leave-them hard-boiled private eye, the society girl out for a thrill, the beautiful but aging woman seeking a young man for a lover, the bewhiskered, tobacco-chewing old prospector, the innocent victim whom the villain uses to try to escape, the hypochondriac forever taking pills, the criminal who swears revenge upon the officer who arrested him or the judge who sentenced him, and so on. You can see these stereotypes on television all the time. A stereo-

type can be used in a novel but only when the type itself is germane to the story. However, as a general rule, novelists should avoid stereotypes, and there are certain principles for doing so.

13. Avoid a stereotype by creating an opposite.

John Steinbeck employs this principle with Reverend Jim Casy in *The Grapes of Wrath*. The stereotyped traveling preacher would be an individual out to convert everyone with threats of hell and damnation for those who did not come forth and give themselves to the Lord. We have seen this stereotype many times in motion pictures and on television, and have often encountered him in fiction. Steinbeck avoided using a stereotype by creating an opposite in Reverend Jim Casy—a preacher who had come to question his beliefs, who did not want to pray as he used to, who did not try to convert anyone, and who did not even want to be a preacher.

14. Avoid stereotypes by making characters conventional.

Conventional behavior is that produced by custom, habit, routine, or social mores. The stereotype character is usually an exaggerated type who owes more to fiction than to real life. For every love-them-and-leave-them hard-boiled private detective there may be in real life, you will find several dozen who are married, have children, own their own home, and are devoted husbands. If you need a private detective as a minor character in a novel, the latter is much preferable to the former. Conventional characters, the kind you know in real life, are much more realistic in the roles of minor characters than stereotypes. This doesn't mean that the novelist shouldn't try to make his minor characters more interesting than in real life. For example, the private detective who is a devoted husband can also be a racing-car enthusiast. In *From Here to Eternity*, there are many conventional Army career characters but the author has made each one of them more interesting than in real life by giving them distinctive character traits.

15. Avoid stereotypes by drawing upon your own experience with people you have met.

This is the best principle of all because it assures the author that his characters will not be stereotypes. During our lifetime, we meet and observe many different kinds of people. In writing

your novel, when you need a doctor as a minor character, use the doctor you most remember; when you need a schoolteacher, use the schoolteacher who stands out in your memory, and so on. Then ask yourself why you remember this doctor or this schoolteacher more than others. The answer will provide you with some character trait you found in them that will make them more interesting to the reader than people in real life.

We come now to clichés in language. The would-be novelist is going to find many of these in his first draft. If the reader has any doubts as to what a cliché in language is, he can consult a list of clichés which almost any college English textbook will have.

Clichés in description are usually the most common type of clichés found in the first draft. Here are some examples from students' novels:

> Her eyes were *limpid blue.*
>
> The *golden moon* shone above.
>
> He was *tall, dark, and handsome.*

A cliché in dialogue should be readily apparent to the would-be novelist. For example:

> *"Better late than never,"* Jim said as he met Helen in the restaurant.
>
> *"Come hell or high water,* I won't go," Pete said.

A cliché in narrative should also be familiar to the beginning novelist. Note the following:

> He was *at a loss for words* as he watched her walk away.
>
> She knew it was like *wishing on a star.* . . .

This brings us to two principles for getting rid of clichés in description, dialogue, and narration.

16. Delete the cliché.

For example:

> Her eyes were blue.
>
> The moon shone.
>
> "I won't go," Pete said.

17. Delete the cliché and rewrite.

For example:

> He was a tall man with dark eyes and a face that attracted the attention of women wherever he went.

> "Sorry I'm late," Jim apologized as he met Helen in the restaurant.

> He stood there trying desperately to think of something to say as he watched her walk away.

> She knew it was hopeless.

There are times, however, in novels when clichés are permissible.

18. Clichés are permissible when used to characterize a character or a group.

When a character has a favorite expression that he uses frequently enough for it to become a character tag, then the expression, cliché or not, may be used. For example:

> "It's dollars to donuts it won't rain," Sam said.

> "It's dollars to donuts he won't be on time," Sam said.

A cliché that is in common usage by a group is permissible. For example, teenagers use slang clichés such as, "He's a cube." This cliché would be permissible in a novel about teenagers. And often people living in a certain region use native cliché expressions such as "Y'all" in the Deep South, and "Nary a one," in northern New England. Then there are clichés that are used only by persons within a particular profession—soldiers, sailors, truck drivers, advertising executives, prize fighters and fans, and so on. When a cliché helps to characterize a member of a profession or a fan, it is permissible to use it in a novel.

The following two principles tell how to eliminate the too frequent use of characters' names:

19. Avoid the too frequent repetition of characters' names in a scene by omitting the names as long as the reader can tell who is talking by the dialogue paragraph breaks.

This principle will also help eliminate the overfrequent use of "he said," "she said," and so on. Let us first look at an example

from a student's novel in which the principle was ignored. The scene is in a lawyer's office between Frank Halsy, the attorney, and a friend of his named Louis Young.

> "Why do you want a divorce?" Frank asked.
> "I can't take it anymore," Louis answered.
> "Take what?" Frank asked.
> "Everybody in town knows Helen is having an affair with Steve Conley," Louis answered.
> "I didn't know," Frank said.
> "Then you are the only one who didn't," Louis said.

Now let us apply our principle to this example and identify the speakers just once.

> "Why do you want a divorce?" Frank asked.
> "I can't take it anymore," Louis answered.
> "Take what?"
> "Everybody in town knows Helen is having an affair with Steve Conley."
> "I didn't know."
> "Then you're the only one who didn't."

20. Avoid frequent repetition of a character's name by identifying the character by a pronoun, by a nickname, by his profession, by his appearance, or by his nationality.

As an example of this principle, James Jones identifies the protagonist in *From Here to Eternity* as Robert E. Lee Prewitt, Prew, he, a soldier, a bugler, a boxer, and by appearance several times: ". . . a very neat and deceptively slim young man in the summer khakis that were still early morning fresh."

During revision of the first draft the author should employ this principle whenever the repetition of a character's name begins to grate on his nerves. Just how often this will happen will depend a great deal on the novel itself. For example, we find Flaubert in *Madame Bovary* identifying the protagonist only as Emma, she, and Madame Bovary.

We come now to another stage in revising the first draft. Almost all novelists admit that bridging time with transitions is difficult, so the first novelist is in good company.

21. A transition is used to bridge a lapse of time in the novel or to move from one scene to another, or both.

Two of the most glaring weaknesses in making transitions found in students' novels are:

(a) Making the transition so abrupt it jars the reader.

(b) Making the transition so long it bores the reader.

Let us first look at an example of (a).

> Harry thought for sure he would get the promotion to Assistant General Manager when old man Irving retired. But he knew when he saw Jim come out of the President's office smiling that Jim was the new Assistant General Manager of the company. He watched the other employees in the office gather around Jim to congratulate their new boss. He knew he had to join them.
>
> Harry knew he was drunk but didn't care as he sat at the bar in Riley's Cocktail Lounge.
> "Give me another double," he said to the bartender.

In this example the reader is in the office with Harry and perhaps feeling sorry that Harry didn't get the promotion, when abruptly and without warning, the reader finds himself with Harry in a bar.

Let us now look at an example of (b).

> Bill knew it was absolutely necessary to see Attorney Dobson as soon as possible. He told his secretary to take all calls. He put on his coat and hat and took the elevator down to the first floor. He left the building and walked to the taxi-stand on the corner. He got into the cab and gave the driver Dobson's address. It took the driver twenty minutes to reach their destination. Bill paid the driver along with a quarter tip. He then entered the building and took an elevator to the sixth floor. Dobson was waiting for him when he entered the attorney's office.

The reader is certainly going to become very bored reading all these useless details.

There is a principle for avoiding both (a) and (b) in making transitions.

22. To avoid an abrupt or long transition, give the reader a clue that the transition is going to take place so that he can anticipate the time lapse or change of scene, or both.

Let us apply this principle to example (a). We will repeat only the last sentence of the first paragraph.

> He knew he had to join them *but as soon as it was over he was going down to Riley's Cocktail Lounge and get drunk.*

Harry knew he was drunk but didn't care as he sat at the bar in Riley's place.

"Give me another double," he said to the bartender.

Let us now apply this principle to example (b).

Bill knew it was absolutely necessary to see Attorney Dobson as soon as possible. *He telephoned the lawyer and was told to come right over.*

Dobson was waiting for him when he entered the attorney's office.

The above examples illustrate making transitions through narration. The principle also applies to dialogue. We will illustrate this using our two examples.

He knew he had to join them. He walked over and waited his turn.

"Congratulations, Jim," he said as they shook hands.

"Thanks, Harry," Jim said, still smiling.

Well, it was over. He had done what was expected of him. He started for his locker. Pete Forester touched his arm.

"Tough break, Harry."

"You can't win them all," he said, forcing a smile to his face.

"Where are you going? You're not quitting, are you?"

Harry shook his head. "No, Pete. *I'm just going down to Riley's and get stinking drunk.*"

Harry knew he was drunk but didn't care as he sat at the bar in Riley's place.

"Give me another double," he said to the bartender.

Let us now look at example (b) using dialogue to make the transition.

Bill knew it was absolutely necessary to see Attorney Dobson as soon as possible. He pushed down the intercom on his desk.

"Margie," he said to his secretary, "see if you can set up an appointment for me with a lawyer named Hugh Dobson right away."

"Yes, sir," his secretary's voice came over the speaker.

He felt nervous as he waited although it couldn't have been more than a couple of minutes before Margie came into his private office.

"Mr. Dobson will see you at once," Margie told him. *"He is waiting for you in his office."*

Dobson was seated behind his desk as a secretary ushered Bill into the lawyer's private office.

Here is another principle for making transitions in a novel:

23. Do not be afraid of using standard phrases in bridging time.

All novelists realize that it is impossible to write a novel and telescope the time element without using standard phrases to bridge time. You will find such standard phrases as the following in any novel you read:

> The next morning . . .
> A week later . . .
> Several months passed . . .
> Ten minutes later he arrived at . . .
> The summer passed quickly for . . .

Let us now look at some examples of standard phrases for bridging time from some of the novels selected for study.

> Six weeks passed. Rudolphe did not come again.
> (*Madame Bovary*)

> On the following day, Leamas arrived twenty minutes late for his lunch with Ashe. . . . (*The Spy Who Came in from the Cold*)

> It was barely the middle of March, hardly ten days since Holmes had first brought him the papers, that the transfer of the Fort Kamehameha cook came back. . . . (*From Here to Eternity*)

> Next morning she began earlier than usual, to "go over our clothes." (*To Kill a Mockingbird*)

We will end our discussion of craftsmanship with three more principles, the first two concerned with increasing the illusion of reality and the last with the achievement of unity.

24. To increase the illusion of reality in a novel, employ accurate objective facts.

This is a principle every would-be novelist should consider carefully before beginning a novel. It is astonishing how many students try to write novels they are completely unqualified to write because objective facts are unknown to them or they do not spend the necessary time in research to make the objective facts accurate.

To increase the illusion of reality in a novel, the author must have at his command all the facts about places, processes, appearances, prices, colors and all of the other things he puts into his novel.

Here is an excellent example of an author (James Jones in *From Here to Eternity*) employing accurate objective facts to increase the illusion of reality:

> He also remembered how it was up there, where they were going. He had been up there last year with the 27th during range season. He remembered the tents pitched over the concrete foundations, the standing in line for chow with mess kits in the mud, he remembered the waiting on the ready line in the fleece padded shooting jackets made from old CKC blouses, the smell of burnt cordite and the ringing ears and the carbon sight blackeners that smudged up everything and the two or three privately owned BC scopes of the top notch shooters, he remembered all of it, the heavy clinking dull glittering unexpended cartridges in the hand, the long deadly streamline disappearing of a cartridge slipped into the chamber with the thumb when you were firing. . . .

Only someone familiar with the range experiences of an infantryman could have written this. The would-be novelist must be qualified by personal experience or research to employ accurate, objective facts in writing a novel.

25. To increase the illusion of reality in a novel, employ accurate emotional facts.

Here are some examples of this principle:

(a) Direct statement about emotion:

> After the ennui of this disappointment her heart once more remained empty, and then the same series of days recommenced. (*Madame Bovary*)

(b) Indirect statement about emotion:

> They were three full, exquisite days—a true honeymoon. They were at the Hotel-de-Boulogne, on the harbour; and they lived there, with drawn blinds and closed doors, with flowers on the floor, and iced syrups were brought them early in the morning.
> Towards evening they took a covered boat and went to dine on one of the islands. It was the time when one hears by the side of the dockyard the caulking-mallets sounding against the hull of vessels. The smoke of the tar rose up between the trees;

there were large fatty drops on the water, undulating in the purple colour of the sun, like floating plaques of Florentine bronze. (*Madame Bovary*)

(c) Fact plus emotion:

Miss Caroline walked up and down the rows peering and poking into lunch containers [Fact], nodding as if the contents pleased her, frowning a little at others [Emotion]. (*To Kill a Mockingbird*)

He swung his leg over the side and dropped lithely to the ground [Fact], but once beside his son he seemed embarrassed and strange [Emotion]. (*The Grapes of Wrath*)

Prew, as he dressed for town with the twenty in his pocket [Fact], felt the degradation of Turp's foul breath still on him that a shower would not wash off . . . [Emotion]. (*From Here to Eternity*)

26. Unity in the traditional novel is the impact of all that the novel contains in terms of idea, experience, emotion, and theme.

An author must have a reason for wanting to write a novel. This reason is the result of his idea, which leads him to his statement of purpose. The experience the reader undergoes vicariously must be interesting and exciting enough to hold his interest. The novel must communicate enough emotion to the reader to make the characters and story believable and realistic. The novel should lead the reader to some conclusion about life. All these factors—idea, experience, emotion, and theme—contribute to unity. And unity is the basic principle from which all the other principles in this book are derived.

We will conclude this chapter by repeating Somerset Maugham's advice that the best way to learn craftsmanship in novel writing is by studying the craftsmanship of successful novelists. This does not mean that one should strive to imitate another man's work; it means that one should simply try to learn from him how he has managed to employ so successfully the various techniques discussed here. The reader who seriously studies the novels we have selected will have a lot more going for him in writing his own novel than the reader who skims through them.

Exercises for Chapter 13

Part I

1. In the novel you are writing, make marginal notes on your first draft for revision, as suggested in principle 2.
2. Are you willing to accept principle 3?
3. Are you willing to accept principle 4?
4. Is your plot or story line a twice-told tale? If so, have you applied the principles given in this chapter for lifting it out of the cliché class?
5. Look for cliché situations in what you've already written and eliminate them by employing the principles given in this chapter.
6. Are any of your characters stereotypes? If so, apply principles 13, 14, and 15 to get rid of them as stereotypes.
7. Look for clichés in description, dialogue, and narration in what you've written and apply principles 16 and 17 where needed.
8. Look for repetition of characters' names in what you've written and apply principles 19 and 20 where needed.
9. Look for abrupt or long transitions and apply principle 22 where needed.
10. Analyze the objective and emotional facts in what you've written and apply principles 24 and 25 where needed.
11. Write Chapter 4 of your novel.

Part II

Re-read Chapter 5 of *The Grapes of Wrath* in Appendix III and answer the following questions.

1. Write down the numbers of two paragraphs in which the author has used direct transitions.
2. State in a single sentence what the central situation is in this chapter.
3. Write down the numbers of the paragraphs in which objective facts were used.
4. Write down the numbers of the paragraphs in which emotional facts were used.
5. The basic situation in Chapter 5 is a cliché. How does the author lift it out of the cliché class?
6. How does the author avoid making all the landowners stereotypes?

14

How to Employ Symbolism

All traditional novels employ symbolism.

Symbolism is a subject often considered to be extremely complex. This brief chapter will explain what symbols are and offer guidelines for their use by the aspiring novelist.

A symbol can be almost anything in a novel—a character, a place, a gesture, or an object—anything that suggests a meaning or many meanings over, above, and beyond itself. For example, in *The Spy Who Came in from the Cold,* the word cold has a number of different meanings. It is more than a metaphor; it is a symbol. In some places, as in the first chapter, it signifies quite literally the cold weather: "He gave her the key and went back to the checkpoint hut, out of the cold." But it also means the loveless, hard, unsympathetic world the spy lives in. It means, as well, the conflict between East and West, the Cold War. And curiously, Leamas frequently links cold with the kind of disaster associated with helpless crowds, such as an auto accident, a bombing, or a street death. Cold, then, symbolizes the cold world of espionage, the Cold War, and also something unplanned, accidental, or brutally mindless, but attention-attracting and therefore, to a spy, terribly dangerous.

If a symbol can have many meanings, how can a writer control them? And should he? These are crucial questions. For a clue to the answers, let us look at closely related figures of speech, the simile and metaphor, to see what they are and how their mean-

ings are held in check. Since poetry is a convenient storehouse of figures of speech, we will take our illustrations from poems.

In his poem, "The Snake," D. H. Lawrence describes the way the snake flickers its tongue "like a forked night on the air." And in "Dover Beach," Matthew Arnold describes the sea along the shores of the continents lying "like the folds of a bright girdle furled." These are similes. A simile is an explicit pairing of two terms otherwise unrelated, and the pairing is accomplished by the use of *like* or *as*. The point of the simile is to establish an identity between dissimilar things—the snake's tongue and night, or the oceans and a girdle or sash—in order to suggest something readily visible that has a certain range of emotional and intellectual meanings. The snake's tongue suggests night, or by extension something menacing, death-dealing. The sea suggests a girdle—today we would call it a sash—or by extension, something protective, widely embracing.

The meaning of the simile is a controlled one. So, too, is the meaning of a metaphor, but the pairing or coupling of terms is not explicit as in the simile. That is, the writer does not use *like* or *as*. He simply brings together the terms he wishes to couple. For example, when Yeats wrote in "Sailing to Byzantium,"

> An aged man is but a paltry thing,
> A tattered coat upon a stick. . . .

he was using a metaphor to define the aged man. He pairs the term *man* with the words *thing* and *stick,* giving us a pathetic sense of valuelessness. Or Shakespeare in Sonnet 73 couples the age of the poem's speaker with several things: "bare ruined choirs," "twilight," and a "fire" that is slowly going out. He wishes to bring about a recognition of the speaker's aging, the possibility of death, the necessity for love.

Unlike the simile, with its close and explicit coupling of one word with another, or the metaphor, with its close identification of one term with another or several others, the symbol gains its significance by its tendency to pair or couple with many other words. Its meaning to a great extent depends on its context. The symbol is like a metaphor that has lost its bond with something close and searches to bond itself to many other words.

Let us look at an example of this, again from poetry because

the immediate context will be brief enough to allow us to see it.
Here is one of William Blake's poems:

> O Rose, thou art sick!
> The invisible worm
> That flies in the night,
> In the howling storm,
>
> Has found out thy bed
> Of crimson joy,
> And his dark secret love
> Does thy life destroy.

The rose, here, is a real rose only to the extent that it can be
destroyed by a worm. Associated or coupled with the words
"night," "bed," "joy," "love," it seems to suggest the sensuousness
of a physical love that is destroyed by the "invisible worm," per-
haps by prudishness, or treachery, or shamed hypocrisy, or lies.
Yet again, the rose may suggest any kind of ideal, such as the ideal
of beauty, perhaps, or of peace that, meeting the corruption of
reality, must necessarily be eaten away.

Thus two things become apparent about the symbol. It may
have many meanings because it readily forms associations with
other words. And the only way in which these meanings can be
controlled is by the context in which the symbol is used. Both of
these points are quite important and will form our first principle.

**1. The only way the writer of a traditional novel can control
the meanings of a symbol is to locate the symbol within the
context of the reality he is attempting to depict.**

Now, of course, many symbols exist outside of any context
whatsoever. They have been in use over so many centuries that
they have acquired a number of stock meanings. They come from
all aspects of man's life: religion, law, heraldry, trade, economics,
government, philosophical and ethical thought, and so on. Reli-
gion has given us many symbols, such as the cross, the bread and
wine, the crown of thorns. The Egyptians employed a number of
symbols, among them the ankh, a ringed cross symbolizing divine
life and also the trials of earthly life. From the animal kindom have
come symbols, such as the fox for cunning, the donkey for stupid-
ity, the mule for stubbornness, and the jackal for trickery. We find
symbols in statuary, some of the most famous being the lady of

justice blindfolded, with a sword in one hand, a scale in the other; the figure of the Winged Victory; and the statues of the Dance of Death motif in the Middle Ages. Colors have held symbolic meanings, such as white for purity, green for the magical and mysterious, and yellow for cowardice. Certain apparel has symbolized roles or professions, as, for example, the gowns worn by judges, the nurse's cap, the uniforms of the military, and the academic robes and mortarboards in education. With each passing decade, new symbols come into existence and may become traditional: the attaché case for the commuting executive, the long hair and beards of discontented youth, the peace symbol (actually an old symbol put to new use), and so on.

It would seem that when a writer wants to use a symbol, all he has to do is to go to the storehouse and pick one up, as though it were a supporting beam, and hammer it into place in his structure. This is not quite so, and our first principle both states and implies the reasons. A symbol derives its vitality from the context within which it works. It is true that a traditional symbol may enter a novel. But its traditional meanings are going to have vitality only so long as the context gives it to them. Otherwise, the context may make the symbol mean something quite different from its stock meaning, or it may point up just one of the meanings associated with it. For example, destruction is one of the qualities traditionally associated with fire. But in Golding's *Lord of the Flies,* the fire that Ralph wants to build and keep going has a different symbolism—it represents rescue and salvation for the boys, and hence the building of a fire has to do with organization, rules, discipline, the seeking of a long-term objective, all of those things, in short, that are quite different from Jack's more immediate pursuits of pleasure. It is the context which determines how a symbol is to be understood.

The second reason why a writer doesn't simply pick up ready-made symbols and affix them to his work is that symbols enter one's writing quite naturally. The beginning writer will use symbols without necessarily being aware that he is doing so. And frankly, for the would-be writer, this is the best procedure. We are going to examine this reason in several moments because of its importance.

The third reason why writers of traditional novels should worry less about the symbol than the context in which it appears is that the writer is attempting to depict a fictional world with some resem-

blance to the real world. He knows that if what he writes does have this resemblance to reality—the technical term is verisimilitude—symbols that occur in his work are going to have their meanings controlled by the context.

We are going to state these last two reasons in the form of a corollary to the first principle.

2. Let symbols enter your writing naturally as a by-product of your effort to capture the nature of reality in your story.

Some time in his student days, the would-be novelist was probably told to search for marvelous obscurities and amazingly deep meanings in the books he was required to read. Now, as a writer, he thinks he ought to give every word he writes some symbolic meaning. If he falls into this trap and loads his novel with obscure symbols, while at the same time he is trying to create a world resembling the real world, he is working at cross purposes with himself and will not succeed.

We mentioned a moment ago that writers who know very little about the subject of symbolism will nevertheless use symbols quite naturally when they write. The real difficulty for the great majority of writers is that they *cannot know in advance* what the meaning is of all the relationships they write about—the relations between people, and objects, and places, and times, and events. For writing is an act of discovery. The writer pursues his idea, but he often enough discovers that his novel is changing under his hands into something other than what he had planned. If there is any creative excitement possible, it must issue from the sense of anticipation and suspense that the author himself feels as he works *to* his idea.

Now that he is aware that the context controls the meanings of a symbol, how is the beginning writer to know what his context is?

3. Write to your idea, intention, attitude, and purpose. These form the context in which symbols will take care of themselves.

This principle means that despite whatever other extended meanings any symbol in a novel might have, the symbol will first of all be a natural, literal, and realistic representation of the author's more abstract thought expressed as his controlling idea. A barber pole is a symbol, but one can walk into it and bump his nose. A symbol is something real in a novel, like a whale, or a knife, or gray hair and timeworn features, and it is in that kind of reality

that the author's social theory, or his psychological observation, or his philosophical beliefs, all inherent in his controlling idea, may represent themselves.

As we indicated in principle 2, a writer may not know the full meaning of his idea before he writes. Hence, he should study very carefully what his subconscious mind provides for him as the symbolic representation of his idea. In order to do this, he should be aware that sometimes a symbol may recur quite naturally several times as he writes his novel.

An excellent illustration of this is found in the animal imagery of *The Pearl*. At the beginning of the novel, Kino is surrounded by animals. As he sits before his hut in the early morning light, he can stare with dispassionate interest—as though he were a god—at the frantic struggles of ants in the dust at his feet. But the nature around him is a nature of continual struggle. The waters of the Gulf are full of predator and prey. After the discovery of the pearl, the town in which Kino lives, acting through greed, becomes the predator and Kino and his family the prey—hunted animals. The town itself is described as a "colonial animal."

Another example of a recurrent symbol is the wall that separates West and East Berlin in *The Spy Who Came in from the Cold*. The first and last chapters take place at the wall, and it occurs here and there throughout the novel as the demarcation line between two systems. When Leamas steps down from the wall at the end of the novel, he disavows it as a symbol of war and expresses a human love transcending all barriers.

We want to mention the protagonist at this point since there are certain features of interest here.

4. The protagonist in a traditional novel may reject the significance that other characters attach to a symbol and make it a matter of his own personal interpretation.

Here are some examples of this:

Madame Bovary: As a place symbol in the novel, the village of Tostes suggests to Charles and the people who live there propriety, tranquillity, and economic security. Emma rejects it as such and finds Tostes dull and meaningless.

To Kill a Mockingbird: The town of Maycomb, as a place symbol in the novel, represents racial bigotry, but Atticus rejects it as such and defends Tom Robinson, an African-American.

Tom Jones: Tom, as a bastard, stands for all the shame, disgrace, and humiliation associated with illegitimacy, but he rejects this role cast for him by others and falls in love with Sophia.

5. In the beginning of the novel, the protagonist may not know the true meaning of a symbol to which he is deeply committed.

Let us look at some examples.

From Here to Eternity: The peacetime Army, when Prewitt joined it, was to him a symbol of economic security, a chance for a poor boy to make a career of soldiering. Its true meaning, its mindless conformism, was not revealed to him until he asserted his own individuality.

The Grapes of Wrath: To the Joad family, California in the beginning of the novel was a place symbol of the Promised Land where they would find work, economic security, and dignity. The true meaning of the symbol was revealed to them after their arrival in California when they discovered that they had simply traded one poverty-stricken environment for another.

The Pearl: To Kino, the pearl symbolized a much better life for him and his family. Its true meaning was revealed after Coyotito died and the pearl had destroyed "the Song of the Family."

We wish to leave the reader with one final point about symbolism and its use. We have throughout this chapter cautioned the writer not to get carried away, not to think without discipline. When a writer is experienced, however—and this may be the same as saying, when his idea seizes him and he writes under its control—he may find himself consciously using a symbolic action, or object, or person, or event, to give a concreteness, a visual and emotional brilliance to his novel that he can give in no other way. In the closing pages of *The Grapes of Wrath*, Steinbeck creates with a density of symbolism an impact that could not have been otherwise achieved. This symbolism—the rain, the flood, the birth of a dead baby, Rose of Sharon's offering her full breasts to a starving man—suggests the multiplicity of issues that the Joad family has had to contend with from the very beginning of the novel: the perversity of nature, the failure of the economic system to recognize human needs, the indifference of the haves toward the have-nots, the brutality of law toward the dispossessed, the nonexistence of the Promised Land, and finally, the ability of those tortured almost beyond endurance to transcend their forlorn lot, to rise above

personal shame and degradation, and to testify to the existence of a spirit of human brotherhood.

Exercises for Chapter 14

Part I

Study carefully the portions of your novel that you've written thus far and answer the following questions.

1. Do all the symbols you have used gain their meaning from their context in the world your novel depicts?
2. Do you have a recurrent symbol in your novel? What is it?
3. Does your protagonist reject the symbolic significance that other characters attach to any of the symbols you've used? If so, explain how.
4. Have you used any symbol whose true meaning as it affects the protagonist is not revealed to him in the beginning of the novel?
5. In dealing with symbolism, have you constantly kept in mind your original idea, intention, attitude, and purpose in writing your novel?
6. Write Chapter 5 of your novel.

Part II

1. In *The Grapes of Wrath,* the tractors are a symbol of evil to the tenant farmers and a symbol of good to the landowners for the same reason. What is this reason?
2. What symbolic significance does the clothing of the tenant farmers have in *The Grapes of Wrath*?
3. Name one of the recurrent symbols in *The Pearl.*
4. Is the biting of Coyotito by a scorpion in *The Pearl* a recurrent symbol?
5. Is the turtle in Chapter 3 of *The Grapes of Wrath* a recurrent symbol?
6. What biblical symbolism do you find in the last chapter of *The Grapes of Wrath* when Uncle John goes into the willows and bushes and places the box containing the body of Rose of Sharon's baby in the stream and says what he says?

15

How to Develop Your Own Style

To the novelist, language is what color and form are to the painter and sound is to the musician. No two painters would paint the same landscape or portrait in exactly the same color and form unless one was copying the other. Nor would two concert pianists play a Beethoven concerto in precisely the same way. Each painter and each musician develops his own style. The same is true of novelists. Just as no two people write a letter to a friend in exactly the same way, no two novelists could possibly write a novel in exactly the same way unless one was imitating the other. The manner in which each of us uses language is highly individual. From this we get our first principle.

1. Style in novel writing cannot be taught.

There are two exceptions of this principle. First of all, Standard English can be taught. Incorrect language is a hideous mask through which style cannot be seen. If a student's language is full of errors in punctuation, spelling, grammar, and sentence structure, he should be instructed, or he should try to teach himself with the aid of a handbook, how to recognize and overcome them. Secondly, a novice writer can be taught not to overwrite. Overwriting contributes as much to the obscuring, distorting, or obliterating of an effective style as incorrect language. Not to be able to write succinctly is to maim the quality of one's ideas. It is a weakness to use twenty words when ten or fewer will do. But it is not merely a question of economy. Rather, in writing simply, one is forced to be accurate in his choice of words and to make the precise qualifications that are essential for the meaningful statement of his ideas.

Excluding both of these areas in the use of language, however, our own experiences and investigations have convinced us that a great many potential fiction writers have had their growth stunted, if not ruined, by unwise advice about style. What can an instructor possibly teach a would-be writer about this aspect of his craft?

(a) If an instructor teaches a student how he, the instructor, writes, he is merely teaching copying or imitation. We know, for example, of some instructors who teach their students to avoid using the word *said* whenever possible. To drop the dialogue guide is fine, as we have previously indicated. But to use such poor substitutes as the following deserves some special kind of curse:

> ". ," he sneered.
> ". ," he chuckled.
> ". ," he laughed.
> ". ," he snorted.
> ". ," he grinned.

One cannot possibly sneer, chuckle, laugh, snort, or grin words. A study of best-selling novels will show that their authors avoid using any word other than *said* whenever possible, or simply drop the dialogue guide when it is unnecessary.

(b) An instructor can try to teach his students to imitate the style of an author he personally admires. To make the works of a particular author required reading is defensible. But to teach students to imitate another author can ruin a student's chances for developing a style of his own.

(c) Some instructors teach styles that are passé. The styles of Stevenson, Henry James, Conrad, and D. H. Lawrence are admirable, but they belong to the fiction of the past. Stevenson's elegance, James's ponderousness, Conrad's lengthy poetical passages, and Lawrence's wordy mysticism have their place in literature, but not in the fiction of today.

The only things a book on writing or an instructor should attempt to teach a would-be writer are certain considerations affecting style. This is what we propose to do in this chapter.

2. The style of a novel is the author's expression of his individuality, in all sincerity and honesty, in his use of language.

Every novel is told in words arranged in such a way as to indi-

cate the author's vision, and this is style. It must be developed by an author working on his own. Reading the seven novels we have selected for study illustrates clearly that each of their authors has developed his own style. The one and only way to do this is to begin with the following principle:

3. Write in a way that is natural for you to write.

This is the best advice that can be given to an author for developing his own manner of expression. The principle gives him complete freedom in writing. By following this principle the author will continually discover ways of improving and developing his individual style.

A corollary of principle 3 is the following:

4. In writing the first draft of a novel, let all the words come naturally.

Style is flow, to begin with. The novelist is striving to express a vision. The moment he stops the flow and starts to belabor each word the vision is displaced by a different interest. Style does not merely consist of the choice of one word over another. It consists of all the complex effects that are to be found in sentence length, rhythm, pauses, climaxes, antitheses, and many other aspects of the use of language. A writer cannot *think* these effects as he writes a first draft. To do so would be like trying to control every hair of a paintbrush when sweeping it across a canvas. The time to think of ways to improve style is during revision. At first, one should let the words flow naturally.

Although style itself cannot be taught, the beginning writer should know what a good style is. Let us define this.

5. Good style in novel writing today is the effective use of words so that they carry their meanings to the reader clearly, logically, and purposefully.

The key to a good style is in being able to express a thought or an action so effectively that it becomes as clear, logical, and purposeful in the reader's mind as it is in the author's mind. On a broader scale, what is true of a thought or action is true of an entire novel. Good style in novel writing involves communicating the author's vision to the reader by the effective use of words.

The touchstones we have mentioned—clarity, logicality, and purposefulness—make their sense in the order named. Essentially, one cannot have purposefulness without logicality, nor logicality without clarity. But these terms all point in one direction, and that is to the idea of the novelist. If there is muddiness in a writer's style, it may be that his central idea is muddy as well. Good style, then, consists of the commitment an author makes to his idea as this reveals itself in the words he uses.

Let us now look at some further principles that will help develop a good style.

6. Decide first if you write subjectively or objectively.

We have discussed subjective and objective writing in Chapter 4. The reader should decide for himself whether his natural bent in writing is subjective or objective. He will have a great deal of trouble if he tries to go against his natural bent. Many writers, including Somerset Maugham, George Orwell, and Gustave Flaubert, have testified to this.

7. Employ all the principles you have learned about the use of exposition, description, narration, and action (Chapters 6, 7, and 8).

8. Employ all the principles you have learned about craftsmanship (Chapters 12 and 13).

9. Do not consciously imitate.

One of the greatest weaknesses of beginning novelists is a tendency to imitate consciously the style of their favorite author. This will retard, if not ruin, their chances for developing a style of their own. Conscious imitation is easily detected. The would-be novelist will gradually become aware of a feeling of uneasiness, a realization of his dependency on another man's style when he should be using language of his own. This is the time to stop and rewrite in words that come naturally.

Imitation is essential to human development; it begins when we are babies and continues throughout childhood. But as we mature we seek an identity of our own. A woman may admire a friend's hat, for example, but she would rather drop dead than go out and buy one just like it. What she would do is to buy a hat that suggests

the original, but is different in some way. The same thing is true of novelists. For example, Hemingway was a great admirer of Ring Lardner, and in his early work he patterned his style after Lardner. He also admired Sherwood Anderson and gained something from him; he finally became so independent of Anderson that he was able to parody his style brutally. When an author gains something from another writer through an early admiration, he is likely to show it, quite unconsciously, in his own work. There will be certain tricks of phrasing, some almost indefinable qualities in the use of words, some grasp of imagery, that will indicate his indebtedness. But out of all this will develop the author's individual style, just as Hemingway's did. For in unconscious imitation, the author adds to the style of an author he admires, or subtracts from it, or modifies it and thereby makes it his own.

10. Write the type of novel whose idea, intention, attitude, and purpose set you on fire with enthusiasm.

A good style comes from such enthusiasm. A writer set ablaze with conviction and purpose will strive to make his conviction and purpose come alive for the reader.

11. Basing your first novel on personal experience will help you to develop your own style immediately.

When you write a novel with a plot or story line based on personal experience, with characters you have known, with an environment that is familiar to you, and with events that have happened to you, your thoughts and feelings about all these are strictly your own. As a result, you will practically be forced to tell the story in your own words and natural style.

12. Listen objectively to your inner voice during revision.

Every writer has an inner voice when it comes to the use of language. He may hear this voice but seldom when he writes his first draft, but he should not worry about it, for he will hear it loudly and clearly when he begins his revision. His inner voice will tell him when the sound and rhythm of his words are disharmonious. It will tell him when a sentence is stiff, awkward, discordant. He will find himself saying to himself, "This doesn't sound right." He will recognize why it doesn't sound right if he listens to his inner

voice. Maybe he has used too many adjectives, or an awkward adverb, or needless qualifying phrases, or a big word when a simple one will do. Or he may be rambling, editorializing, going into too much detail, writing dialogue that is stiff and out of character, employing bad syntax, using words whose meaning is not logical and clear, or making any of a dozen other errors that contribute to a bad style. If is sometimes helpful on such occasions to read the words aloud and thus by one's "outer" voice awaken the inner one.

Very closely associated with style is the type of novel, whether literary or popular, a person can write best. A novel in itself comprises a world which is a reflection of the many worlds within an author—his thoughts, feelings, and attitudes about people and life which heredity, environment, personal experience, and study have formed. These will determine the type of novel he will write and, to a great extent, the style in which he will write it.

In the beginning chapters of this book, we gave the reader suggestions to help him decide which kind of novel he can best write. However, the decision is certainly his own. Without seeing several sample chapters, it would be impossible for us to help a reader decide whether to write a literary novel or a popular one. We can only make rather broad generalizations.

If the reader has fine literary tastes, enjoys reading only literary novels, and has an above-average mastery of the English language, he will probably write literary novels. If, on the other hand, he enjoys reading only popular novels with strong and clear characterizations, a theme that has wide appeal, a protagonist with a chief motivating force and tangible objective that are readily understandable, and a natural style that is easily comprehensible, it is probable that he will write popular novels. In short, the choice between writing a literary novel or a popular novel boils down to the following principle:

13. Write your novel as it comes naturally for you to write and let an agent or an editor decide if it is a literary or a popular novel.

Only by abiding by this principle can the would-be novelist give himself complete freedom of expression and arrive at an honest evaluation of his qualifications as a writer. It will also save him a great deal of time if he tries to write a literary novel when he

lacks the qualifications to do so or decides to write a popular novel when his talent should be directed at writing a literary novel. We would estimate, based on our teaching experience, that only one reader of this book out of twenty-five has the ability to write a literary novel; the other twenty-four should write popular novels. The same, we suspect, is true in all the arts. Of twenty-five students who are studying painting under the same instructor, the chances are that only one will be successful as a creative artist.

What we have given the reader in this chapter is advice, the intent of which is to encourage him to discover and be himself. It is, perhaps, paradoxical that what cannot be taught must nevertheless be learned. And knowledge of oneself may take considerable time and effort. For an illustration of this, along with much wisdom on the subject of style, one can do no better than refer the reader to what Somerset Maugham has to say about it in his book, *The Summing Up*.

Exercises for Chapter 15

Part I

1. Of the chapters of your novel that you've completed thus far, can you honestly say you've written them in a way that came naturally?
2. Can you honestly say that you have not consciously imitated the style of an author you admire?
3. Have you conscientiously tried to use words that carry their meanings to the reader with logic, clarity, and purpose?
4. Is your writing subjective or objective?
5. Have you employed all the principles you learned in previous chapters on exposition, description, narration, action, and craftsmanship?
6. Have your idea, intention, attitude, and purpose set you on fire with enthusiasm?
7. Take the chapters you've written and improve your style by applying principle 12.
8. Which of the novels selected for study did you enjoy the most? Why?

9. How would you classify these novels in terms of their being literary or popular?

Madame Bovary Tom Jones
The Grapes of Wrath From Here to Eternity
The Pearl The Spy Who Came in from the Cold
To Kill a Mockingbird

10. Complete your novel and good luck.

Part II

1. Write from memory the fourteen common elements of structure of the traditional novel.

16

The Future of the Novel

When the novel first began there was no distinction between the popular and the literary novel. As a form, it concerned itself with a mass readership; it dealt with the lives led by the common man, and it ordered the experiences of life so that some insight could be gained about human nature. If the novel was a "good" novel with a strong theme and successful characterization, and if it held the reader's interest, it could qualify as literature.

There then occurred during the novel's history several phenomena that led to the drawing of distinctions between several kinds of novels. The first of these was an inevitable widening between the work of novelists of great talent and that of novelists of lesser talent. Novelists of great talent began to contribute technical innovations that allowed them to probe more deeply into character, to make the chief motivating force of the protagonist more abstract, to make the tangible objective wider in scope and more symbolic, and to employ language that was much more literary. Through their handling of theme, viewpoint, description, dialogue, and style, they tested the imagination, sensibility, and intellect of the reader in ways quite beyond the ability of novelists of lesser talent.

As a result, such novels began to build up a medium-sized audience of readers with fine literary tastes who demanded more than adventure, and the all-too-obvious techniques commonly used to arouse interest. It was at this period in the history of the novel that critics began dividing novels into literary novels and popular (commercial) novels. The phenomenon of growing artistry was healthy for the novel since it elevated the literary tastes of many readers.

The second phenomenon occurred when some novelists left

the mainstream of the traditional novel and began to delve deeply into psychology and the subconscious. Instead of keeping to the wide social vision of the traditional novelist, they turned their gaze inward, away from the world and toward the psyche. As a result, several types of nontraditional novels which one can label "expressionistic" were born. These novels violated some or all of the common elements of structure of the traditional novel. Using the term expressionistic to signify any departure from the structure of the kind of novel we have described in this book, one may classify as expressionistic such widely different novels as Dostoevsky's *Notes from the Underground*, Joyce's *Ulysses*, and Robbe-Grillet's *Jealousy*.

Each departure from the traditional form has rather consistently brought critics to cry that the novel from that moment on could never be the same. At the time of the publication of *Ulysses*, for example, certain literary commentators pronounced the traditional novel dead. However, the pronouncement seems not to have inhibited the sales of Steinbeck's *The Grapes of Wrath*, Hemingway's *The Sun Also Rises*, Mailer's *The Naked and the Dead*, Jones's *From Here to Eternity*, and Metalious's *Peyton Place*. All of these novels were, of course, published after *Ulysses* supposedly killed the form.

Another phenomenon in the history of the novel is the episodic novel. From the very beginning, works in this form, such as Le Sage's *Gil Blas*, Defoe's *Moll Flanders*, and later Dickens's *The Posthumous Papers of the Pickwick Club*, have been popular. This type of novel very frequently has no unified plot or story line, but it is not an expressionistic novel because of that. Instead, each chapter or segment of the work is a kind of miniature novel, with one big complication and several minor complications. The major complication is resolved in each chapter or segment. Each major complication is loosely linked to the next by means of a time transition. Since each chapter or segment is a novel on a small scale, the reader who wants to write such a form will find knowing the elements of structure very helpful. An example of a current episodic novel is *The Great Brain* by one of the authors of this book.

However, because expressionistic and episodic novels are more difficult to write than a traditional novel, we strongly urge the reader to make his first attempt traditional. Experimentation with the nontraditional forms should wait until the author has established himself. Moreover, we would hazard the guess, based on a review

of publications for several years, that only a few first novels published each year are nontraditional; the would-be novelist should give due consideration to these odds.

We have given this very brief survey of the novel in order to suggest that this youngest of major art forms has a vigorous history, and to reassure the would-be novelist that the future of the novel is not only secure but filled with promise of growth. The confident proclamations of gloomy critics that the novel is dead meet again and again the inconsistency we have noted, each funeral cry matched by some fresh example on the publication lists of a best-selling and widely popular novel.

We firmly believe that more and more novels of all types will be published in the future for the following reasons: The great increase in the number of students attending colleges and universities is bound to produce a larger audience of critical, intellectual readers who enjoy reading nontraditional novels. The increase in college graduates should also result in a greater number of persons with fine literary tastes who enjoy reading traditional literary novels. The short work week of the near future will give people more leisure time and will produce a larger audience of readers who read novels for entertainment. The mass media of communication, notably cinema and television, far from curbing the appetite for reading novels, have in fact stimulated it, and very likely will continue to do so.

There has been since the turn of the century a virtual explosion of artistic experimentation in fiction. But the critic who asserts that this now makes all future attempts at the novel meaningless and uncertain takes too short a view of any artistic development. Rather, for the writer, the possibility of integrating within traditional fiction some of the glittering efforts in experimentation is a matter for creative excitement.

As an illustration, traditional literary novelists of the future will borrow more and more those aspects of psychology originally the province of the expressionistic novel. There is also a place in the future traditional literary novel for the startling juxtaposition of place, time, and event now found in such expressionistic novels as those by Robbe-Grillet.

If there is a future for the traditional literary novel, so, too, one exists for the popular novel. Changing conditions of life, new discoveries, new inventions test afresh the imaginative power of the

novelist. The mystery, adventure, light romantic, historical, and other entertaining popular novels will certainly continue to be published.

In a troubled world, one must place his faith in some probabilities for which, despite all we have said to the contrary, there must remain insufficient evidence for belief. And one of these probabilities is that if a man has an idea which compels him to probe it and to wish to share it with others, and if he dedicates his talent meaningfully to it, he will be heard.

APPENDICES

Appendix I

The Common Elements of Structure

1. All traditional novels begin with an idea that inspires the author to write it. (Chap. 1)
2. All traditional novels have a protagonist representing a group, a class, a profession, or some other segment of society who is in conflict with his own environment or the environment of others. (Chap. 2)
3. All traditional novels have a protagonist with a chief motivating force and a tangible objective. (Chap. 2)
4. All traditional novels have a plot or a story line. (Chap. 3)
5. All traditional novels have a time element into which the story is telescoped. (Chap. 3)
6. All traditional novels present one major complication, sometimes more than one, and minor complications within the framework of the major complication. (Chap. 3)
7. All traditional novels are narrated from one, or sometimes more than one, of eight possible viewpoints. (Chap. 4)
8. All traditional novels portray a struggle between good and evil. (Chap. 5)
9. All traditional novels demonstrate that certain people had certain experiences, and these experiences comment upon life, leaving the reader with some conclusion about the nature of existence which may be factually verified. This conclusion is the theme of the novel. (Chap. 5)
10. All traditional novels employ exposition, description, narration, and action to tell the story. (Chaps. 6, 7, and 8)
11. All traditional novels use characters to dramatize the story. (Chap. 9)
12. All traditional novels employ certain techniques to hold the reader's interest. (Chap. 11)

13. All traditional novels use regional or universal material. (Chap. 12)
14. All traditional novels employ symbolism. (Chap. 14)

Appendix II

How to Prepare the Manuscript of a Novel and Submit It to a Publisher

In preparing a manuscript for submission to a publisher, it is wise to follow a standard format. The manuscript should have a professional appearance and not draw undue attention to itself in misguided attempts to create a sense of novelty.

Type the manuscript with a clean black typewriter ribbon on good white bond paper, 8½ by 11 inches. Do not use "erasable" paper. Pica type is preferable to any other, and the author should avoid using a typeface resembling script. It is very important to make a carbon copy. The manuscript should be double-spaced throughout. The author should proofread his copy carefully so as to avoid misspellings, faulty punctuation, and typing errors. He should retype pages to avoid messy erasures or inked-in corrections.

The title page contains the title in capitals about halfway down, and two spaces below that, the author's name. In the upper left-hand corner of the title page, the agent will place his name and address. In the upper right-hand corner there should be an indication of the approximate wordage. One can usually compute the wordage of a novel fairly accurately by multiplying the number of pages by 250.

Following the title page, all pages should have the title in capitals in the upper left-hand corner, two spaces down. In the upper right-hand corner goes the page number. Four spaces below the title the text begins.

The first page of each chapter should start with the chapter number halfway down on the page. The text begins four spaces below the chapter number. A drop of four spaces within the text is an indication of a transition.

The page margins should be fifteen spaces on the left, or a margin

of about an inch and a half, and ten spaces on the right, a margin of about an inch. A margin of an inch should be left at the bottom of the page.

Each paragraph begins with an indentation of five spaces. If the author is uncertain of the spacing used with the various marks of punctuation, he should consult a handbook in English.

The author can mail his manuscript via first-class mail or fourth-class mail, marked "special fourth-class manuscript rate." First-class mail is expensive, but assures better handling. It is a good idea to insure or register the package. If the manuscript is mailed as an unsolicited manuscript, the author should include postage in an amount sufficient to cover the return of the material according to his instructions. Wrap the manuscript carefully, using either cardboard or the box the typing paper came in. The entire package should be wrapped in strong wrapping paper.

We do not advise the author to send his manuscript in "cold" to a publisher. The vast majority of novels published are obtained by publishers from literary agents and literary scouts. There are two kinds of literary agents, those who advertise in writers' magazines and those who do not. The agents who do not advertise generally require that a client have some published writing credits—short stories which have been published in national magazines or one novel—before they will agree to act in his behalf. You will find the names and addresses of these agents listed in *Literary Market Place,* which is available at any large library. If you have some published writing credits, make sure you select an agent whose requirements as listed in LMP state that he does handle novels. Write to the agent listing your published writing credits and tell him you have just completed a novel you would like to submit. You will receive a letter from the agent either asking you to submit the novel or stating that he is not taking on any new clients at the present time. If the latter is the case, write to another agent. You are almost certain to get a favorable reply from one of these agents although you may have to write to as many as four or five before you do.

In the event you have no published writing credits, you must contact an agent who advertises in one of the writer's magazines such as *The Writer's Digest* or *The Writer.* Both magazines are usually available where magazines are sold. In selecting an agent who advertises, make certain you choose one who lists the names of book publishers to whom he has sold novels for his clients. These agents charge a nominal fee for reading and evaluating a book-length manuscript. The amount of the fee appears in the advertisement. Send him your manuscript with a check to cover the fee and also a letter telling him about yourself—how long you've been writing, your profession, and

a very short autobiography, not more than 300 words—and let your novel speak for itself. If they can see any possibility in it, these agents will work with you like a devoted brother to help make your novel salable and will act as your agent in submitting it to publishers for the usual 10 percent fee. They are only interested in developing authors whose work will sell. If your novel is not salable in their opinion and cannot be made into a salable novel with revision, they will tell you so and return the manuscript to you.

We come now to the second method of submitting a novel to a publisher: through a literary scout. Literary consultants, some booksellers, representatives of literary clubs, and teachers of creative writing at some colleges and universities may act as literary scouts. There are also publishers who send literary scouts around the country in search of new talent and whose salesmen also function as scouts. If the novelist has access to a teacher of creative writing, he should see if the teacher will act as scout and get in touch with a publisher's salesman. Another method is to take the manuscript to a bookseller and ask him to read it. If the bookseller likes the manuscript, he can do one of three things: (1) He can arrange for the author to meet the publisher's representative. (2) He can arrange to have a publisher's salesman act as scout and send the manuscript to the publisher. (3) He can write a letter to the trade book editor of a publishing company and arrange to have an editor read the manuscript.

We would recommend that the author of a first novel either get himself an agent or submit his novel to one of the many prize novel contests conducted each year by publishers. These first novel contests are listed in writers' magazines. As we said before, the would-be novelist should avoid at all costs sending a manuscript in "cold," or "over the transom." Such a manuscript can lie around a publishing house for months without being read. An editor knows when he receives the manuscript of a novel from an agent that the agent believes it to be a salable novel, and that in itself is half the battle in getting a novel published. Moreover, novels submitted by agents get top priority handling in publishing houses.

Let us now follow a novel submitted by an agent to a publishing house. Nearly all publishers employ first readers who work on a straight salary or commission. When a novel is submitted by an agent, even if the first reader's report is negative, it will be sent on to an associate editor. If the novel is one that has come in "over the transom" the first reader can reject it without sending it on. The reports of first readers vary with different publishing houses. Some publishers merely ask the reader to tell briefly why he thinks the manuscript merits acceptance or rejection. Others require their first readers to make out lengthy reports. Still others use a form on which the first reader

briefly outlines the plot or story line and comments on the style, reader appeal, topical interest, and so on.

If the novel gets by the first reader with a favorable report, it still has a long way to go. Assistant or associate editors reject fifteen out of twenty novels that have received favorable first-reader reports. Let us assume the novel is one of the five out of twenty that an assistant or associate editor likes and sends on with a favorable report to an editor. Upon what qualities does the editor base his decision? This varies with different editors; in fact, many novels that have become best sellers were rejected by anywhere from five to as many as twenty editors before reaching an editor they pleased. For example, the best seller, *Papa Married a Mormon*, written by one of the authors of this book, was rejected by six publishers before an editor accepted it. Another novel by the same author, *The Great Brain*, was rejected by ten publishers before it was accepted. This brings us back to the value of having an agent. An agent who likes a novel well enough to handle it will have as much if not more faith in it than the author. An agent will keep on trying, knowing that sooner or later he is going to find an editor the book will please. And an editor takes the view that if the book pleases him, it will please enough readers to make it profitable for his company.

In smaller publishing houses the trade book editor's approval of a novel means acceptance. In the larger houses, the manuscript must go to an editor-in-chief for his approval, and in some cases it is then necessary to sell the book to a management meeting consisting of the president or a vice-president, sales manager, business manager, publicity director, and so on, any one of whom may veto it. The foregoing are all reasons why it takes from two to three months to get an acceptance or a rejection from a publisher.

To be a novelist one must have great patience and believe that if the novel has merit, sooner or later it will land with an editor who likes it. One can cite such examples as *Magnificent Obsession* by Lloyd C. Douglas which was rejected by eighteen publishers, and such runaway best sellers as *Auntie Mame* and *Peyton Place*, both of which were rejected by more than a dozen publishers.

If an editor thinks a novel has possibilities, he may suggest certain revisions. The making of revisions is usually a part of the acceptance or rejection of a novel. The editor will first contact the agent and ask whether the author would be willing to revise portions of the novel. The agent in turn will contact the author. We strongly suggest that the author of a first novel agree to make any revisions the editor may want. Editors are sensitive, intelligent, highly trained people whose business is to accept novels that will make money for their companies and consequently for the authors. Many a would-be novelist who has

refused to go along with an editor's suggestions has one or two un-published novels gathering dust in trunks. A Hemingway, or a Stein-beck, or a Mailer may be able to refuse to revise his work, but a writer trying to get his first novel published must rely on the editor's judgment and agree gratefully to any revisions that will make his novel salable.

Appendix III

Reprint of Chapter 5 of
The Grapes of Wrath

When this troubled century ends, *The Grapes of Wrath* will almost certainly be recalled as one of the enduring masterpieces of American literature. A topical, regional, controversial novel, it captured the stresses and strains of the Depression period, and it was widely popular. But it also earned world-wide praise as a novel of universal significance. Its compassion for the small people whose love for the land was tested and thwarted and finally abided is remarkable. Out of such a vision, of drought ending in disastrous flood, with human beings undergoing the journey to the Promised Land only to remain dispossessed, there emerged a criticism of the American Dream that has remained as valid and relevant today as it was in the Thirties.

Readers will, of course, be curious as to why we chose Chapter 5, rather than another chapter of this novel, to reprint. Naturally we wanted to exemplify the important technical principles, and this chapter, as well perhaps as any other chapter from the novel, certainly is capable of illustrating them, whether of conflict, scenes, description, symbolism, or the tools of basic craftsmanship. But mere techniques, considered only as such, are barren. In using Chapter 5 as our example, we have chosen a chapter illustrating how the vision of a novelist works. Throughout this book, we have been mindful that whatever principles we have urged upon a reader can have no real validity unless they have been subjected to the novelist's own grasp of an idea he sees so clearly, and even so fiercely, that he must make use of them to succeed.

Chapter 5 shows how a great writer can lift his story line upward into an understanding of the forces at work in his basic idea for a novel. Steinbeck here demonstrates how his idea penetrated him. He had a vast theme, the theme of corporate forces at work against a

whole region. He could not confine such a theme to the life of a single character for this would have done violence to his idea. He had to give a picture of those large-scale confrontations that occur between corporate power and a region of human beings. In this chapter, we get an elevation of story line through the anonymity of the people involved, suggesting the size of the conflict, and through an awareness of the issues at stake for a whole people. Steinbeck had to guard against our taking such issues as merely personal ones, for that would have been to defeat the final appeal he makes to the reader—the lamenting of the loss of human brotherhood. And he had to bring us pictures of his idea so concretely and so vividly that we could not fail to see what he thought and felt.

He succeeded magnificently. The owner men with their soft hands, insistent fears, and final inhumanity sit in their autos, above the land, not touching it, nor caring for it. They speak to the squatting men, men dazed and perplexed, men with a past of which they are mindful, men who squat in the dust and feel it and feel the ties they have to it running through their fingers in the dried earth. And in the very middle of the chapter there comes the machine, a machine that rapes the land methodically, removing men from the ground, from Mother Earth, destroying men's passions and hopes and fears, and finally the fabric of their lives. In the man who sells out, Joe Davis's boy, we have the coming of a new man in America. He has lost his ties to the earth and has succumbed to economic fears that have brought the circle of his interests and his commitments down to the narrowness of family outside the complex expanse of human brotherhood. When tractors inherit the land, what has been destroyed?

Because Steinbeck saw so fully the changing of America in this novel, because he rendered it so well in this chapter that we can see the changes concretely and visually, we have chosen Chapter 5 as an example of the way the idea a novelist has must come to be embodied. Steinbeck knew what he was doing, and the chapter, therefore, recommends itself as an illustration of a principle it would be difficult to state without some sense of triteness, but which it would be disastrous for a writer not to recognize when he sits down to write a novel—he must have a grasp of his own material.

1 The owners of the land came onto the land, or more often a spokesman for the owners came. They came in closed cars, and they felt the dry earth with their fingers, and sometimes they drove big earth augers into the ground for soil tests. The tenants, from their sun-beaten dooryards, watched uneasily when the closed cars drove along the fields. And at last the owner men drove into the dooryards and sat in their cars to talk out of the windows. The tenant men stood beside the cars

for a while, and then squatted on their hams and found sticks with which to mark the dust.

2 In the open doors the women stood looking out, and behind them the children—corn-headed children, with wide eyes, one bare foot on top of the other bare foot, and the toes working. The women and the children watched their men talking to the owner men. They were silent.

3 Some of the owner men were kind because they hated what they had to do, and some of them were angry because they hated to be cruel, and some of them were cold because they had long ago found that one could not be an owner unless one were cold. And all of them were caught in something larger than themselves. Some of them hated the mathematics that drove them, and some were afraid, and some worshiped the mathematics because it provided a refuge from thought and from feeling. If a bank or a finance company owned the land, the owner man said, The Bank—or the Company—needs—wants—insists —must have—as though the Bank or the Company were a monster, with thought and feeling, which had ensnared them. These last would take no responsibility for the banks or the companies because they were men and slaves, while the banks were machines and masters all at the same time. Some of the owner men were a little proud to be slaves to such cold and powerful masters. The owner men sat in the cars and explained. You know the land is poor. You've scrabbled at it long enough, God knows.

4 The squatting tenant men nodded and wondered and drew figures in the dust, and yes, they knew, God knows. If the dust only wouldn't fly. If the top would only stay on the soil, it might not be so bad.

5 The owner men went on leading to their point: You know the land's getting poorer. You know what cotton does to the land; robs it, sucks all the blood out of it.

6 The squatters nodded—they knew, God knew. If they could only rotate the crops they might pump blood back into the land.

7 Well it's too late. And the owner men explained the workings and the thinkings of the monster that was stronger than they were. A man can hold land if he can just eat and pay taxes; he can do that.

8 Yes, he can do that until his crops fail one day and he has to borrow money from the bank.

9 But—you see, a bank or a company can't do that, because those creatures don't breathe air, don't eat side-meat. They breathe profits; they eat the interest on money. If they don't get it, they die the way you die without air, without side-meat. It is a sad thing, but it is so. It is just so.

10 The squatting men raised their eyes to understand. Can't we just hang on? Maybe the next year will be a good year. God knows how much cotton next year. And with all the wars—God knows what price

cotton will bring. Don't they make explosives out of cotton? And uniforms? Get enough wars and cotton'll hit the ceiling. Next year, maybe. They looked up questioningly.

11 We can't depend on it. The bank—the monster has to have profits all the time. It can't wait. It'll die. No, taxes go on. When the monster stops growing, it dies. It can't stay one size.

12 Soft fingers began to tap the sill of the car window, and hard fingers tightened on the restless drawing sticks. In the doorways of the sun-beaten tenant houses, women sighed and then shifted feet so that the one that had been down was now on top, and the toes working. Dogs came sniffing near the owner cars and wetted on all four tires one after another. And chickens lay in the sunny dust and fluffed their feathers to get the cleansing dust down to the skin. In the little sties the pigs grunted inquiringly over the muddy remnants of the slops.

13 The squatting men looked down again. What do you want us to do? We can't take less share of the crop—we're half starved now. The kids are hungry all the time. We got no clothes, torn an' ragged. If all the neighbors weren't the same, we'd be ashamed to go to meeting.

14 And at last the owner men came to the point. The tenant system won't work any more. One man on a tractor can take the place of twelve or fourteen families. Pay him a wage and take all the crop. We have to do it. We don't like to do it. But the monster's sick. Something's happened to the monster.

15 But you'll kill the land with cotton.

16 We know. We've got to take cotton quick before the land dies. Then we'll sell the land. Lots of families in the East would like to own a piece of land.

17 The tenant men looked up alarmed. But what'll happen to us? How'll we eat?

18 You'll have to get off the land. The plows'll go through the dooryard.

19 And now the squatting men stood up angrily. Grampa took up the land, and he had to kill the Indians and drive them away. And Pa was born here, and he killed weeds and snakes. Then a bad year came and he had to borrow a little money. An' we was born here. There in the door—our children born here. And Pa had to borrow money. The bank owned the land then, but we stayed and we got a little bit of what we raised.

20 We know that—all that. It's not us, it's the bank. A bank isn't like a man. Or an owner with fifty thousand acres, he isn't like a man either. That's the monster.

21 Sure, cried the tenant men, but it's our land. We measured it and broke it up. We were born on it, and we got killed on it, died on it. Even if it's no good, it's still ours. That's what makes it ours—being

born on it, working it, dying on it. That makes ownership, not a paper with numbers on it.

22 We're sorry. It's not us. It's the monster. The bank isn't like a man.

23 Yes, but the bank is only made of men.

24 No, you're wrong there—quite wrong there. The bank is something else than men. It happens that every man in a bank hates what the bank does, and yet the bank does it. The bank is something more than men, I tell you. It's the monster. Men made it, but they can't control it.

25 The tenants cried, Grampa killed Indians, Pa killed snakes for the land. Maybe we can kill banks—they're worse than Indians and snakes. Maybe we got to fight to keep our land, like Pa and Grandpa did.

26 And now the owner men grew angry. You'll have to go.

27 But it's ours, the tenant men cried. We—

28 No. The bank, the monster owns it. You'll have to go.

29 We'll get our guns, like Grampa when the Indians came. What then?

30 Well—first the sheriff, and then the troops. You'll be stealing if you try to stay, you'll be murderers if you kill to stay. The monster isn't men, but it can make men do what it wants.

31 But if we go, where'll we go? How'll we go? We got no money.

32 We're sorry, said the owner men. The bank, the fifty thousand-acre owner can't be responsible. You're on land that isn't yours. Once over the line maybe you can pick cotton in the fall. Maybe you can go on relief. Why don't you go on west to California? There's work there, and it never gets cold. Why, you can reach out anywhere and pick an orange. Why, there's always some kind of crop to work in. Why don't you go there? And the owner men started their cars and rolled away.

33 The tenant men squatted down on their hams again to mark the dust with a stick, to figure, to wonder. Their sunburned faces were dark, and their sun-whipped eyes were light. The women moved cautiously out of the doorways toward their men, and the children crept behind the women, cautiously, ready to run. The bigger boys squatted beside their fathers, because that made them men. After a time the women asked, What did he want?

34 And the men looked up for a second, and the smolder of pain was in their eyes. We got to get off. A tractor and a superintendent. Like factories.

35 Where'll we go? the women asked.

36 We don't know. We don't know.

37 And the women went quickly, quietly back into the houses and herded the children ahead of them. They knew that a man so hurt and

so perplexed may turn in anger, even on people he loves. They left the men alone to figure and to wonder in the dust.

38 After a time perhaps the tenant man looked about—at the pump put in ten years ago, with a goose-neck handle and iron flowers on the spout, at the chopping block where a thousand chickens had been killed, at the hand plow lying in the shed, and the patent crib hanging in the rafters over it.

39 The children crowded about the women in the houses. What we going to do, Ma? Where we going to go?

40 The women said, We don't know yet. Go out and play. But don't go near your father. He might whale you if you go near him. And the women went on with the work, but all the time they watched the men squatting in the dust—perplexed and figuring.

41 The tractors came over the roads and into the fields, great crawlers moving like insects, having the incredible strength of insects. They crawled over the ground, laying the track and rolling on it and picking it up. Diesel tractors, puttering while they stood idle; they thundered when they moved, and then settled down to a droning roar. Snubnosed monsters, raising the dust and sticking their snouts into it, straight down the country, across the country, through fences, through dooryards, in and out of gullies in straight lines. They did not run on the ground, but on their own roadbeds. They ignored hills and gulches, water courses, fences, houses.

42 The man sitting in the iron seat did not look like a man; gloved, goggled, rubber dust mask over nose and mouth, he was a part of the monster, a robot in the seat. The thunder of the cylinders sounded through the country, became one with the air and the earth, so that earth and air muttered in sympathetic vibration. The driver could not control it—straight across country it went, cutting through a dozen farms and straight back. A twitch at the controls could swerve the cat', but the driver's hands could not twitch because the monster that built the tractors, the monster that sent the tractor out, had somehow got into the driver's hands, into his brain and muscle, had goggled him and muzzled him—goggled his mind, muzzled his speech, goggled his perception, muzzled his protest. He could not see the land as it was, he could not smell the land as it smelled; his feet did not stamp the clods or feel the warmth and power of the earth. He sat in an iron seat and stepped on iron pedals. He could not cheer or beat or curse or encourage the extension of his power, and because of this he could not cheer or whip or curse or encourage himself. He did not know or own or trust or beseech the land. If a seed dropped did not germinate, it was nothing. If the young thrusting plant withered in drought or drowned in a flood of rain, it was no more to the driver than to the tractor.

43 He loved the land no more than the bank loved the land. He could admire the tractor—its machined surfaces, its surge of power, the roar of its detonating cylinders; but it was not his tractor. Behind the tractor rolled the shining disks, cutting the earth with blades—not plowing but surgery, pushing the cut earth to the right where the second row of disks cut it and pushed it to the left; slicing blades shining, polished by the cut earth. And pulled behind the disks, the harrows combing with iron teeth so that the little clods broke up and the earth lay smooth. Behind the harrows, the long seeders—twelve curved iron penes erected in the foundry, orgasms set by gears, raping methodically, raping without passion. The driver sat in his iron seat and he was proud of the straight lines he did not will, proud of the tractor he did not own or love, proud of the power he could not control. And when that crop grew, and was harvested, no man had crumbled a hot clod in his fingers and let the earth sift past his fingertips. No man had touched the seed, or lusted for the growth. Men ate what they had not raised, had no connection with the bread. The land bore under iron, and under iron gradually died; for it was not loved or hated, it had no prayers or curses.

44 At noon the tractor driver stopped sometimes near a tenant house and opened his lunch: sandwiches wrapped in waxed paper, white bread, pickle, cheese, Spam, a piece of pie branded like an engine part. He ate without relish. And tenants not yet moved away came out to see him, looked curiously while the goggles were taken off, and the rubber dust mask, leaving white circles around the eyes and a large white circle around nose and mouth. The exhaust of the tractor puttered on, for fuel is so cheap it is more efficient to leave the engine running than to heat the Diesel nose for a new start. Curious children crowded close, ragged children who ate their fried dough as they watched. They watched hungrily the unwrapping of the sandwiches, and their hunger-sharpened noses smelled the pickle, cheese, and Spam. They didn't speak to the driver. They watched his hand as it carried food to his mouth. They did not watch him chewing; their eyes followed the hand that held the sandwich. After a while the tenant who could not leave the place came out and squatted in the shade beside the tractor.

45 "Why, you're Joe Davis's boy!"

46 "Sure," the driver said.

47 "Well, what you doing this kind of work for—against your own people?"

48 "Three dollars a day. I got damn sick of creeping for my dinner—and not getting it. I got a wife and kids. We got to eat. Three dollars a day, and it comes every day."

49 "That's right," the tenant said. "But for your three dollars a day fifteen or twenty families can't eat at all. Nearly a hundred people have to go out and wander on the roads for your three dollars a day. Is that right?"

50 And the driver said, "Can't think of that. Got to think of my own kids. Three dollars a day, and it comes every day. Times are changing, mister, don't you know? Can't make a living on the land unless you've got two, five, ten thousand acres and a tractor. Crop land isn't for little guys like us any more. You don't kick up a howl because you can't make Fords, or because you're not the telephone company. Well, crops are like that now. Nothing to do about it. You try to get three dollars a day someplace. That's the only way."

51 The tenant pondered. "Funny thing how it is. If a man owns a little property, that property is him, it's part of him, and it's like him. If he owns property only so he can walk on it and handle it and be sad when it isn't doing well, and feel fine when the rain falls on it, that property is him, and some way he's bigger because he owns it. Even if he isn't successful he's big with his property. That is so."

52 And the tenant pondered more. "But let a man get property he doesn't see, or can't take time to get his fingers in, or can't be there to walk on it—why, then the property is the man. He can't do what he wants, he can't think what he wants. The property is the man, stronger than he is. And he is small, not big. Only his possessions are big—and he's the servant of his property. That is so, too."

53 The driver munched the branded pie and threw the crust away. "Times are changed, don't you know? Thinking about stuff like that don't feed the kids. Get your three dollars a day, feed your kids. You got no call to worry about anybody's kids but your own. You get a reputation for talking like that, and you'll never get three dollars a day. Big shots won't give you three dollars a day if you worry about anything but your three dollars a day."

54 "Nearly a hundred people on the road for your three dollars. Where will we go?"

55 "And that reminds me," the driver said, "you better get out soon. I'm going through the dooryard after dinner."

56 "You filled in the well this morning."

57 "I know. Had to keep the line straight. But I'm going through the dooryard after dinner. Got to keep the lines straight. And—well, you know Joe Davis, my old man, so I'll tell you this. I got orders whenever there's a family not moved out—if I have an accident—you know, get too close and cave the house in a little—well, I might get a couple of dollars. And my youngest kid never had no shoes yet."

58 "I built it with my hands. Straightened old nails to put the sheath-

ing on. Rafters are wired to the stringers with baling wire. It's mine. I built it. You bump it down—I'll be in the window with a rifle. You even come too close and I'll pot you like a rabbit."

59 "It's not me. There's nothing I can do. I'll lose my job if I don't do it. And look—suppose you kill me? They'll just hang you, but long before you're hung there'll be another guy on the tractor, and he'll bump the house down. You're not killing the right guy."

60 "That's so," the tenant said. "Who gave you orders? I'll go after him. He's the one to kill."

61 "You're wrong. He got his orders from the bank. The bank told him, 'Clear those people out or it's your job.'"

62 "Well, there's a president of the bank. There's a board of directors. I'll fill up the magazine of the rifle and go into the bank."

63 The driver said, "Fellow was telling me the bank gets orders from the East. The orders were, 'Make the land show profit or we'll close you up.'"

64 "But where does it stop? Who can we shoot? I don't aim to starve to death before I kill the man that's starving me."

65 "I don't know. Maybe there's nobody to shoot. Maybe the thing isn't men at all. Maybe like you said, the property's doing it. Anyway I told you my orders."

66 "I got to figure," the tenant said. "We all got to figure. There's some way to stop this. It's not like lightning or earthquakes. We've got a bad thing made by men, and by God that's something we can change." The tenant sat in his doorway, and the driver thundered his engine and started off, tracks falling and curving, harrows combing, and the phalli of the seeder slipping into the ground. Across the dooryard the tractor cut, and the hard, foot-beaten ground was seeded field, and the tractor cut through again; the uncut space was ten feet wide. And back he came. The iron guard bit into the house-corner, crumbled the wall, and wrenched the little house from its foundation so that it fell sideways, crushed like a bug. And the driver was goggled and a rubber mask covered his nose and mouth. The tractors cut a straight line on, and the air and the ground vibrated with its thunder. The tenant man stared after it, his rifle in his hand. His wife was beside him, and the quiet children behind. And all of them stared after the tractor.

Appendix IV

Answers to Part II of Exercises

Chapter 1:
1. (a).
2. (b).
3. (a).
4. (c).

Chapter 2:
1. (b).
2. (b).
3. (a).
4. (a).
5. It changes.
6. It changes.
7. Principle 9. The finding of the pearl changes Kino's status quo from a very poor pearl fisherman to a potentially rich man; this brings him into conflict with his environment.
8. (a).

Chapter 3:
1. A story line.
2. A plot.
3. The two chief motivating forces both fail to reach their tangible objectives.
4. The chief motivating force fails to reach its tangible objective.
5. (a).
6. (b).
7. (a) (b) (c).
8. (a).
9. (a).
10. (a).

Chapter 4:
1. Third person.
2. Third person.
3. Unrestricted omniscient powers.
4. Unrestricted omniscient powers.
5. VP VIII.
6. VP VIII.
7. Subjective.
8. Subjective.

Chapter 5:
1. Poverty-stricken conditions are an indication of evil.
2. Anything that corrupts happiness and destroys a family is evil.
3. (a).
4. (a).
5. Good.
6. Good.
7. Evil.
8. Evil.
9. (b).
10. (a).

Chapter 6:
1. Paragraphs containing expository information: 1, 3, 4, 5, 6, 7, 8, 9, 11, 14, 15, 16, 18, 19, 20, 21, 22, 23, 24, 25, 26, 27, 28, 30, 32, 37, 41, 42, 43, 44, 48, 49, 50, 51, 52, 53, 54, 55, 56, 57, 58, 59, 60, 61, 62, 63, 65, 66.

Chapter 7:
1. Paragraphs containing descriptive details: 1, 2, 3, 4, 5, 12, 13, 19, 33, 34, 37, 38, 39, 40, 41, 42, 43, 44, 53, 66.

Chapter 8:
1. Paragraphs using narration: 1, 41.
 Paragraphs using action: 2–30; 42–66.
 Paragraphs containing a big scene: 2–32; 44–66.
 Paragraphs containing a small scene: 33–40; 42, 43.

Chapter 9:
1. Paragraph 1: Principles 1, 2, 3, 7, 15.
 Paragraph 42: Principles 1, 2, 4, 5-b, 14, 16.
 Paragraphs 44–51; Principles 1, 2, 3, 4, 5-b, 5-e, 6, 7, 9, 11, 12, 13, 14, 15, 16.

2. *General group traits:* They drive in closed cars and talk out of the window to the tenants; they are caught in an economic squeeze of ownership.

 Physical traits: Steinbeck emphasizes their soft fingers as opposed to the hard hands of the farmers.

 Personal traits: They are all driven to overlook their own emotional feelings, which vary considerably, because of the commitment they have to the economic proposition: Banks need profit in order to live.

 Emotional traits: Some kind, some cold, some hateful, some afraid, some proud, some angry.

3. *General regional traits:* Strong affiliation with the land.

 General group traits: Hardworking, stubborn in their conflict with the poor land, committed to the land, begging for another chance.

 Physical traits: Hardened physically, sunburned, dressed poorly (in ragged clothes).

 Personal traits: All are true lovers of the land and of their families; they are hardworking and not lazy.

 Emotional traits: Smoldering anger under bewilderment, perplexity, and wonder at their lot.

4. *General regional traits:* The original ones are gone and in their place the tractor driver is now a dehumanized machine, "a part of the monster."

 General group traits: No longer a self-directed worker, he is muzzled, goggled, and removed from the land and the love of it.

 Physical traits: These he shares with the tenant farmers.

 Personal traits: Uncaring, unfeeling, an admirer of power.

 Emotional traits: Hardened, selfish.

5. The choice they make between economic profit and compassion for the tenant farmers reveals the owners as being angry, uncaring, and selfish.

 The tenant farmers have only one choice, to move on, and this reveals the helplessness of their pride and sense of dignity.

 The tractor driver's decision to desert the tenant farmers and join the owners reveals him as being selfish and dehumanized.

Chapter 10:

1. Three. A roadside restaurant, the highway, and the cab of the truck.
2. Inside the restaurant.
3. Two. The truck driver and Tom Joad.
4. Unrestricted omniscient powers.
5. The truck driver is described as a man older than Tom Joad.

6. Tom Joad is described as a man "not over thirty."
7. Yes. In some detail.
8. Yes. In some detail.
9. Yes, when she says, "Don't let the flies in. Either go out or come in."
10. Yes, when the truck driver says, "Didn't you see the *No Riders* sticker on the win'shield?"
11. (a).
12. The scene begins as a small scene that conveys information to the reader about Tom Joad, truck drivers, and sharecroppers who are being moved out. It develops into a big scene beginning with the sentence, "You sure took a hell of a long time to get to it, buddy." There is conflict present between Tom Joad and the truck driver from that point until the end of the chapter.
13. Principle 9-b. The author presents a minor complication. Tom Joad had just been released from prison at McAlester and faces being on parole for some time. This has a bearing on the major complication because it means Tom must violate his parole when the Joad family begin their trek to California.

Chapter 11:
1. Kino must sell the pearl before somebody cheats him out of it or steals it from him.
2. The Joad family must reach California before their money runs out.
3. (b).
4. Coyotito is bitten by a scorpion and if not treated in time, he may die.
5. The last paragraph.
6. The pearl is described as "rich and warm and lovely, flowing and gloating and triumphant." This suggests that exciting events will follow.
7. (1) Opponents try to steal the pearl.
 (2) Opponents try to cheat Kino out of the pearl.
 (3) Kino cannot get a fair price for the pearl in town and is forced to flee to the mountains.
8. Principle 2.
9. (b).

Chapter 12:
1. Kino and Juana try to get the doctor to treat their son who has been bitten by a scorpion.
2. Tom Joad is hitchhiking home after his release from prison and gets a lift from a truck driver.

3. The five elements of the situation are:

Who: Kino, Juana, Coyotito, the doctor, his servants, and curious hangers-on.

Where: The situation takes place first in Kino's hut, then on the way to the doctor's house, and finally before the doctor's gate.

What: The main event is the stinging of Coyotito by a scorpion.

When: In the first chapter, and it lasts a couple of hours.

Why: Kino and Juana are very poor people living in a hut into which a scorpion may easily enter.

4. The five elements of the situation are:

Who: Tom Joad, the truck driver, and the waitress.

Where: The situation takes place at a roadside restaurant and inside the cab of the truck.

What: Tom Joad has just been released from prison and is hitchhiking his way home.

When: In the second chapter, and the event takes place in a few hours.

Why: While it is true that Tom Joad would not be hitchhiking his way home from prison if he had not killed a man, his motivation for hitching a ride is to get back home as quickly as possible.

5. No. The situation is not departed from for a broad and general panoramic view of the setting, the culture of the people, or the region.

6. Yes. The first six paragraphs give a panoramic view of the development of the dust bowl.

7. It was against company regulations to give rides to hitchhikers.

8. Kino did not have the money to pay the doctor.

9. Both (b) and (c).

Chapter 13:

1. Paragraphs 41 and 44.

2. The central situation is the confrontation between the landowners, who are the mathematical extension of a profit system, and the tenant farmers, whose work is not mathematical but age-old human toil.

3. Paragraphs in which objective facts are used: 1, 3, 5, 6, 7, 8, 9, 11, 14, 15, 16, 19, 20, 21, 24, 25, 28, 30, 32, 38, 41, 42, 43, 44, 48, 49, 50, 51, 52, 53, 54, 58, 59, 61, 62, 63, 66.

4. Paragraphs in which emotional facts are used: 1, 2, 3, 6, 7, 10, 12, 13, 14, 15, 17, 19, 20, 21, 22, 24, 25, 26, 27, 32, 33, 34, 37, 38, 39, 40, 42, 43, 44, 45, 48, 49, 50, 58, 59, 66.

5. The basic situation of Chapter 5 is an old melodramatic one: the

hardhearted banker who forecloses the mortgage and forces the family out. Steinback lifts it out of the cliché class in several ways: he updates the situation, making it relevant to the 1930's, but chiefly, he makes the issues involved important to our emotions.

6. The author avoids making the landowners stereotypes by having each landowner react differently to the situation.

Chapter 14:

1. The tractors are machinery which replace manpower.
2. Torn, patched, faded clothes suggest people who are very poor, without jobs, without money.
3. The pearl itself.
4. No.
5. No.
6. Moses as a baby was placed in bulrushes at the brink of a river. He later delivered his people from persecution by the Pharaoh and the Egyptians and led them to the Promised Land. Uncle John's forlorn hope is that the dead baby as a symbol might deliver the Joads and people like them from the wretchedness of their existence.

Chapter 15:

1. See Appendix I for answers.

Index *

* No attempt has been made in this index to provide page references for any of the seven novels selected for study (*The Grapes of Wrath, From Here to Eternity, To Kill a Mockingbird, Madame Bovary, The Pearl, The Spy Who Came in from the Cold, Tom Jones*), their characters, or any of the significant places or things mentioned in them. The references are so numerous and so thoroughly integrated within the text as to make such a task virtually meaningless for the reader, who would be better guided by the various elements of structure and technique that are indexed and which use these novels as examples.